Nikon®

Creative Lighting System

Digital Field Guide,
Second Edition

Nikon®
Creative Lighting System

Digital Field Guide, Second Edition

J. Dennis Thomas

WILEY

Wiley Publishing, Inc.

Nikon® Creative Lighting System Digital Field Guide, Second Edition

Published by
Wiley Publishing, Inc.
10475 Crosspoint Boulevard
Indianapolis, IN 46256
www.wiley.com

ISBN: 978-0-470-45405-3

Manufactured in the United States of America

10 9 8 7 6 5 4 3 2 1

For general information on our other products and services or to obtain technical support, please contact our Customer Care Department within the U.S. at (877) 762-2974, outside the U.S. at (317) 572-3993 or fax (317) 572-4002.

Wiley also publishes its books in a variety of electronic formats. Some content that appears in print may not be available in electronic books.

Library of Congress Control Number: 2009935229

WILEY

About the Author

J. Dennis Thomas is a freelance photographer based out of Austin, Texas. He's been using a camera for fun and profit for almost 25 years. Schooled in photography first in high school then at Austin College, he has won numerous awards for both his film and digital photography. Denny has a passion for teaching others about photography and has taught black and white film photography to area middle school students as well as lighting and digital photography seminars in Austin. His photographic subjects are diverse, from shooting weddings and studio portraits to photographing concerts and extreme sports; he enjoys all types of photography. He has written seven highly successful Digital Field Guides for Wiley Publishing and has more in the works. His work has been published by *Rolling Stone* as well numerous magazines, newspapers, and Web sites.

Credits

Senior Acquisitions Editor
Stephanie McComb

Development Editor
Jama Carter

Technical Editor
Ben Holland

Senior Copy Editor
Kim Heusel

Editorial Director
Robyn Siesky

Editorial Manager
Cricket Krengel

Business Manager
Amy Knies

Senior Marketing Manager
Sandy Smith

Vice President and Executive Group Publisher
Richard Swadley

Vice President and Executive Publisher
Barry Pruett

Project Coordinator
Patrick Redmond

Graphics and Production Specialists
Andrea Hornberger
Jennifer Mayberry
Mark Pinto

Quality Control Technicians
Laura Albert
Melanie Hoffman

Proofreading and Indexing
Linda Seifert
Ty Koontz

To Henrietta and Maddie, the sweetest girls in the world.

Acknowledgments

Thanks to Cricket, Stephanie, Courtney, and Laura at Wiley. Thanks to the folks at Precision Camera in Austin, TX, and Jack Puryear at Puryear Photography.

Contents

Acknowledgments **xiii**

Introduction **xxi**

The Evolution of the Nikon CLS. xxi

What's in This Book for You? xxiii

QUICK TOUR

Getting Started . 2

Taking Your First Photos with a Speedlight. . . 4

CHAPTER 1

Exploring the Nikon Creative Lighting
System **9**

Main Features and Functions 10

Anatomy of the Speedlight 13

 SB-400 . 14

 SB-600 . 15

 Control buttons 19

 Combination buttons 20

 SB-800 . 21

 Control buttons 25

 Combination buttons 26

 SB-900 . 27

 Control buttons 30

 Camera compatibility 34

 D40, D40X, D50, D60, D3000,
 and D5000. 36

 D70/D70s. 36

 D80, D90, D200, D300/D300s,
 and D700. 37

 D2X/D2Xs, D2H/D2Hs, D3/D3X 37

Included Accessories. 37

 SB-900 . 38

 SS-900 soft case 38

 AS-21 Speedlight stand 38

 SJ-900 color filter set. 38

 SZ-2 color filter holder 39

 SW-13H diffusion dome. 39

SB-800 . 40
 SS-800 soft case 40
 SD-800 quick-recycling battery pack . . 40
 AS-19 Speedlight stand 40
 SJ-800 colored filter set 40
 SW-10H diffusion dome. 41
SB-600 . 41
 SS-600 soft case 41
 AS-19 Speedlight stand 41
Add-on Accessories. 41
 SU-800 wireless Speedlight
 Commander. 41
 R1/R1C1 and SB-R200 42
 SG-3IR. 44

CHAPTER 2
Setting Up Your Nikon Speedlights 45

Power Requirements. 46
 Nonrechargeable. 46
 Rechargeable 47
Navigate the Settings and Menus 47
 Flash modes . 47
 i-TTL and i-TTL BL 48
 Non-TTL Auto Flash/Auto Aperture . . . 50
 Guide Number Distance Priority 52
 Manual. 53
 Repeating Flash 54
 SU-4 mode. 54
 SB-900 custom functions and settings . . 55
 Non-TTL Auto flash mode 56
 Master RPT flash 57
 Manual mode output 57
 SU-4. 57
 Illumination pattern 57
 Test firing button 58
 Flash output level of test firing
 in iTTL . 58
 FX/DX. 58
 Power zoom. 59
 AF-Assist . 59
 Standby . 60
 ISO. 60
 Remote ready light. 61

LCD panel illuminator. 61
Thermal cut-out 61
Sound monitor 62
LCD panel contrast 62
Distance unit 62
Zoom position setting for wide-flash
 panel . 62
My Menu settings 63
Firmware . 63
Reset . 64
SB-800 custom functions and settings. . . 64
ISO. 64
Wireless Flash mode 64
Sound monitor 65
Non-TTL Auto flash mode 65
Standby . 66
Distance unit 67
Power zoom. 67
Zoom position setting for wide-flash
 panel . 67
LCD panel illuminator. 68
LCD panel contrast 68
AF-Assist . 68
Flash Cancel. 68
SB-600 custom functions and settings . . 69
Wireless remote flash mode 69
Sound monitor 69
Remote ready light. 70
AF-Assist . 70
Standby . 71
Power zoom. 71
Zoom position setting for wide-flash
 panel . 71
LCD illuminator 72

CHAPTER 3
Flash Photography Fundamentals 73

Understanding Flash Exposure 74
Key Terms. 74
Basics of Using Flash 82
Achieving proper exposures. 82
Guide Number 82
Aperture. 87

Distance. 87
GN / D = A 88
Flash sync modes. 88
Sync speed 89
Front-curtain sync 91
Red-eye reduction 93
Slow sync. 93
Rear-curtain sync 94
Flash Exposure Compensation (FEC) 95
Understanding Color Temperature 97
What is Kelvin? 97
White balance settings 98
Mixed lighting 98
Using Repeating Flash. 100
Using Bounce Flash 104
Fill Flash. 106
Simple Light Modifiers 109
Diffusion Domes. 109
Bounce cards 111
Speedlights versus Studio Strobes 112

CHAPTER 4
Advanced Wireless Lighting 115

Flash Setup for Advanced Wireless
Lighting. 116
Setting Up a Master or Commander 119
SB-900 . 119
SB-800 . 119
Built-in flash 120
Setting the Flash Mode 120
SB-900 . 121
SB-800 . 122
SU-800 . 122
Setting Up Remotes 123
SB-900 . 123
SB-800 . 123
SB-600 . 124
Setting Up Remote Groups 124
SB-900 . 125
SB-800 . 125
SB-600 . 125

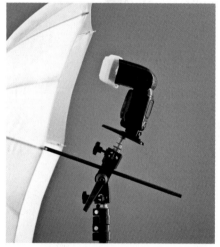

Making Adjustments on the -Fly 126
 SB-900 . 126
 SB-800 . 127
 SU-800 . 127

CHAPTER 5
Setting up a Portable Studio **129**

Introduction to the Portable Studio 130
Equipment . 130
 Stands . 130
 Brackets and multiclamps 131
 Umbrellas . 133
 Softboxes . 135
 Flash-mount softboxes 135
 Stand-mounted softboxes 136
 Reflectors and diffusers 138
 Diffusion panel 138
 Reflectors . 139
 Backdrops . 140
 Seamless paper 142
 Vinyl . 143
 Muslin . 143
 Canvas . 144
 Background stands 144
 Filters . 144
 Attaching the filters 145
 Settings . 146
 Using filters 147
Transporting Your Portable Studio 152

CHAPTER 6
Advanced Flash Techniques **155**

Action and Sports Photography 156
 Setup . 156
 Tips and tricks . 158
Concert Photography 159
 Setup . 160
 Tips and tricks . 161
Macro Photography 162
 Setup . 163
 Tips and tricks . 165

Night Photography. 167
 Setup . 167
 Tips and tricks. 167
Portrait Photography 170
 Indoor . 171
 Outdoor. 172
 Pet Portraits 175
Special Effects Photography 177
 Setup . 179
 Tips and tricks. 180
Still-Life and Product Photography 181
 Setup . 182
 Tips and tricks. 183
Wedding and Engagement Photography. . . 186
 Setup . 187
 Tips and tricks. 188

APPENDIX A
Posing Considerations **191**
Getting Started 191
Positioning the Head and Neck 194
Additional Tips. 200

APPENDIX B
Resources **203**
Informational Web Sites 203
 Nikon . 203
 Nikonians.org. 203
 Photo.net . 203
 J. Dennis Thomas's Digital Field
 Guide Companion 203
Workshops . 204
 Ansel Adams Gallery Workshops. . . . 204
 Brooks Institute Weekend
 Workshops 204
 Great American Photography
 Workshops 204
 Mentor Series Worldwide Photo
 Treks . 204
 Photo Quest Adventures 204
 Summit Series of Photography
 Workshops 204
 Santa Fe Photographic Workshops. . . 204

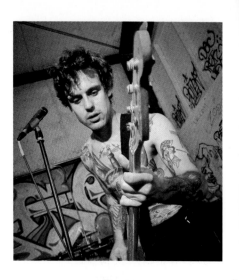

Online Photography Magazines and
 Other . 204
 Digital Photographer 204
 Digital Photo Pro 205
 Flickr. 205
 Outdoor Photographer 205
 Photo District News. 205
 Popular Photography & Imaging 205
 Shutterbug. 205

APPENDIX C
How to Use the Gray Card and
Color Checker 207

The Gray Card . 207
The Color Checker. 208

Glossary 209

Index 217

Introduction

When Nikon introduced the Creative Lighting System in 2004, it was mostly overlooked. The focus was on the rapidly changing advancement of digital SLR cameras. This disregard was a shame because the Nikon Creative Lighting System was the most amazing development to happen to photographic lighting in decades. The ability to infinitely control the output of multiple lights *and* to be able to do it wirelessly, with full Through-the-lens (TTL) metering was almost unheard of.

The popularity of Nikon's Creative Lighting System has grown exponentially in recent years with more and more people becoming interested in photographic lighting. The fact that these flashes can take care of most of the work for you at an affordable cost is a major factor in the popularity of this system. With the SB-800, the SB-600, the SU-800, and more recently the SB-900 and SB-400, no other company comes close to offering such a multitude of tools for specific lighting needs.

The main feature of CLS is the ability to get the flashes off of the camera and to be able to control them wirelessly. Nikon refers to this as Advanced Wireless Lighting (AWL). Quite simply, when you're stuck with the flash mounted on the camera or even to a flash bracket, your ability to control the lighting is severely impeded — leaving you stuck with full frontal lighting.

With the CLS, you can direct the light. Thus, you can create the same lighting patterns that professionals achieve with expensive studio strobes, at a much lower cost. This is the key to professional-looking images: controlling the lighting to get the effect that you want.

The Evolution of the Nikon CLS

Nikon started toying with wireless Speedlight control in 1994 with the introduction of the SB-26 Speedlight. This flash incorporated a built-in optical sensor that enabled you to trigger the flash with the firing of another flash. While this was handy, you still had to meter the scene and set the output level manually on the SB-26 itself.

With the release of the SB-28 in 1997, Nikon dropped the built-in optical sensor. You could still do wireless flash, but you needed to buy the SU-4 wireless sensor. Wireless flash still had to be set manually because the pre-flashes used by the TTL metering system caused the SU-4 to fire the Speedlight prematurely.

In 1999 Nikon released the SB-28DX; this flash was made to work with Nikon's emerging line of digital SLRs. The only change from the SB-28 was the metering system. The Nikon film-based TTL metering was replaced by DTTL. This metering system compensated for the lower reflectivity of a digital sensor as opposed to film's highly reflective surface.

In 2002 Nikon replaced the SB-28DX with the SB-80DX. The changes were minimal, more power, wider zoom, and a modeling light. They also returned the wireless optical sensor. As before, although you could use this Speedlight wirelessly, you still had to set everything up on the flash itself.

When 2004 rolled in, Nikon revolutionized the world of photographic lighting with the SB-800, the first flash to be used with the new Creative Lighting System. The first camera to be compatible with the CLS was the D2H. Using the D2H with multiple SB-800s enabled you to control the Speedlights individually by setting them to different groups, all which were metered via pre-flashes and could be adjusted separately.

With the introduction of the D70 and later the D70s and D200, users could even control any number of off camera Speedlights using the camera's built-in flash. Of course using the built-in flash had some drawbacks. Using the D70s, you can only control one group of Speedlights, and with the D200, you can only control two groups. Even so, this is remarkable. Never before could you use a Speedlight off camera while retaining the function of the iTTL metering. Today all of Nikon's current dSLR cameras are CLS compatible. Although not all of the cameras allow you to control using a built-in flash, any one of the cameras can be used with one of the Speedlights that act as a commander to control any number of off camera Speedlights.

Eventually, Nikon augmented the CLS line with the SB-600, the little brother to the SB-800. While lacking some of the features of the SB-800, such as the ability to control Speedlights, it's still an amazing little flash. Nikon also released a couple of kits for doing macro photography lighting, the R1 and R1C1. The R1 macro lighting kit has two small wireless Speedlights, the SBR-200, which you can mount directly to the lens via an adaptor. The SBR-200 can also be purchased separately enabling you to use as many lights as you want. The R1C1 kit is essentially the same as the R1 kit, with the addition of the SU-800 commander unit. The SU-800 is a wireless transmitter that enables you to control groups of flashes just like the SB-800 without a visible flash.

Recently Nikon has rounded out the system by adding the bare-bones SB-400 and the newest flagship model, the SB-900.

What's in This Book for You?

While the manuals that come with the Speedlights are informative and contain all the technical data about your Nikon Speedlight, they don't exactly go into detail about the nuances of lighting — the small things and pitfalls you may encounter or the types of settings you might want to use on your camera and lenses.

That's where this book comes in. This book offers you tips and advice acquired in real world situations by a photographer who has been using the Nikon Creative Lighting system almost daily since it was first introduced.

Initially, flash photography is often thought of with dread as mysterious and confusing. However, with this book I hope to dispel that myth and help to get you on the road to using the flash and CLS as another creative tool in your photographic arsenal.

Quick Tour

Many cameras come equipped with a built-in flash. Like any photographer who takes many photos with flash, you soon learn the limitations of these built-in flashes. Adding one or more Speedlights to your photographic arsenal enhances your photographic capabilities beyond what a built-in flash can provide.

Speedlights are not only useful in lowlight situations, but can be used in many other situations as well. Uses range from fill flash (which you learn more about later in the book) in direct sunlight to completely lighting a subject in the studio.

The SB-900 or SB-800 are ready to go for quick snapshots, but also configurable for some complex wireless multi-flash photo shoots. So get ready; you are about to explore the world of the Nikon Speedlights and the Nikon Creative Lighting System.

Right out of the box, a Speedlight can be used to capture dramatic portraits.

Getting Started

If you want to get up and running quickly with your Nikon Speedlight, all you really need to do is insert the batteries, attach the Speedlight to your camera, and then turn both the Speedlight and the camera on. You'll be amazed at the quality of flash photos you can take with the Speedlight as soon as you take it out of the box, whether it's the entry level SB-400 or the top-of-the-line SB-900.

> **NOTE** The Nikon Creative Lighting System Digital Field Guide assumes that you are familiar with your camera's settings and modes. If you're unsure about certain camera settings, consult your owner's manual or the appropriate Digital Field Guide for your camera.

Attaching the Speedlight is quite easy:

1. **Turn off the camera and Speedlight.** Turning off the equipment reduces any risk of short circuits when attaching different electronic devices.

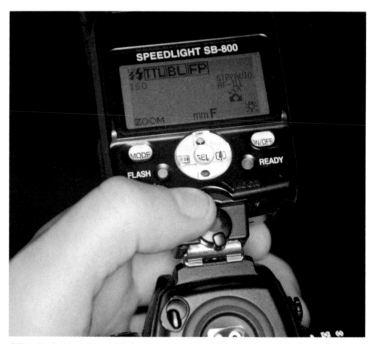

QT.1 Slide the Speedlight foot into the hot shoe and lock the mounting foot.

2. **Unlock the mounting foot lock lever.** Move the mounting foot lock lever of the Speedlight to the left — its unlocked position.

3. **Attach the Speedlight to your camera.** Slide the Speedlight foot into the camera's hot shoe. Turn the mounting foot lock lever to the right to lock the Speedlight in place.

4. **Turn on your camera.**

5. **Turn on your Speedlight.** The On/Off switch is located on the back panel.

After your Speedlight is attached with the flash head in the horizontal position and the camera and Speedlight are turned on, you can reposition your flash head if you want. Repositioning the flash head allows you to do *bounce flash,* which is a technique in which the light from the flash is bounced off of a nearby surface to diffuse the light.

For more information on bounce flash, see Chapter 3.

QT.2. **Repositioning the flash head for bounce flash**

 Nikon Speedlights accept alkaline, lithium, or rechargeable NiMH AA batteries.

Taking Your First Photos with a Speedlight

Once the Speedlight is attached to the camera and both are turned on, the Speedlight defaults to through-the-lens (TTL) metering, which means that the camera is reading the light levels through the lens and sets the flash level output from the data that it receives. Nikon refers to the proprietary metering systems as i-TTL.

 TTL is covered in more detail in Chapter 2.

There are two types of TTL metering available with all current CLS-compatible Speedlights.

▶ **TTL BL.** TTL BL means that the camera is taking a reading of the entire scene and attempting to *balance* the light from the flash with the ambient lighting. This is generally the best setting to use and yields the most natural looking results in most situations. When your camera's meter is set to matrix metering, TTL BL is the default TTL setting.

▶ **TTL.** When the camera's metering mode is set to Center-weighted or Spot metering, the camera switches to a straight TTL metering system. The camera meters for the subject only and doesn't take into account the ambient lighting. This can often cause your background to be underexposed or overexposed depending on the lighting situation.

Probably the easiest way to get started is to set your camera to Matrix metering mode and use the Speedlight's default TTL BL mode. This mode produces great results and you don't have to do anything but press the Shutter Release button.

 Speedlights aren't just for shooting in dim light. Using the Speedlight outside in bright light can fill in harsh shadows giving your images a more natural look.

QT.3 An outdoor portrait using an SB-900 Speedlight to add some fill flash

QT.4 A quick snapshot of Henrietta using the diffusion dome on the SB-800

Taking photos with the Speedlight using Nikon's TTL-BL or TTL is just as easy as taking photos without a flash. Just focus and shoot. The camera makes all the adjustments for exposure and adjusts the flash head zoom for you. The flash head zoom is a feature of the Speedlight that adjusts the flash to match the focal length of the lens

you're using. Don't be concerned if you don't completely understand how TTL BL works or why the flash zoom is important — you will in good time. By the time you finish this book, you should nearly be an expert. In the meantime, this Quick Tour is just to get you started with flash photography and comfortable with your flash equipment.

 If your Speedlight comes with a diffusion dome, use it. This simple device softens the light for more pleasing effect. For best results, position the flash head at a 60-degree angle.

Everything is attached and you have the basic settings, so get out there and shoot. Take some pictures of your friends or significant other. Pose your dog or cat. Set up a still life. Experiment with different apertures and shutter speeds. Above all, have fun!

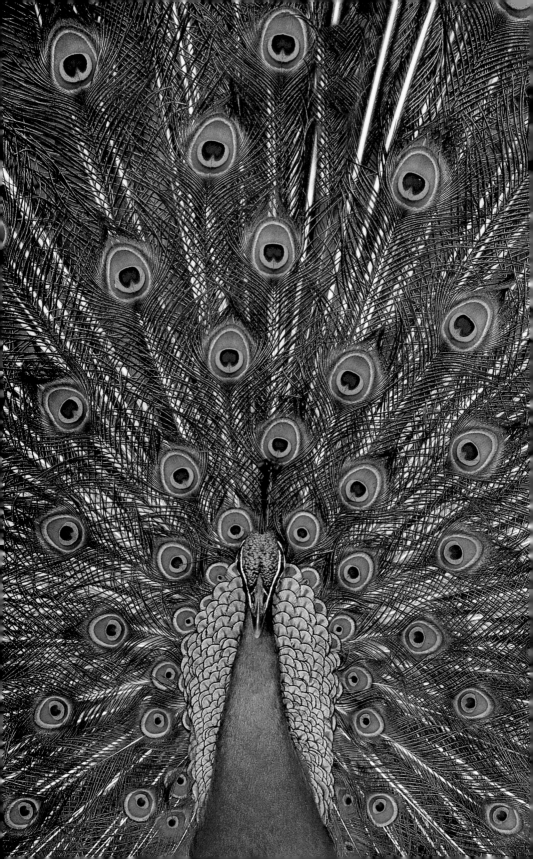

Exploring the Nikon Creative Lighting System

Like most sophisticated camera equipment, Nikon Speedlights are complicated devices with many different parts and features. To get the most out of your Speedlight or Speedlights, it helps to be familiar with all of the moving parts. In this chapter, I dissect each of the Speedlights and explain what each button, switch, dial, and lever does, as well as discuss some of the accessories and the different cameras that can be used. By the end of this chapter you should be familiar with all of the different accessories and terminology.

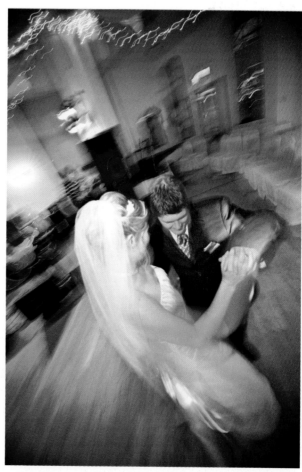

The Nikon Creative Lighting System, or CLS, mainly consists of a couple of different components: a CLS-compatible camera and a Speedlight. This is just the start, however, because CLS is a completely modular system that can comprise a camera and many different Speedlights functioning as commanders and/ or remotes.

Knowing when and how to use such features as slow sync allows you to add creative aspects to your images.

Main Features and Functions

Nikon Speedlights offer many different features and functions, each of which is designed to make Nikon Speedlights a flexible and powerful tool for any photographer — from a complete newcomer to photography to a seasoned professional.

Once you understand what each of these features do and how to use them, you can unlock your creative abilities by utilizing them to get the utmost control out of your Speedlights.

The main features and functions of the Nikon Creative Lighting System are as follows:

▶ **i-TTL/i-TTL BL.** This is Nikon's most advanced flash metering system. It uses pre-flashes fired from the Speedlight to determine the proper flash exposure. The pre-flashes are read by a 1005-pixel RGB metering sensor. The information is then combined with the information from matrix metering, which is a reading of how much available light is falling on the subject. The Speedlight uses this information to decide how much flash exposure is needed (i-TTL) or to balance the flash output and ambient light for a more natural-looking image (i-TTL BL). All CLS-compatible cameras can use this function when attached to any of the CLS Speedlights. The built-in flash also uses i-TTL technology.

▶ **Advanced Wireless Lighting (AWL).** This is probably the most exciting and useful feature of the CLS and probably the main reason why you bought this book. AWL allows you to control up to three groups of flashes, which gives you a total of four groups if you use the built-in flash or an SB-800 or SB-900 Speedlight in the hot shoe as a commander. You can control an unlimited amount of Speedlights assigned to each group with one single commander, which can be a built-in flash, an SB-800, SB-900, or SU-800. This option is available on all cameras when using an SB-900, SB-800 or SU-800 as a commander and another Speedlight as a remote. Cameras with a built-in flash that acts as a commander can also use this feature. The D40/D40X, D50, D60, and D5000 built-in flash doesn't support this feature.

▶ **AUTO FP High-Speed Sync.** This feature allows you to use a shutter speed that's faster than the rated sync speed for your camera. This is achieved by firing a series of low-power flashes during the exposure. This feature is used for adding fill flash to an action shot that requires a fast shutter speed. It's also handy when using a fill flash on an outdoor portrait that requires a wide aperture, which necessitates a fast shutter speed. Please note that this feature is not available with all camera bodies.

For more information on sync speed, see Chapter 3.

▶ **Flash Value Lock (FV Lock).** This feature enables you to lock the flash exposure to maintain a consistent exposure over a series of images. It's also used to ensure proper flash exposure when recomposing your shot. When enabling the FV Lock the camera fires the pre-flash to get the correct flash exposure reading. This reading is locked giving you the opportunity to recompose the shot without causing the flash output level to change, or to wait for just the right moment or expression. You essentially make the pre-flash several seconds before the exposure instead of milliseconds before. This feature is available with all cameras and flash combinations with the exception of the D40/D40X, D50, D60, D3000, and D5000. In most cases, the FV Lock must be assigned to a Function button using the camera's Custom Settings menu.

▶ **Multi-Area AF-Assist Illuminator.** The SB-900, SB-800, SB-600, and SU-800 have a built-in LED that projects an array onto your subject when shooting in low light to assist the camera's AF system in locking focus on a subject. This feature works with all camera and flash combinations. Note that the AF-Assist Illuminator does not function when the camera is in Continuous AF or Manual focus.

▶ **Flash Color Information Communication.** As the flash duration changes, the color temperature of the flash output changes as well. Longer flash durations are required for bright output and cause the color temperature to shift a little cooler. The opposite is true for shorter duration flashes; the color temperature tends to get warmer. When your camera is set to Auto White Balance, the Speedlight communicates this information to your camera, which allows the camera to compensate for the color shift. This can be more accurate than simply setting your camera to Flash WB, which is fixed at 5500K. This feature is available with all camera and flash combinations. Please note that the camera WB must be set to Auto for this feature to be enabled.

Depending on your camera and Speedlight combination, all of these features may or may not be available. Certain cameras, especially the entry-level models, don't allow the use of some features of the Nikon CLS such as Auto FP High-Speed Sync and FV Lock. Your camera must be CLS-compatible in order to take advantage of any of these features. Here is a list of current CLS-compatible cameras:

▶ **F6**

▶ **D3/D3X**

▶ **D2X / D2H / D2Hs**

- ▶ **D700**

- ▶ **D300/D300s**

- ▶ **D200**

- ▶ **D70/D70s**

- ▶ **D80**

- ▶ **D90**

- ▶ **D40/D40X**

- ▶ **D50**

- ▶ **D60**

- ▶ **D3000**

- ▶ **D5000**

NOTE The Nikon COOLPIX P5000, P5100, and P6000 are equipped with a hot shoe for an accessory Speedlight. Although they can accept the SB-400, SB-600, SB-800, and SB-900 Speedlights, these cameras aren't CLS compatible. They use i-TTL metering, but cannot perform any Advanced Wireless Lighting or other CLS functions. The Commander function is disabled when an SB-900, SB-800, or SU-800 is attached to the camera.

Understanding DX and FX

As you may already know Nikon offers two different sensor sizes within their line of dSLR cameras, DX and FX. The DX format sensor is approximately 24 × 16mm while the FX format is 36 × 24mm.

SLR camera lenses were designed around the 35mm film format. Photographers use lenses of a certain focal length to provide a specific field of view. The field of view, also, called the angle of view, is the amount of the scene that is captured in the image. This and is usually described in degrees. For example, when a 16mm lens is used on a 35mm camera, it captures almost 180-degrees horizontally of the scene, which is quite a bit. Conversely, when using a 300mm focal length, the field of view is reduced to a mere 6.5-degrees horizontally, which is a very small part of the scene. The field of view was consistent from camera to camera because all SLRs used 35mm film, which had an image area of 24 × 36mm.

With the advent of digital dSLRs, the sensor was made smaller than a frame of 35mm film to keep costs down because the sensors are more expensive to manufacture. This sensor size was called APS-C, or in Nikon terms, the DX- format. The lenses that are used with DX-format dSLRs have the same focal length they've always had, but because the sensor doesn't have the same amount of area as the film, the field of view is effectively decreased. This causes the lens to provide the field of view of a longer focal lens when compared to 35mm film images.

Fortunately, the DX sensors are a uniform size, thereby supplying consumers with a standard to determine how much the field of view is reduced on a DX-format dSLR with any lens. The digital sensors in Nikon DX cameras have a 1.5X crop factor, which means that to determine the equivalent focal length of a 35mm or FX camera, you simply have to multiply the focal length of the lens by 1.5. Therefore, a 28mm lens provides an angle of coverage similar to a 42mm lens, a 50mm is equivalent to a 75mm, and so on.

What does this mean to you and your Speedlights? Not much actually. The SB-600 and SB-800 were designed to cover the full-frame format so, although the widest setting shown is 14mm, that is the FX setting, which, in terms of the crop factor, allows coverage for a 10mm lens on DX format (10 X 1.5 = 15mm), although you will get some slight light fall off when using the 10.5mm fisheye lens.

The SB-900 was designed to automatically recognize between DX and FX sensors and is optimized to provide even light coverage for either format all the way up to the 10.5mm fisheye lens

Anatomy of the Speedlight

For the most part, Speedlights are all pretty similar. Each Speedlight has a few parts that are common to all Speedlights. The higher up the chain you go and the more expensive the Speedlight gets, the more features, knobs, dials, and bells and whistles you find.

Although some Speedlights, such as the SB-900, seem to have more dials and buttons than you can shake a stick at, it's pretty easy to master the controls once you know what each button and dial is intended for. That's where this chapter comes in. I cover each part of the Speedlight to help you learn what it does so when it comes time to master the settings and modes, you are familiar with the layout of your Speedlight.

SB-400

The SB-400 is the simplest Speedlight. For its diminutive size, this little flash is a powerhouse.

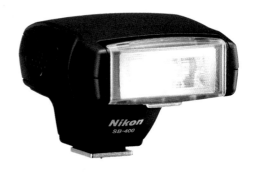

Figure courtesy of Nikon, Inc.
1.1 The SB-400

▶ **Tilting flash head.** The flash head contains the business part of your Speedlight, the *flash-tube*. Simplified, the flashtube is a sealed glass tube that contains xenon gas and electrodes that pass a high-voltage electric charge through the gas that makes it light up very brightly for a relatively brief duration. The flash head of SB-400 can be tilted up vertically to execute a bounce flash. The head can be pointed straight ahead horizontally or tilted vertically at a 60-, 75-, or 90-degree angle. The flash head is optimized for 18mm coverage with a DX camera and 28mm with an FX camera.

For more information on bounce flash, see Chapter 3.

▶ **Battery chamber lid.** Sliding this cover toward the back of the SB-400 opens the battery chamber where you install the two AA batteries.

▶ **Mounting foot.** This slides into the hot shoe on top of your camera. The mounting foot has contacts that convey the flash information between the camera and the Speedlight.

▶ **On/Off switch.** Sliding this switch turns the Speedlight unit on or off. Be sure this is switched to Off before attempting to mount the SB-400 to your camera to prevent any accidental damage that could be caused by any electrical charges between the contacts.

▶ **Ready light.** When the ready light is on, your SB-400 is fully charged and ready to fire at full power. This light also blinks as a warning if there is a problem with the Speedlight or camera it is attached to.

 • **3 seconds at 4 Hz.** If immediately following your shot the ready light blinks at this frequency, your image may be underexposed. Adjust your ISO setting higher, open your aperture, or move closer to the subject to increase the exposure.

- **40 seconds at 2 Hz.** When the ready light blinks at this frequency, the batteries are nearly depleted and need to be replaced or recharged.

- **1/2 second at 8 Hz.** When the ready light repeatedly flashes at this rate, the SB-400 is attached to a non-CLS-compatible camera. The SB-400 cannot be used with non-CLS cameras.

- **Repeatedly at 1 Hz.** When the ready light is repeatedly blinking one time per second, the SB-400 is overheated and should be allowed to cool down before shooting more flash exposures.

▶ **Mounting foot locking lever.** Move this lever to the right to lower the mounting pin, which locks the SB-400 in place in the camera's hot shoe.

SB-600

The SB-600 is a full-functioning Speedlight that can do much more than the SB-400, but not quite as much as the SB-900 or SB-800. The SB-600 is a big step up from the SB-400 and has many more buttons to change the different settings and make adjustments. The SB-600 is still pretty easily understood especially when compared to the SB-900 and SB-800.

▶ **Zooming/tilting flash head.** This is where the flashtube is located. Inside is a mechanism that moves the flashtube back and forth inside the flash head behind the Speedlight's lens to provide flash coverage for lenses of different focal lengths. The zooming flash head allows the Speedlight to conserve energy by focusing the flash output on the appropriate area. The flash head is adjustable; it can be tilted upward to 45, 60, 75, or 90 degrees. It can also be moved horizontally 30, 60, 90, 120, 150, or 180 degrees to the left or 30, 60, or 90 degrees to the right.

▶ **Wide-flash adapter.** This built-in diffuser provides you with the ability to use the Speedlight with a lens as wide as 14mm without having light falloff at the edges of the image. The diffuser spreads the light out a bit more, which gives you even illumination with wide-angle lenses. The SB-600 doesn't recognize DX or FX; however, it is set up to cover FX sensors or 35mm film.

▶ **Flash head lock release button.** Pressing this button releases the flash head lock allowing you to adjust the flash head angle vertically or horizontally for bounce flash.

Flash head

Flash head
lock release
button

Wireless
remote
ready light

Battery
chamber
lid

AF assist
illuminator

Light sensor
for TTL
wireless flash

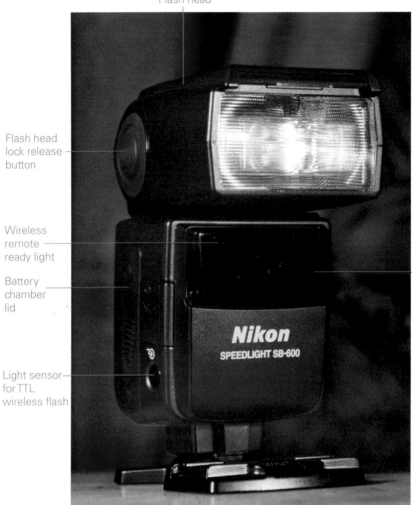

1.2 The front of the SB-600 Speedlight

▶ **Battery compartment lid.** Sliding the battery lid downward gains you access to the battery compartment so you can install the four AA batteries that power the Speedlight.

▶ **Light sensor for TTL wireless flash.** This sensor reads signals from commander units enabling wireless flash.

▶ **Wireless remote ready light.** When the SB-600 is being used as a remote flash this LED blinks to let you know that the flash is powered up and ready to be fired.

▶ **AF-Assist Illuminator.** This emits an LED array to achieve focus in low-light situations.

1.3 **Wide-flash adapter**

▶ **External AF-assist contacts.** These electronic contacts are for use with the optional SC-29 TTL remote cord. This allows the SC-29's AF-assist beam to function when using your SB-600 off-camera.

▶ **Mounting foot.** This slides into the hot shoe on your camera body and locks down with a lever. The hot shoe mounting foot has electronic contacts that enable the camera and Speedlight to communicate flash output and white balance information.

▶ **Flash head tilting angle scale.** This scale allows you to see to which angle the flash head is tilted: 45, 60, 75, or 90 degrees.

1.4 **External AF-assist contact and the hot shoe mounting foot**

▶ **Flash head rotating angle scale.** This scale enables you to see where the flash head is set to when turned horizontally left. The scale markings include 30°, 60°, 90°, 120°, 150°, and 180°. To the right it can be adjusted 30°, 60°, and 90°.

▶ **LCD panel.** The LCD panel is where all of the Speedlight settings are displayed.

1.5 Flash head rotating angle scale

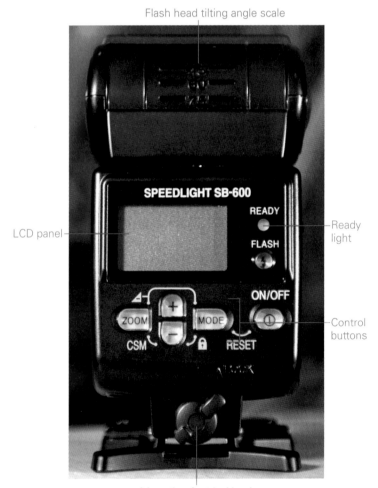

Flash head tilting angle scale

LCD panel

Ready light

Control buttons

Mounting foot locking lever

1.6 The back of the SB-600 Speedlight

▶ **Ready light.** When this light is on, the Speedlight is ready to fire. After the Speedlight fires at full power using TTL, this light blinks indicating a possible underexposure.

▶ **Control buttons.** These buttons are used to set and change the different settings on the SB-600. The Control buttons are covered more in depth in the next section.

▶ **Mounting foot locking lever.** This lever locks the Speedlight into the hot shoe or the AS-19 Speedlight stand.

Control buttons

The control buttons are used to change some of the main settings of the SB-600 such as the flash mode and zoom head setting. Some of these are set automatically but can be overridden by pressing the appropriate button.

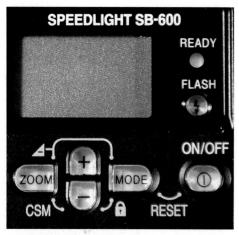

1.7 SB-600 control panel

▶ **On/Off button.** Press the On/Off button for about a half-second to turn the SB-600 on or off.

▶ **Flash button.** Press this button to test fire the SB-600.

▶ **Zoom button.** Pressing this button changes the zoom of the flash head to change coverage for different focal-length lenses and allows coverage for 24mm to 85mm lenses. 14mm coverage is achieved with the built-in wide-angle diffuser.

▶ **+/- buttons.** The +/- buttons are used to change the values and settings. Depending on the flash mode the values and settings will be different.

 • **TTL/TTL BL.** The +/- buttons allow you to set the flash compensation of the Speedlight to underexpose or overexpose from the camera's TTL reading. The flash compensation can be set +/- 3 stops in 1/3-stop increments.

 • **M.** The +/- buttons are used to set the flash exposure manually from 1/1 to 1/64. These settings are also adjustable in 1/3-stop increments.

- **CSM.** When in the Custom Settings Mode, the +/- buttons are used to cycle through the different custom settings.

The Custom Settings menu is covered in detail in Chapter 2.

▶ **Mode button.** The Mode button allows you to switch among the available flash modes. The modes available with the SB-600 are

- **TTL BL.** iTTL balanced fill flash. The exposure is determined by the camera and matched with the ambient light.

- **TTL.** iTTL flash. The exposure is determined by the camera to sufficiently illuminate the subject that is focused on.

- **M.** Full Manual mode. The photographer determines the flash power.

For more detailed information on flash modes, see Chapter 2.

Combination buttons

There are certain functions and settings that are accessed by pressing two buttons simultaneously. The following list describes the buttons and how they work together.

▶ **Zoom + Mode.** When shooting TTL or TTL BL and you get an underexposure warning (blinking ready light), pressing these two buttons simultaneously displays the underexposure value from the TTL reading on the upper-right-hand corner of the LCD.

▶ **Mode + On/Off.** Pressing these two buttons together and holding them for about 2 seconds resets the SB-600 settings to factory default. All settings are reverted, even the Custom Settings.

▶ **Mode + minus.** When the Mode button and the minus button are pressed at the same time, the control buttons are locked to prevent any accidental changes to the settings. Press and hold these buttons again to unlock.

The lock does not affect the flash button and the On/Off button.

▶ **Zoom + minus.** Pressing these two buttons for 2 seconds gains access to the Custom Settings Menu (CSM). For more information on the CSM, see Chapter 2.

SB-800

The SB-800 was initially Nikon's top-of-the-line CLS Speedlight, but it was recently replaced by the SB-900. Although the SB-900 has some added functionality, the SB-800 is still no slouch. It can act as an accessory flash on-camera, or a commander unit or even a remote flash. It has more available flash modes than the SB-600 and a few more buttons to add functions.

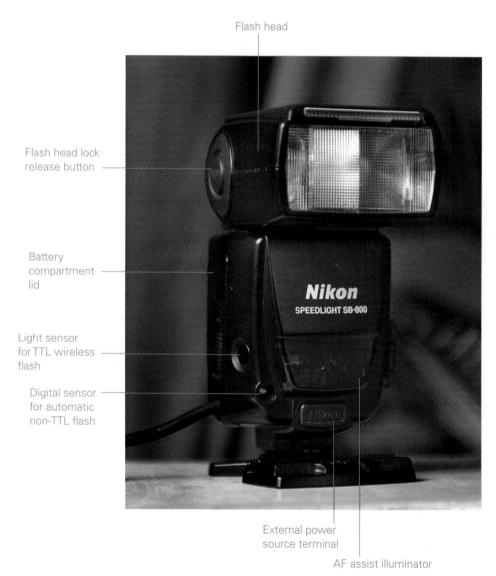

Flash head

Flash head lock release button

Battery compartment lid

Light sensor for TTL wireless flash

Digital sensor for automatic non-TTL flash

External power source terminal

AF assist illuminator

1.8 The front of the SB-800 Speedlight

► **Zooming/tilting flash head.** This is where the flashtube is located. Inside is a mechanism that zooms the flashtube back and forth to provide flash coverage for lenses of different focal lengths. The zooming flash head allows the Speedlight to conserve energy by focusing the flash output on the appropriate area. The flash head is adjustable; it can be tilted upward to 45, 60, 75, or 90 degrees or downward to 7 degrees. It can also be moved horizontally 30, 60, 90, 120, 150, or 180 degrees to the left or 30, 60, or 90 degrees to the right.

► **Bounce card.** When using the SB-800 for bounce flash, pulling out the bounce card redirects some of the light forward, which allows you to achieve a highlight in your subject's eyes (catchlight), giving the eyes a brighter, livelier appearance. On top of the bounce card is a list of some of the button features for reference.

► **Wide-flash adapter.** This built-in diffuser provides you with the ability to use the Speedlight with a lens as wide as 14mm without having light falloff at the edges of the image. The diffuser spreads the light out a bit more giving you even illumination with wide-angle lenses.

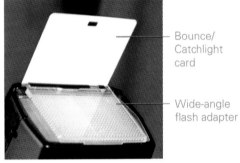

Bounce/ Catchlight card

Wide-angle flash adapter

1.9 Wide-flash adapter and built-in bounce card

► **Flash head lock release button.** Pressing this button releases the flash head lock allowing you to adjust the flash head angle vertically or horizontally for bounce flash.

► **Battery compartment lid.** Sliding the battery lid downward gains you access to the battery compartment so you can install the four AA batteries that power the Speedlight. This can also be removed and replaced with the SD-800 Quick-Recycling Battery Pack.

► **Light sensor for TTL wireless flash.** This sensor reads signals from commander units, enabling wireless flash.

► **Light sensor for automatic non-TTL flash.** This sensor reads the light reflected off of the subject telling the flash when to shut off when operating in AA, aperture automatic, or A, non-TTL automatic.

► **AF-Assist Illuminator.** This emits an LED array to provide additional contrast to help achieve focus in low-light situations.

▶ **External power source terminal.** Nikon's optional external power sources can be plugged in to this terminal. These power sources include the SC-7 DC unit, the SD-8A high-performance battery pack, and the SK-6 power bracket unit. The terminal is protected by a removable cover emblazoned with the Nikon logo.

▶ **External AF-assist contacts.** These electronic contacts are for use with the optional SC-29 TTL remote cord. This allows the SC-29's AF-assist beam to function when using your SB-800 off-camera.

▶ **Mounting foot.** This slides into the hot shoe on your camera body and locks down with a lever. The hot shoe mounting foot has electronic contacts that enable the camera and Speedlight to communicate flash output and white balance information.

▶ **Flash head tilting angle scale.** This scale allows you to see at which angle the flash-head is tilted to: 45, 60, 75, or 90 degrees.

▶ **Flash head rotating angle scale.** This scale enables you to see where the flash head is set to when turned horizontally left. The scale markings include 30, 60, 90, 120, and150 degrees. To the right it can be adjusted to 30, 60, and 90 degrees.

▶ **Modeling flash illuminator button.** Pressing this button causes the Speedlight to fire repeatedly very quickly at low power to allow a preview of how the shadows from the lighting will appear on the subject.

▶ **TTL multiple flash terminal.** Used for linking more than one flash together using TTL metering. It requires a Nikon TTL flash cord such as the SC-27, SC-26, SC-19, or SC-18.

▶ **PC sync terminal.** This terminal allows you to trigger the SB-800 using a PC sync cord. The sync cord connects to the camera via the camera's PC sync terminal with a PC to PC sync cord. If the camera doesn't have a PC sync terminal, you can use a hot shoe adapter such as the Wein Safe-Sync or the Nikon AS-15 PC sync terminal adapter. These adapters slide into the hot shoe of your camera.

1.10 TTL multi-flash terminal (top) and the PC sync terminal (bottom)

CAUTION The PC sync terminal does not connect your flash to your personal computer (PC). The term PC as it relates to flash is derived from Prontor-Compur, which were two manufacturers of leaf-type shutters in the early 1900s.

▶ **LCD panel.** The LCD panel is where all of the Speedlight settings are displayed.

▶ **Ready light.** When this light is on the Speedlight is ready to fire. After the Speedlight fires at full power using TTL, this light blinks indicating a possible underexposure.

▶ **Mounting foot locking lever.** This lever locks the Speedlight into the hot shoe or the AS-19 Speedlight stand.

Flash head tilting angle scale

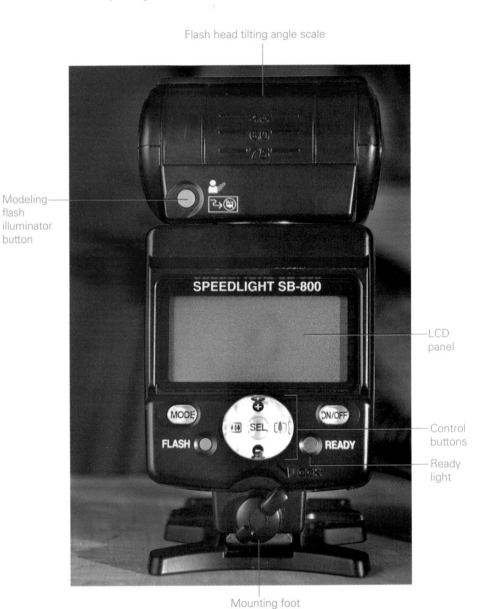

Modeling flash illuminator button

LCD panel

Control buttons

Ready light

Mounting foot locking lever

1.11 The back 0f the SB-800 Speedlight

Control buttons

The control buttons on the SB-800 are a bit different from the ones on the SB-600. Like the SB-600, the control buttons are used to change some of the main settings such as the flash mode and zoom head setting.

> ▶ **On/Off button.** Press the On/ Off button for about a half-second to turn the SB-800 on or off.

> ▶ **Flash button.** Pressing this button test fires the SB-800 to check output levels or to simply confirm that the Speedlight is working.

1.12 SB-800 control panel

> ▶ **Multi-selector button.** The main button on the SB-800 is a multi-selector button. It can be pressed up and down, left and right, or in the center.

>> • **The up button has the + symbol and the down button has the – symbol.** The up and down buttons are used to change the values of whatever items are highlighted.

>> • **The left and right buttons are labeled with icons representing trees.** The left button has three trees symbolizing wide angle and the right button has one tree, meaning telephoto. The buttons are used to change the zoom of the flash head for different lens coverage from 24mm wide angle to 105mm telephoto.

>> • **The center button is the Select button.** This button is used to select an item to be highlighted for change. The options will be different depending in which mode your Speedlight is set to operate (TTL, M, AA, and so on). When this button is pressed for 2 seconds, it takes you to the Custom Settings Menu (CSM). The CSM is used to set up specific functions of the SB-800, such as the wireless flash modes, ISO settings, the power zoom function, and many other things.

CAUTION The Custom Settings Menu is covered in detail in Chapter 2.

▶ **Mode button.** This button is used to cycle among the different flash modes of the SB-800 Speedlight. The different modes are

- **TTL BL.** iTTL balanced fill flash. The exposure is determined by the camera and matched with the ambient light.

- **TTL.** iTTL flash. The exposure is determined by the camera to sufficiently illuminate the subject that is focused on.

- **AA.** Aperture-based automatic mode. The photographer enters the aperture value and the Speedlight determines the flash power using data collected from the camera such as aperture, ISO, distance, and exposure compensation.

- **A.** Non-TTL Auto Flash. This mode uses the SB-800's sensor and determines the flash output by measuring the light reflected back from the subject.

- **GN.** Distance-based automatic mode. The photographer enters the distance to the subject and the Speedlight determines the flash power.

- **RPT.** Repeating flash mode. This fires a series of flashes at a rate determined by the photographer.

- **M.** Manual flash mode. The photographer determines the flash output.

For more detailed information on flash modes, see Chapter 2.

Combination buttons

On the SB-800, pressing two buttons simultaneously can display custom menus or affect certain settings. These combination button presses are listed on top of the SB-800 bounce card for quick reference.

▶ **Mode + Select.** When shooting TTL or TTL BL and you get an underexposure warning (blinking ready light), pressing these two buttons simultaneously displays the underexposure value from the TTL reading on the upper-right-hand corner of the LCD.

▶ **Mode + On/Off.** Pressing these two buttons together and holding them for about 2 seconds resets the SB-800 settings to factory default. All settings are reverted, even the custom settings.

▶ **On/Off + Select.** When the on/off button and the Select button are pressed at the same time, the control buttons are locked to prevent any accidental changes to the settings. Press and hold these buttons again to unlock.

 The lock does not affect the flash button and the On/Off button.

SB-900

The SB-900 is Nikon's newest Speedlight. It has the same functions as the SB-800 with a newly designed user interface as well as more automatic and custom settings features. The SB-900 has a new Command dial that's unlike anything on any previous Nikon Speedlight.

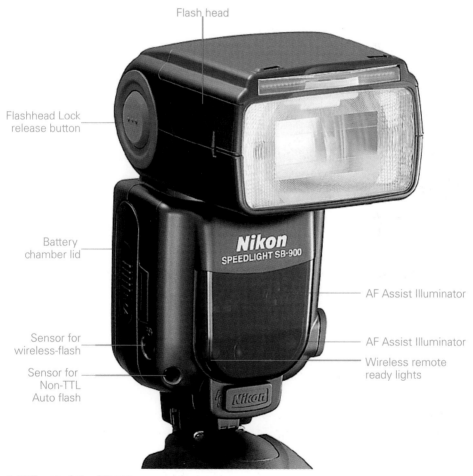

Flash head

Flashhead Lock release button

Battery chamber lid

Sensor for wireless-flash

Sensor for Non-TTL Auto flash

AF Assist Illuminator

AF Assist Illuminator

Wireless remote ready lights

1.13 Front of the SB-900

▶ **Zooming/tilting flash head.** This is where the flashtube is located. Inside is a mechanism that moves the flashtube back and forth inside the flash head behind the Speedlights lens to provide flash coverage for lenses of different focal lengths. The zooming flash head allows the Speedlight to conserve energy by focusing the flash output on the appropriate area. The flash head is adjustable; it can be tilted upward to 45, 60, 75, or 90 degrees, or downward to 7 degrees. It can also be moved 180 degrees horizontally to the right or left.

▶ **Bounce card.** When using the SB-900 for bounce flash, pulling out the bounce card redirects some of the light forward and allows you to achieve a highlight in your subject's eyes, which gives the eyes a brighter livelier appearance.

▶ **Wide-flash adapter.** This built-in diffuser provides you with the ability to use the Speedlight with a lens as wide as 14mm (FX) or 11mm (DX) without having light falloff at the edges of the image. The diffuser spreads the light out a bit more giving you even illumination with wide-angle lenses.

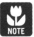 **NOTE** The SB-900 can recognize whether an FX or DX camera is attached and adjusts the flash head for the appropriate format.

▶ **Filter detector.** The sensor detects when a compatible Nikon filter is attached to the SB-900 flash head using the SZ-2 Color Filter Holder. The sensor reads the encoded filter and sends the flash filter information to the camera so that the WB can be adjusted automatically when the camera's WB is set to Auto or Flash. This information is only used with cameras that are compatible with the filter detection system (D90, D300s, D700, and D3 series).

▶ **Flash head lock release button.** Pressing this button releases the flash head lock allowing you to adjust the flash head angle vertically or horizontally for bounce flash.

Bounce card Wide-angle lens adapter

Filter detector

1.14 SB-900 wide-flash adapter, bounce card, and filter detector

▶ **Battery chamber lid.** Sliding the battery lid downward gains you access to the battery compartment so you can install the four AA batteries that power the Speedlight.

▶ **Light sensor for TTL wireless flash.** This sensor reads signals from Commander units enabling wireless flash.

▶ **Light sensor for automatic non-TTL flash.** This sensor reads the light reflected off of the subject telling the flash when to shut off when operating in AA, aperture automatic, or A, non-TTL automatic.

▶ **Wireless remote ready light.** When the SB-900 is being used as a remote flash, this LED blinks to let you know that the flash is powered up and ready to be fired.

▶ **AF-Assist Illuminator.** This emits an LED array to provide additional contrast to help achieve focus in low-light situations.

▶ **External power source terminal.** Nikon's optional external power sources can be plugged in to this terminal. These power sources include the SC-7 DC unit, the SD-8A high-performance battery pack, and the SK-6/SK-6A power bracket unit.

1.15 External power source terminal with the cover off and on

▶ **External AF-assist contacts.** These electronic contacts are for use with the optional SC-29 TTL remote cord. This allows the SC-29's AF-assist beam to function when using your SB-900 off-camera with the TTL cord.

▶ **Mounting foot.** This slides into the hot shoe on your camera body and locks down with a lever. The hot shoe mounting foot has electronic contacts that enable the camera and Speedlight to communicate flash output and white balance information.

▶ **Flash head tilting angle scale.** This scale allows you to see which angle the flash head is tilted: 45, 60, 75, or 90 degrees.

▶ **Flash head rotating angle scale.** This scale enables you to see where the flash head is set to when turned horizontally left or right. The scale markings include 30, 60, 90, 120, 150, and 180 degrees.

▶ **PC sync terminal.** This terminal allows you to trigger the SB-800 using a PC sync cord. The sync cord connects to the camera via the cameras PC sync terminal with a PC to PC sync cord. If the camera doesn't have a PC sync terminal, you can use a hot shoe adapter such as the Wein Safe-Sync or the Nikon AS-15 PC sync terminal adaptor. These adapters slide into the hot shoe of your camera.

1.16 PC sync terminal

▶ **LCD panel.** The LCD panel is where all of the Speedlight settings are displayed.

▶ **Ready light.** When this light is on the Speedlight is ready to fire. After the Speedlight fires, this light blinks until the Speedlight is fully recycled. The ready light blinks when in TTL mode and fired at full power which may indicate an under-exposure. The ready light doubles as a test fire button and can also be set to fire a modeling flash which causes the Speedlight to fire repeatedly very quickly at low power to allow a preview of how the shadows from the lighting will appear on the subject.

▶ **Mounting foot locking lever.** This lever locks the Speedlight into the hot shoe or the AS-21 Speedlight stand.

Control buttons

These buttons are the control center of the SB-900. The control buttons and selector dial allow you to quickly change your settings. With Nikon's additional features, there are more buttons and dials than on previous Speedlights, which allows the SB-900 to have a user interface that is a bit easier to navigate.

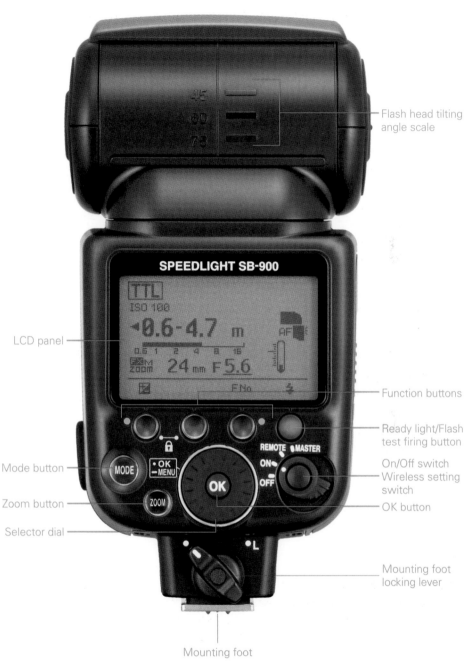

Flash head tilting angle scale

LCD panel

Function buttons

Ready light/Flash test firing button

Mode button

On/Off switch
Wireless setting switch

Zoom button

OK button

Selector dial

Mounting foot locking lever

Mounting foot

1.17 Back of the SB-900

▶ **On-Off/Wireless mode setting switch.** This is a new feature that was introduced with the SB-900. Rotating the switch one click turns the SB-900 on and readies it for operation. The other settings on the switch include Master and Remote. To switch to these settings, you must press the button in the center of the switch and rotate the switch at the same time. The lock button is used to prevent the Speedlight from being accidentally switched to the Master or Remote settings.

▶ **Selector dial.** This dial is used to quickly change whatever setting is selected. The selected setting is highlighted on the LCD panel.

▶ **OK button.** Pressing the OK button once confirms changes to the selected setting. Pressing and holding the OK button for 1 second displays the Custom Settings Menu.

▶ **Mode button.** Pressing the button once selects the mode for change. The flash modes can then be cycled through by rotating the selector dial. Pressing this button multiple times also cycles among the different flash modes of the SB-900 Speedlight. The different modes are

 • **TTL BL.** iTTL balanced fill flash. The exposure is determined by the camera and matched with the ambient light.

 • **TTL.** iTTL flash. The exposure is determined by the camera to sufficiently illuminate the subject that is focused on.

 • **AA.** Aperture-based automatic mode. The photographer enters the aperture value and the Speedlight determines the flash power, using data collected from the camera such as aperture, ISO, distance, and exposure compensation

 • **A.** Non-TTL Auto Flash. This mode uses the SB-900's non-TTL sensor and determines the flash output by measuring the light reflected back from the subject.

 • **GN.** Distance-based automatic mode. The photographer enters the distance to the subject and the Speedlight determines the flash power.

 • **RPT.** Repeating flash mode. This fires a series of flashes at a rate determined by the photographer.

 • **M.** Manual flash mode. The photographer determines the flash output.

 For more detailed information on flash modes and the Custom Settings Menu, see Chapter 2.

▶ **Zoom button.** Adjusts the zoom setting of the flash head to change coverage for different focal length lenses. Allows coverage for lenses ranging from 17mm to 200mm in FX mode and 12mm to 200mm in DX mode. 14mm coverage is achieved with the built-in wide-angle diffuser (FX) or 10mm (DX).

▶ **Function buttons.** These three buttons allow you to highlight different items to select them for change. The selected function differs depending on the flash mode or wireless setting.

- **Manual.** In Manual mode, Function button 1 selects the flash output for adjustment. Function button 3 allows you to manually change the aperture setting on the flash (only when using a non-CPU lens or non-CPU lens data is not entered into the camera). Function button 2 has no function in this mode.

- **TTL/TTL BL.** In TTL modes, Function button 1 selects the flash exposure compensation for adjustment. Function button 2 recalls display of underexposure (if any). Function button 3 allows you to manually change the aperture setting on the flash (only when using a non-CPU lens or non-CPU lens data is not entered into the camera).

- **AA.** In Auto Aperture mode, Function button 1 selects the flash exposure compensation for adjustment. Function button 3 allows you to manually change the aperture setting on the flash (only when using a non-CPU lens or non-CPU lens data is not entered into the camera). Function button 2 has no function in this mode.

- **GN.** In Distance (GN) Priority mode, Function button 1 selects the flash exposure compensation for adjustment. Function Button 2 selects the flash distance setting for change. Function button 3 allows you to manually change the aperture setting on the flash (only when using a non-CPU lens or non-CPU lens data is not entered into the camera).

- **RPT.** In Repeating flash mode, pressing Function button 1 allows you to adjust the flash output. Function button 2 selects the number of times for the flash to fire. Function button 3 allows you to change the frequency of the repeating flash.

 For more information on Repeating flash, see Chapter 3.

- **Master.** When the SB-900 is set to function as a Master flash, Function button 1 is used to select the Group so you can change the flash mode for the individual group. Function button 2 is used to select the channel that the SB-900 is communicating on. Function button 3 does nothing in this mode.

- **Remote.** When the SB-900 is set to function as a wireless remote, Function button 1 is used to assign a Group to the Speedlight. Function button 2 is used to assign the channel number. Function button 3 does nothing in this mode.

- **Function button 1 + Function button 2.** Pressing and holding these buttons simultaneously for 2 seconds locks the Speedlight to prevent accidental changes to the settings.

Camera compatibility

Some camera bodies only allow certain features to be used with CLS. Table 1.1 shows which functions are supported by each different camera.

Table 1.1 Nikon CLS Camera Compatibility

Camera Model or Series	CLS Feature	Details
D40, D40X, D50, D60, D3000, D5000	iTTL flash	Available with the built-in Speedlight, SB-900, SB-800, SB-600, and SB-400
	iTTL balanced fill flash	Available with the built-in Speedlight, SB-900, SB-800, SB-600, and SB-400
	Auto aperture	Available only with the SB-900 and SB-800 and an auto focus lens
	Non-TTL Auto	Available with the SB-900 and SB-800
	Distance priority manual	Available with the SB-900 and SB-800
	Wide Area AF-assist illuminator	Available with the SB-900, SB-800, SU-800, and SB-600

Camera Model or Series	CLS Feature	Details
D70/D70s, D80, D90	iTTL flash	Available with the built-in Speedlight, SB-900, SB-800, SB-600, and SB-400
	iTTL balanced fill flash	Available with the built-in Speedlight, SB-900, SB-800, SB-600, and SB-400
	Auto aperture	Available only with the SB-900 and SB-800 and an auto focus lens
	Non-TTL Auto	Available with the SB-900 and SB-800
	Distance-priority manual	Available with the SB-900 and SB-800
	Built-in flash acts a wireless remote commander	
	Flash Value (FV) lock	
	Wide Area AF-assist illuminator	Available with the SB-900 SB-800, SU-800, and SB-600
D200, D300/D300s, D700	iTTL flash	Available with the built-in Speedlight, SB-900, SB-800, and SB-600
	Auto aperture	Available only with the SB-900 and SB-800 and a CPU lens
	iTTL balanced fill flash	Available with the built-in Speedlight, SB-900, SB-800, SB-600, and SB-400
	Non-TTL Auto	Available with the SB-900 and SB-800
	Distance priority manual	Available with the SB-900 and SB-800
	Built-in flashacts a wireless remote commander	
	Flash Value (FV) lock	
	Auto FP high-speed sync	Available with the SB-900, SB-800, and SB-600
	Wide Area AF-assist illuminator	Available with the SB-900, SB-800, SU-800, and SB-600

continued

Table 1.1 Nikon CLS Camera Compatibility *(continued)*

Camera Model or Series	CLS Feature	Details
D2X/D2Xs, D2H/ D2Hs, D3/D3X	iTTL flash	Available with the built-in Speedlight, SB-900, SB-800, SB-600, and SB-400
	Auto aperture	Available with the SB-900, and SB-800
	iTTL balanced fill flash	Available with the SB-900, SB-800, SB-600, and SB-400
	Non-TTL Auto	Available with the SB-900, SB-800
	Distance priority manual	Available with the SB-900, SB-800
	Flash Value (FV) lock	Available with the SB-900, SB-800, and SB-600
	Auto FP high-speed sync	Available with the SB-900, SB-800, and SB-600
	Wide Area AF-assist illuminator	Available with the SB-900, SB-800, SU-800, and SB-600

Even though each camera doesn't offer full functionality of the CLS features that each Speedlight offers, there are some caveats, as the next sections explain.

D40, D40X, D50, D60, D3000, and D5000

With the these cameras, just because you can't use the built-in flash as a remote commander doesn't mean you can't use advanced wireless lighting. The SB-900, SB-800, or the SU-800 can be used as the commander for wireless remote Speedlights.

D70/D70s

Although the D70/D70s does allow you to use the built-in flash as a commander, it is somewhat limited. When used as a commander, the built-in Speedlight does not produce enough light to add to the exposure (this can be good or bad). It allows you to use as many remote Speedlights as you need, but all of the remote units can be used as only one group. Therefore, any exposure compensations you want to make has an effect on all of the Speedlights in the group.

Considering the price of the D70/D70s, this is still an amazing and useful feature. Being able to command even one off-camera Speedlight without the purchase of any additional accessories (other than camera and flash) is a great deal.

There are ways to lessen the exposure of one Speedlight in a group, such as moving it further away from the subject. The other drawback to using the D70/D70s built-in Speedlight as a commander is that it only allows you the option of using one channel.

When using the Advanced Wireless Flash different channels can be used to transmit the information to the remote Speedlights. Therefore, in a competitive shooting environment, if someone near you is using the D70 to fire an off-camera flash, their flash will set off yours and vice versa. As with the D50, when used in conjunction with an SB-800 or SU-800 the full range of advanced wireless lighting options are available, including access to multiple channels.

While the D70/D70s do support FV lock, to gain this control you need to access the camera's Custom Settings Menu. In the CSM you can select the AF/AE lock button to act as the FV lock when a Speedlight is attached.

D80, D90, D200, D300/D300s, and D700

With these cameras, built-in flash can be used as a wireless remote commander. This group of camera's built-in flash is a lot more flexible than that of the D70. You can use any number of Speedlights in two groups on four channels. These cameras also allow you the option of turning off the built-in flash so as not to add to the exposure when acting as a commander.

To achieve the FV lock feature, the Function button must be set in the camera's Custom Settings Menu.

This group of cameras offers the full range of CLS features when used with the SB-900 or SB-800 and a CPU lens, with the added benefit of a built-in wireless commander — something that the D2 and D3 series, which are much more expensive, does not provide.

D2X/D2Xs, D2H/D2Hs, D3/D3X

With any of the pro-level D2 or D3 series cameras you have the full functionality of any of the Speedlights. Because the cameras at this level do not feature a built-in flash however, you will need an SB-900, SB-800, or SB-600 to take advantage of Advanced Wireless Lighting.

Included Accessories

Each Speedlight comes with some accessories. And while some come with more than others, they all have a few small extras in the box. These accessories range from small stands to place your Speedlight off-camera to soft cases in which to store your Speedlights when transporting them.

The SB-400 and SU-800 only include a soft case with them. For that reason they aren't mentioned any further in this section.

SB-900

Included in the box along with the SB-900 are some handy accessories. The SB-900 is currently (as of this writing) the newest, top-of-the-line Nikon Speedlight, it has some accessories that weren't included with any Speedlight previously, even the venerable SB-800, which the SB-900 has effectively replaced.

SS-900 soft case

This is a simple padded nylon soft case that is used to provide a bit of protection to your Speedlight when you're transporting it. It has a couple of small pouches as well, one to hold your filters and the other for the stand. On the bottom of the case is a zippered compartment for holding the diffuser and filter holder. There is also a loop on the back for attaching it to your belt or your camera bag.

AS-21 Speedlight stand

This is a small plastic stand that has an accessory shoe slot. When you attach the Speedlight to the stand, you can then place your Speedlight on any flat surface. This stand also has a standard 1/4 20 threaded socket (same as the tripod socket on your camera body) for attaching to light stands or even a tripod mount.

I'm a bit disappointed in the design of this stand, largely because of the plastic threaded socket. With moderate use my socket has become stripped rendering the stand useless for attaching the Speedlight to my light stands. The AS-19 stand that is supplied with the SB-800 and SB-600 has a threaded metal insert that is infinitely more durable. Unfortunately, due to the larger foot of the SB-900 the AS-19 stand cannot be used with the SB-900.

SJ-900 color filter set

This is a set of color filters used for balancing the light from the flash with ambient light from incandescent or fluorescent light sources. This filter set comes with four filters: TN-1 and TN-2 for standard incandescent (tungsten) light bulbs, and FL-1 and FL-2 for non-color-balanced fluorescent lamps. This filter set is not to be confused with the SJ-3 Color Filter Set, which also includes color filters for special effects. The SJ-3 filter set is available separately.

Image courtesy of Nikon, Inc.
1.18 The SJ-900 filter pack

SZ-2 color filter holder

This handy piece of clear plastic allows you to fit a filter from one of the previously mentioned filter kits in it. It then snaps over top of the flash head. This allows the filter to not be in direct contact with the flash lens, which generates quite a bit of heat that can melt and discolor the filter. This is a much-appreciated accessory that makes using filters with the SB-900 a better experience.

For more information on color filters, see Chapter 5.

SW-13H diffusion dome

This accessory snaps over top of the flash head and diffuses the light from the Speedlight to help you avoid the harsh lighting that the direct light from a flash can have. The diffusion dome also fits right over the top of the SZ-2 filter holder so that you can also use it when using color filters.

For more information on using diffusers, see Chapter 3.

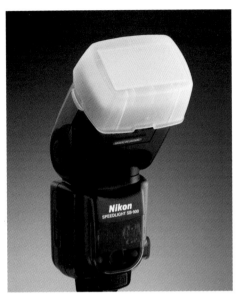

Image courtesy of Nikon, Inc.

1.19 The SB-900 with the SW-13H diffusion dome

SB-800

While the SB-800 doesn't have quite as many accessories as the SB-900, it does have a few and even has one accessory that no other Speedlight has.

SS-800 soft case

This is a padded nylon soft case with a Velcro closure and a loop for attaching it to things just like the one that comes with the SB-900. It has a small pouch on the inside for storing the stand and filters.

SD-800 quick-recycling battery pack

This is a small battery pack that fits one AA battery. This gives your SB-800 a little extra juice that allows it to recycle to full power a little quicker. This comes in handy in situations such as at a wedding where you need the flash for your main light and you don't want to miss any shots waiting for your flash to recycle. You attach this accessory to the SB-800 by replacing the removable battery compartment cover with the SD-800.

AS-19 Speedlight stand

This is similar to the AS-21 Speedlight stand that comes with the SB-900. This stand has three accessory shoe slots. You attach the Speedlight to the stand and you can then place your Speedlight on any flat surface. This stand also has a standard 1/4 20 threaded socket (same as the tripod socket on your camera body) for attaching to light stands or a tripod quick-release plate.

 This stand is compatible only with the SB-800 and SB-600 Speedlights. The SB-900 hot shoe is too large and doesn't fit in the slots.

SJ-800 colored filter set

Similar to the SJ-900, but with filters made to work with the SB-800 (or SB-600), this is a set of color filters used for balancing the light from the flash with ambient light from incandescent or fluorescent light sources. This filter set comes with different

color filters: TN-1 for standard incandescent (tungsten) light bulbs and FL-1 for non-color-balanced fluorescent lamps. This filter set is not to be confused with the SJ-1 Color Filter Set that also includes color filters for special effects. The SJ-1 filter set is available separately.

SW-10H diffusion dome

This is a standard diffusion dome that snaps over top of the flash head and diffuses the light from the Speedlight to help you avoid the harsh lighting that the direct light from a flash can have. The diffusion dome can also be placed over the top of the flash head while the color filters are in place.

SB-600

The SB-600 only comes with the barest accessories: a case and a stand.

SS-600 soft case

This is a padded nylon soft case with a Velcro closure and a loop for attaching it to things just like the one that comes with the SB-800 except a bit smaller. It has a small pouch on the inside for storing the stand and filters if you buy the kit.

AS-19 Speedlight stand

This is the same Speedlight stand that comes with the SB-800. This stand has three accessory shoe slots. You attach the Speedlight to the stand and you can then place your Speedlight on any flat surface. This stand also has a standard 1/4 20 threaded socket (same as the tripod socket on your camera body) for attaching to light stands or a tripod quick-release plate.

Add-on Accessories

There are a few accessories that you can purchase that can play an integral part in your CLS setup, or you can just use them as add-ons. Some of these accessories can be used in conjunction with others and some of them replace another function on another Speedlight.

SU-800 wireless Speedlight Commander

A commander (also known as a master) is what tells the remote Speedlights when to fire. It also reads the data provided by the remote Speedlight's preflashes and relays the information to the camera body for use in setting the exposure levels.

The SU-800 is an infrared wireless commander for the Nikon Creative Lighting System. It functions in much the same way as the SB-800 and SB-900 do in Master mode except that it doesn't emit any visible light. Like the SB-900 and SB-800, the SU-800 Commander has four independent channels, so if you are working near other photographers, you can work on different channels so someone else's SU-800 Commander doesn't set off your flashes.

It slides into the hot shoe of your camera like any other Speedlight and is used to wirelessly control any number of SB-900, SB-800, SB-600, or SB-R200 Speedlights. With the SU-800 you can control up to three groups of flashes. From the SU-800 you can control the output of each group individually. You

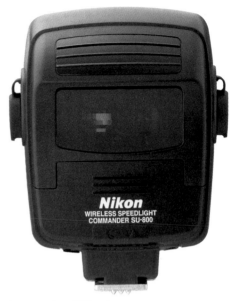

Image courtesy of Nikon, Inc.

1.20 The SU-800 Speedlight Commander

can set each group to TTL, A, or M in order to fine-tune the lighting to suit your needs. In addition, not all groups need to be set to the same metering mode. For example, you can set Groups A and C to TTL and Group B to M or any combination that you choose.

You can also use the SU-800 solely as an AF-Assist Illuminator by setting all Groups to the "–" setting, which tells it not to fire remote Speedlights. This is beneficial in low-light situations when you're not using a Speedlight and you're using a D3 or D2 series camera that doesn't have a built-in AF-Assist Illuminator, or if you'd rather have the less obtrusive red LED pattern of the SU-800 as opposed to the bright white LED of the AF-Assist of Nikon's other cameras.

For information on setting up the SU-800, see Chapter 2.

R1/R1C1 and SB-R200

The R1 and R1C1 kits are the Creative Lighting System answer for close-up and macro photography. For all intents and purposes, both of these kits are the same except the R1 kit doesn't come with an SU-800 Commander and the R1C1 kit does. With the R1 kit, you need an SU-800, SB-900, SB-800, or camera with a built-in flash that can be used as a Commander, such as the D200 or the D90.

The kits revolve around the SB-R200 Speedlight. Each kit comes with two SB-R200 Speedlights, an SX-1 attachment ring clips onto the front of your lens via adapter ring that fits the SX-1 filter threads to the same size as your specific lens filter threads. The SB-R200 is then attached to the SX-1 and can be positioned in a number of ways so that you can shape the light on your subject. The SB-R200 Speedlights also come with an AS-20 Speedlight stand so you can use the flashes separately without mounting them to the SX-1 ring.

The SX-1 ring fits up to four SB-R200 Speedlights when attached to the camera or can be used off-camera with a total of eight SB-R200s attached.

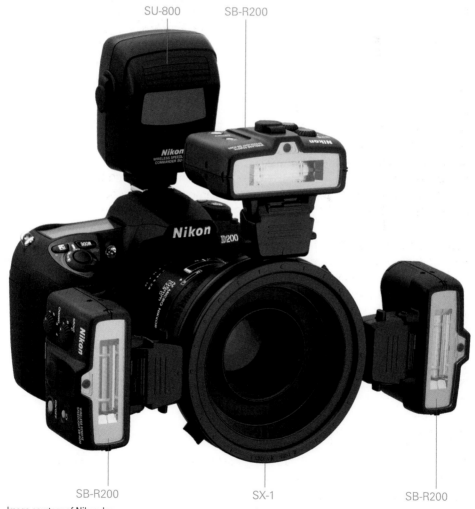

SU-800 SB-R200

SB-R200 SX-1 SB-R200

Image courtesy of Nikon, Inc.

1.21 The R1C1 as mounted on the D200

SG-3IR

The SG-3IR is a simple and inexpensive little accessory, yet it comes in very handy. The SG-3IR is a small plastic device that fits into the camera's hot shoe and suspends an infrared filter that goes in front of the built-in flash to block the output of the flash when used as a commander for close-up photography with the R1 kit or even when photographing objects close up with an SB-900, SB-800, or SB-600 Speedlight.

Image courtesy of Nikon, Inc.

1.22 The SG-3IR

When the built-in flash is used as a commander, the pre-flash (or more accurately the triggering flash) can sometimes add to the exposure. This is usually only noticeable when photographing your subject up close.

Setting Up Your Nikon Speedlights

As you may have discovered, there are quite a few settings that you can change on your Speedlights. Although you can just slide your Speedlight into the hot shoe of your camera and use the automatic settings and get decent shots, my guess is that you bought this book because you want to get the most of out your Speedlight or Speedlights.

This chapter walks you through using the different flash modes as well as adjusting the custom settings so that the flash operates exactly how you want it to.

Image courtesy of Nikon, Inc.

The SB-900 control panel has been refined to make operating it much quicker than previous models.

Power Requirements

The power requirements are the same for the SB-900, SB-800, and the SB-600: four AA batteries. Having ample batteries for your Speedlight is very important. What's the use in having a wireless portable studio when your batteries die on you? You should probably carry at least one extra set of batteries for each Speedlight you have.

 The SB-800 can use five AA batteries with the additional SD-800 Quick Recycling Battery Pack.

If you're going to be using your Speedlights a lot, I highly suggest purchasing rechargeable batteries. The initial investment is a little more than standard alkaline batteries, but you make it back easily when you don't have to pay several dollars for batteries every couple of days. I recommend buying two sets of rechargeable batteries for each Speedlight. You don't want to have to stop in the middle of a shoot to run down to a convenience store to buy second-rate batteries for twice the normal price. Trust me, I've been there. I always have plenty of spare batteries with me now.

Three different types of AA batteries are available for use in Nikon Speedlights that fall into two categories.

Nonrechargeable

These types of batteries are thrown away when the charge is depleted. They are the most common types of batteries. I don't especially recommend using these batteries except in a pinch. Speedlights are a high-energy drain accessory, and you can run through quite a few of these batteries in a month. These batteries usually end up in a landfill leaking toxic sludge into the earth. Regardless, here are a couple of types of nonrechargeable battery types that are safe to use with any of your Speedlights.

▶ **Alkaline-manganese.** These are your everyday, standard type of battery. Alkaline batteries are available nearly everywhere from your local gas station to high-end camera shops. There can be differences in quality depending on the manufacturer. When buying these types of batteries, I suggest purchasing the batteries that specify they are for use with digital cameras. These batteries usually last longer than the cheaper brands.

▶ **Lithium.** Lithium batteries cost a little more than standard alkaline batteries, but they last a lot longer and are actually lighter than standard alkaline batteries. They weigh about half what normal batteries do. You can find lithium batteries at most electronics stores, specialty battery shops, and most camera shops have them in stock.

Rechargeable

Rechargeable batteries require more of an initial investment, but you easily get your money back in what you save by not having to buy disposable batteries often. I recommend buying a few sets of rechargeable batteries. There used to be a couple of different types of rechargeable batteries, but as of late the only type that is generally available is the nickel-metal hydride (NiMH) battery.

NiMH batteries are the most expensive type of batteries, but as the saying goes, "you get what you pay for." These batteries have a good life and can usually be used for a few years before they need to be replaced. NiMH batteries come in different power ratings that are expressed in milliampere hours (mAh). You can find them from about 1400 mAh up to 3000 mAh. The higher the mAh rating, the longer the battery will hold its charge. I recommend using a battery with an mAh of 2500 or better.

CAUTION Most NiMH batteries must be fully charged before you install them into your Speedlight. If one of the batteries in the set becomes discharged before the others, the discharged battery goes into polarity reversal, which means the positive and negative poles become reversed, causing permanent damage to the cells rendering it useless and possibly damaging the Speedlight. Some manufacturers sell pre-charged rechargeable batteries.

Navigate the Settings and Menus

This section covers all of the different settings that are available for use with your Speedlights. Some Speedlights offer a lot of different functions, features, and custom settings (SB-900), and some Speedlights offer only the most basic features (SB-600).

The following section covers every flash mode and custom setting available with the SB-900, SB-800, and SB-600.

Flash modes

Nikon Speedlights function with different flash modes. These modes control how the camera determines the amount of light the Speedlight needs to put out in order to achieve a proper exposure for the scene. These flash modes are not to be confused with *flash sync modes,* which control how the flash interacts with different exposure and camera settings.

The flash modes available differ with each Speedlight model. The SB-900 and SB-800 offer all of the different available modes, while the SB-600 only offers a few modes.

For more information on flash sync modes, see Chapter 3.

i-TTL and i-TTL BL

TTL stands for through-the-lens. This means that the flash exposure is metered directly by the camera by reading the amount of light that is entering the lens of the camera. Nikon has made use of TTL flash metering for quite a few years and has redesigned and adapted the TTL metering system for the changing technology that is prevalent with today's innovations in digital photography.

Nikon's most current TTL system is referred to as i-TTL. The i-TTL system is the newest and most innovative flash mode by Nikon. The camera gets most of the metering information from monitor preflashes emitted from the Speedlight. These preflashes are emitted almost simultaneously with the main flash so it looks as if the flash fires once. The preflashes are fired and reflect off of the subject, and the light travels down the lens and is evaluated by the camera's metering sensor. The camera interprets the data from the sensor and tells the Speedlight at what power to fire. The camera also uses data from the lens, such as distance information and f-stop values to help get an accurate exposure. i-TTL metering is used on all CLS-compatible cameras with all current Speedlights. The i-TTL metering system can also be employed when using Speedlights off-camera as a remote; with any of the built-in Speedlights; and when using the SB-900, SB-800, or SU-800 as a commander. Of course other modes can be used as well (they are covered in later sections).

Going hand-in-hand with TTL is TTL BL. TTL BL uses Nikon's i-TTL system just as before but takes into account metering information from the camera of the ambient lighting. The camera then adjusts the flash output to better match the ambient lighting scene to give the image a more natural look instead of one that's obviously "flashed."

2.1 Although the LCD screen shows TTL, the Speedlight is using i-TTL.

This flash metering system is known as Automatic Balanced Fill Flash in Nikon terminology (this is where the *BL* comes from in TTL BL). Fill flash is a flash technique that employs the flash to fill in shadows on the subject when photographing a subject outdoors in natural light.

Backward Compatibility

In the past, Nikon tried to make its flashes backward compatible, meaning that the Speedlights will function with older model cameras that use different metering methods to determine flash exposure. Unfortunately, Nikon discontinued the backward-compatibility feature with the release of the SB-900.

Some of Nikon's older SLR and dSLR camera bodies offer some sort of auto flash metering system that's similar to the i-TTL system that's in use today in the current crop of dSLRs and the SLR film camera, the F6. When an SB-800 or SB-600 Speedlight is attached to one of these cameras, the Speedlight automatically reverts to the flash metering mode of the camera body it is connected to. There are two types of metering modes that function with the backward compatibility of the SB-800 and SB-600.

▶ **TTL.** The TTL metering system, also known as 3D Multi Sensor metering, is Nikon's older film-based flash metering system. The flash exposure is based on the readings of the monitor flash on a sensor that reads the reflected light off of the film that is loaded into the camera body. The SB-800 and SB-600 also are able to perform 3D Multi Sensor balanced fill flash similar to the i-TTL BL of the current line of SLRs. When the SB-800 and SB-600 are connected to cameras such as the N80/F80, N90/F90, N90s/F90x, and F100, they perform in this mode.

▶ **DTTL.** DTTL was the first flash metering system for the Nikon digital SLRs. DTTL also relies on monitor preflashes and distance information, but was basically a variation of the film-based TTL metering system. This system was implemented with the Nikon D1 series cameras as well as the D100. The DTTL system was unreliable, causing almost unpredictable results. If you attach an SB-800 or SB-600 to a D1, D1X, D1H, or D100, the Speedlight will operate in DTTL mode that also offers a similar balanced fill flash feature.

While the SB-900 isn't backward compatible with the TTL metering modes, it can be used with any of the Nikon SLR cameras in the Non-TTL Auto, GN Distance Priority, Manual, or Repeating Flash mode.

 For more information on fill flash, see Chapter 3.

 i-TTL BL is only available when the camera's exposure metering system is set to Matrix or Center-weighted.

 Because the SB-400 is Nikon's simplest Speedlight, it only functions using i-TTL. No other flash modes are available.

Non-TTL Auto Flash/Auto Aperture

When using Non-TTL Auto Flash, the camera uses no TTL metering to determine the flash output. There are a few variations of this flash mode. These can be set or changed in the Custom Settings Menu of the SB-900 or SB-800 Speedlight (the SB-600 doesn't support Non-TTL Auto Flash modes). See the Custom Settings Menu section for the corresponding Speedlight in this chapter.

The SB-900 has four Non-TTL Auto flash settings.

▶ **Auto Aperture with preflashes.** When using this mode the camera automatically transmits aperture and ISO information to the Speedlight, which fires a series of preflashes immediately preceding the main flash. When the flash is fired, the Speedlight

2.2 Auto Aperture with preflashes

reads the reflected light from the subject using the non-TTL auto flash sensor on the front of the Speedlight. When the flash detects enough light to make a proper exposure for the aperture and ISO setting, the flash is stopped. The information provided by the preflash helps to get a more accurate flash exposure.

▶ **Auto Aperture.** When using AA or Auto Aperture Flash, the flash output is determined by the aperture and ISO settings of the camera, which are automatically transmitted from the camera to the Speedlight. The flash is fired and the Speedlight reads the reflected light from the subject using the non-TTL auto flash sensor on the front of the Speedlight.

2.3 Auto Aperture

▶ **Non-TTL auto flash with preflashes.** In this mode, pre-flashes are fired to obtain subject information to aid in the exposure, but there is no aperture information communicated between the camera and the Speedlight. In order to achieve a proper exposure using this mode, the aperture setting must be entered directly to the SB-900. You can do this by pressing the Function button 3 repeatedly until the proper aperture setting appears, or you can press the button once and rotate the selector dial until the desired aperture setting is displayed. When using this mode you can adjust the exposure by adjusting the aperture setting on the camera without adjusting the setting on the Speedlight.

2.4 Non-TTL auto flash with preflashes

2.5 Non-TTL auto flash

▶ **Non-TTL auto flash.** This mode is the same as the previous mode, but without the pre-flashes. The aperture setting is adjusted the same as above.

Some people prefer the Non-TTL Auto modes without the preflash for children and pet photography because the preflashes (both i-TTL and non-TTL Auto) can cause your subject to blink resulting in portraits with closed eyes.

The SB-800's Non-TTL auto flash has only two options to select from. Unlike the SB-900 Speedlight, it does not have the option to use preflashes when using these modes.

▶ **Auto Aperture.** When using AA or Auto Aperture Flash, the flash output is determined by the aperture and ISO settings of the camera, which are automatically transmitted from the camera to the Speedlight. The flash is fired and the Speedlight reads the reflected light from the subject using the non-TTL auto flash sensor on the front of the Speedlight.

2.6 Auto Aperture

▶ **Non-TTL auto flash.** In this mode, no aperture information is communicated between the camera and the Speedlight. In order to achieve a proper exposure using this mode, the aperture setting must be entered directly to the SB-800. You can do this by using the Multi-selector +/- buttons. When using this mode you can adjust the exposure by adjusting the aperture setting on the camera or the lens (with a non-CPU lens) without adjusting the setting on the Speedlight.

2.7 Non-TTL auto flash

Guide Number Distance Priority

This is a semiautomatic mode in which you set the flash-to-subject distance on the SB-900 or SB-800 (not available on the SB-600). When the aperture is adjusted the Speedlight automatically adjusts the flash output to ensure consistent exposures even while shooting at different apertures.

This mode should only be used when the camera/Speedlight and subject are in a set position and the distance isn't going to change. If the distance changes, the exposure will not be accurate.

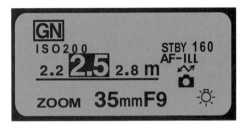

The preferred exposure modes are Manual or Aperture Priority. This allows you to control the flash exposure by adjusting the aperture setting on the camera.

2.8 The Guide Number Distance Priority setting. The highlighted number is the distance the subject needs to be from the Speedlight.

 GN Distance Priority mode is only available when the Speedlight is on the camera or connected with a TTL cord and the flash head is pointed at the default straight ahead position or at the –7-degree position.

To set GN Distance Priority mode with the SB-900:

1. **Press the Mode button (or press Mode and rotate the dial) until GN appears on the LCD panel in the upper-left-hand corner.** Press OK to set the mode.

2. **Press Function button 2 and rotate the Selector dial until the preferred distance appears on the LCD.** Press OK to set the distance.

3. **Set your camera to Aperture Priority or Manual exposure mode.** Shoot as usual.

 If you are using a non-CPU lens with a camera that does not support non-CPU lens data you can set the aperture on the flash manually by pressing Fn. button 3 and rotating the Selector dial. FEC can be adjusted by pressing Fn. button 1 and rotating the Selector dial.

To set GN Distance Priority mode with the SB-800:

1. **Press the mode button until GN appears on the LCD panel in the upper-left-hand corner.**

2. **Press SEL.** This highlights the distance setting.

3. **Press the Multi-selector + or – buttons to adjust the distance setting.** Press the SEL button to set the distance. This highlights the exposure compensation setting for change.

4. **Use the Multi-selector + or – buttons to adjust the exposure compensation if desired.** Press the SEL button to set.

 If you are using a non-CPU lens with a camera that does not support non-CPU lens data, set the aperture on the SB-800 Speedlight using the +/- buttons.

Manual

Setting your Speedlight to Manual mode requires you to adjust the flash output settings yourself. The best way to figure this out is by using a formula. You need to know the guide number (GN) of the Speedlight. The guide number is a measure of the flash output. The higher the guide number the more output and range the flash has.

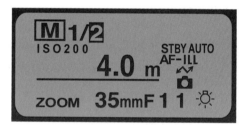

2.9 Manual flash setting display

You need to know the GN in order to figure out which aperture to use to get the correct flash exposure for the distance to your subject. The formula to get the correct aperture is: GN/Distance = Aperture. Of course, you can also use a flash meter to determine the proper settings to use.

 For more information on how to use the GN/D = A equation to determine the proper exposure settings, see Chapter 3.

Manual exposure is usually used in studio-type settings where you want to have complete control of the flash output or when you don't deal with the inconsistencies that sometimes occur when using i-TTL.

Repeating Flash

In this mode, abbreviated as RPT, the flash fires repeatedly like a strobe light during a single exposure. You must manually determine the proper flash output using the formula to get the correct aperture (GN/D = A), and then you decide the frequency and the number of times you want the flash to fire. The slower the shutter speed, the more flashes you are able to capture. For this reason, I recommend only using this mode in a low-light situation because the ambient light tends to overexpose the image. Use this mode to create a multiple exposure-type image.

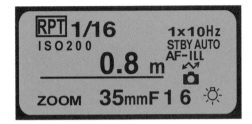

2.10 Repeating (RPT) flash setting

 For detailed information on using the RPT flash mode, see Chapter 3.

SU-4 mode

The name for this mode comes from a Nikon accessory that was used to achieve wireless TTL prior to the CLS. The SU-4 is a small hot shoe optical trigger that is attached to a Speedlight and allows the remote flash to operate in conjunction with the master flash. When the master flash fires, the remote fires; when the master flash stops firing, the remote also stops. This type of operation is very useful when shooting sports or action. Because the CLS preflashes cause a bit of a shutter lag, this can cause you to miss the peak of the action while the camera does the CLS operation. Because the SU-4 mode doesn't use CLS preflashes, the flashes fire instantaneously allowing you to capture the shot at the precise moment you press the Shutter Release button.

Setting the SB-900 and SB-800 to SU-4 mode disables the CLS functions of the Speedlights. They act as a single group of optical remote flashes and exposure compensation must be physically adjusted on each remote flash separately.

Using SU-4 mode as a master

Setting the SB-800 or SB-900 as a master flash while set to SU-4 mode automatically disables the preflashes. The only flash modes that operate with SB-900 as a master in SU-4 mode are Manual, Non-TTL Auto, and GN Distance Priority. The SB-800 adds the functionality of RPT flash mode along with the other modes. Press the Mode button to cycle through available flash modes.

 When using the SB-800 as a master flash in SU-4 mode cycling through the flash mode shows TTL and TTL BL (unless spot metering is set) flash modes. These modes are not actually usable though the icons are shown. The flash mode defaults to Non-TTL Auto when TTL is set.

 When the SB-800 is set to SU-4 mode it is automatically set to function as a master when attached to the camera's hot shoe. When the Speedlight isn't connected to a hot shoe, it is automatically set to Remote mode. Use the SB-900 switch to choose between Remote and Master modes.

Using SU-4 mode as a remote

When your Speedlight is set to SU-4 mode and set as a remote, you have two modes to choose from: Manual or Auto. Pressing the Mode button toggles between the two modes.

▶ **Manual.** In this mode, the remote Speedlight output is set on the flash the same way you would when using the Speedlight in Manual mode when not set to SU-4. Of course, you should use a flash meter or use the GN/D = A equation to determine the proper settings. In this mode, the remote flash is triggered by the master flash and starts firing when the master flash fires.

2.11 Manual mode icon

▶ **Auto.** This mode functions a little differently than Manual mode. This mode is best suited when using the master flash in Non-TTL Auto mode. The remote flash starts and stops in sync with the master flash. This results in all of the SU-4 remotes firing at the

2.12 Auto mode icon

some output as the master flash. You will want to be sure that your remote flashes are the same distance away from the subject as the master flash or adjust the FEC on the remote to reflect the differences and to ensure proper exposures.

SB-900 custom functions and settings

The Custom Functions menu on the SB-900 allows you to change different settings of your flash and controls how the flash functions in different modes and also allows you to customize other aspects of the Speedlight's output as well as many other different settings that allow you to make the flash "yours."

Entering the SB-900's Custom Functions menu is as simple as pressing and holding the OK button for approximately 1 second. From here use the Selector dial to scroll through the different options until the specific option that you want to adjust is highlighted on the LCD screen. Once the selected option is highlighted, press the OK button to enable the function to be changed. Use the Selector dial to scroll between the choices. When the selected setting is changed, press the OK button to return to the Custom Functions menu. When you finish making adjustments in the Custom Functions menu, press Function button 1 to exit to return to normal operation.

Non-TTL Auto flash mode

This is where you set the Non-TTL Auto flash mode. The different options are discussed in detail earlier in the chapter in the Flash modes section. Only one mode can be selected at a time. The options are

▶ **Auto Aperture with preflash (default)**

2.13 Auto Aperture with preflash — this is the default mode.

▶ **Auto Aperture without preflash**

2.14 Auto Aperture without preflash

▶ **Non-TTL Auto with preflash**

2.15 Non-TTL Auto with preflash

▶ **Non-TTL Auto without preflash**

2.16 Non-TTL Auto without preflash

Master RPT flash

Setting this Custom Function to On allows the SB-900 to control the remote Speedlights using the Repeating Flash function.

 For more information on using the RPT flash mode, see Chapter 3.

Manual mode output

Setting this Custom Function option to On allows you to adjust the output level from 1/3 EV or 1 EV only between 1/1 and 1/2 power when in Manual flash mode. Settings from 1/2 all the way down to 1/128 are still adjusted in 1/3 EV steps.

SU-4

Turning on this Custom Function option enables the flash to work in SU-4 mode in both Master and Remote settings. Turning on this option disables CLS and preflashes causing it to function as a simple optical remote.

Illumination pattern

This is a Custom Function option that is a new feature introduced with the SB-900. You can adjust the illumination pattern to better suit the type of shooting situation and subject. This allows you to control how much light falloff you have at the edges of the image frame. The options are

▶ **Center-weighted.** This lighting pattern causes the light from the Speedlight to be focused a little bit tighter at the center of the frame, allowing the light to fall off at the edges of the frame drawing attention to the subject in the middle of the frame. This pattern is good to use for single portraits or close-ups of a subject that is placed in the middle of your frame.

2.17 Center-weighted icon

▶ **Standard.** This is the default setting for the SB-900. This pattern is good for most subjects. The light falloff at the edges of the frame is minimal but may be noticeable in some situations.

2.18 Standard pattern icon

▶ **Even.** This lighting pattern gives a more dif-
fused light that covers more of the frame
than the other two options. There is little
light falloff and the edges are sufficiently
illuminated. This lighting pattern is best
suited to subjects that fill the entire frame

2.19 Even pattern icon

of the image such as group portraits or still-life images that dominate most of
the image frame.

Test firing button

This Custom Function option allows you to choose the function of the test fire button
of the SB-900. You have two choices.

▶ **Flash.** When set to this, pressing the test
fire button fires a single flash pop. This is
the default setting.

2.20 Test flash ready to fire

▶ **Modeling.** Selecting this option causes the
flash to fire a continuous series of low-
power flashes for about 1.5 seconds. This
allows you to see what effect the
Speedlight's output will have on your sub-
ject. This is mostly useful for checking the
shadow placement on your subject.

**2.21 Modeling flashes ready to
fire**

Flash output level of test firing in iTTL

This Custom Function option determines the output level of the Speedlight's test fire
when the SB-900 is set to iTTL. You can choose from three power levels: 1/128
(default), 1/32, or 1/1 (full power).

NOTE Pressing the test fire button when in Non-TTL Auto or AA causes the Speedlight
to flash at the output specified by the settings. When in Manual modes (M,
GN, and RPT) the flash test fires at the selected setting.

FX/DX

The SB-900 can automatically detect whether the camera it is attached to is DX or FX
(or an FX camera set to DX mode). This allows the Speedlight to adjust the light distri-
bution so that the light is utilized in a more efficient manner, saving power. You can
use this Custom Function setting to disable the automatic setting and manually set
the SB-900 to FX or DX.

▶ **FX <-> DX.** This is the default setting. The SB-900 automatically adjusts the light distribution depending on the camera image area.

▶ **FX.** This sets the light distribution to be optimized for cameras using Nikon's full-frame (FX) sensor. If the Speedlight is attached to a DX camera, the SB-900 will not automatically switch to DX.

▶ **DX.** This sets the light distribution to be optimized for cameras using Nikon's smaller APS-C-sized (DX) sensor. If the Speedlight is attached to an FX camera, the SB-900 will not automatically switch to FX.

Power zoom

The SB-900 has an automatic zooming flash head, which allows the SB-900 to adjust the light distribution based upon the focal length of the lens in use. As you can see in the following list, this Custom Function option is a little counterintuitive. There are two options for this setting.

▶ **On.** This turns the power zoom *off*. This means you must adjust the zoom setting manually by pressing the Zoom button on the back of the SB-900.

▶ **Off.** This turns the power zoom *on*. The Speedlight automatically detects the focal length of the lens and adjusts the zoom head position.

When a non-CPU lens is attached, the Speedlight zoom setting must be **NOTE** adjusted manually. With cameras that support non-CPU lens data, the Speedlight zoom head adjusts automatically to the specified setting.

When the wide-angle flash panel is down or the SW-13H diffuser is attached, **CAUTION** the power zoom function is disabled and the zoom head is set to 17mm (FX) or 11mm (DX).

AF-Assist

This Custom Function setting is used to control whether the AF-Assist feature is on or off. The AF-Assist projects an array pattern using LEDs to help give the scene some elements of contrast so that the AF can lock on to the subject when the light is dim. There are three options for this setting.

▶ **On.** This allows the AF-Assist illuminator light to come on when photographing with the SB-900 in low-light situations.

2.22 AF-Assist illuminator light on

▶ **Off.** This disables the AF-Assist feature. You may want to use this setting when you don't want the AF-Assist LED array to distract your subject prior to snapping the shot.

2.23 AF-Assist feature disabled

▶ **AF Only.** This option allows the AF-Assist to function but disables the flash altogether. This option comes in handy if you are in a dim situation, but you don't want to use flash. The AF-Assist array helps the AF to lock focus, but the flash doesn't fire. This

2.24 AF-Assist on, no flash

can be handy when photographing in low-light situations such as weddings, concert events, or at museums where flash photography isn't permitted.

Standby

This Custom Function option allows you to set the amount of time that the SB-900 stands idle before the Speedlight goes into Standby mode (sleep). There are six options for this setting.

▶ **Auto.** This setting syncs the SB-900 with the camera's exposure meter. When the camera goes to "sleep," the Speedlight goes into Standby mode.

▶ **40.** This activates Standby mode after the SB-900 is idle for 40 seconds.

▶ **80.** This activates Standby mode after the SB-900 is idle for 80 seconds.

▶ **160.** This activates Standby mode after the SB-900 is idle for 160 seconds.

▶ **300.** This activates Standby mode after the SB-900 is idle for 300 seconds.

▶ **– –.** This disables the Standby function altogether.

The flash can be woken up by lightly tapping the Shutter Release button or by pressing the test fire button.

ISO

This Custom Function option allows you to manually adjust the ISO setting of the Speedlight. This affects the GN of the flash. The ISO can be adjusted from ISO 3 all the way up to ISO 8000 in 1/3-stop increments. Use this function when you connect your Speedlight to an older Nikon film camera. For all Nikon cameras from the N8008 and up, the ISO information is communicated to the SB-800 and is set automatically.

Remote ready light

When the SB-900 is set to function as a remote, there are two LEDs up front and the test fire button on the rear of the Speedlight that light up to indicate that the Speedlight is ready to fire, depending on the option you choose. There are three options for this Custom Function setting.

2.25 Remote ready light indicator

▶ **Rear, Front.** At the default setting, the rear ready light is lit and the fronts LEDs blink to indicate that the Speedlight is ready to fire.

▶ **Rear.** When this option is selected, only the rear ready light is lit.

▶ **Front.** This option allows only the front LEDs to blink to indicate that the SB-900 is ready to fire.

LCD panel illuminator

The SB-900's LCD panel is illuminated by a bright blue light for easy reading in low-light situations. There is a Custom Function that allows you to turn off the LCD illuminator when you're shooting in the daylight to conserve energy.

2.26 LCD illuminator on indicator

NOTE When the Speedlight is in the Custom Functions menu or the camera's LCD control panel illuminator is activated, the SB-900's LCD panel illuminator is automatically activated.

Thermal cut-out

The SB-900 features a thermal cut-out feature that shuts down the SB-900 in the event that the SB-900 becomes overheated from firing the flash multiple times in succession. This thermal cut-out Custom Function feature can be deactivated by setting the Custom Function to Off.

2.27 Thermal cut-out on indicator

This is a touchy subject but some photographers (including myself) have found that the thermal cut-out feature is too sensitive and powers down the Speedlight too often. I myself have turned this feature off due to missing shots while the Speedlight cools down. I don't necessarily advocate turning this feature off, but it works for me.

 Turning off the thermal cut-out feature can result in damage to your SB-900 if overheating occurs. Do this at your own risk.

Sound monitor

The SB-900 has a sound monitor that beeps to indicate the status of the Speedlight when used as a remote. Using this Custom Function option, you can deactivate the sound monitor for silent operation.

2.28 Sound monitor on

▶ **One beep.** The SB-900 is charged and ready to fire at full power.

▶ **Two short beeps.** After the SB-900 fires, the Speedlight beeps twice to indicate that the subject received proper flash exposure.

▶ **Eight short beeps.** When the SB-900 beeps eight times quickly after firing, the flash has either fired at full power and the image may be underexposed or the remote sensor didn't detect the preflashes or Non-TTL Auto flash correctly. You should review your images to ensure that it's properly exposed.

▶ **Two quick beeps.** This is a warning that the Speedlight is overheating. You should let the Speedlight cool down before continuing use.

LCD panel contrast

This Custom Function allows you to control the contrast of the LCD panel. Making the contrast higher enables you to view the LCD better when in bright light.

2.29 LCD panel contrast adjustment indicator

Distance unit

This option allows you to choose whether the distance settings on the SB-900 appear in imperial or metric units (you can choose feet or meters).

2.30 Distance setting indictor

Zoom position setting for wide-flash panel

If the wide-angle flash panel is broken off accidentally, the automatic power zoom function of the SB-900 may become disabled and stay set to the widest setting (17mm for FX or 11mm for DX). If this situation arises, you can set this option to On to allow the camera to automatically detect the focal length.

2.31 Zoom position for wide-flash on

 If this setting is turned on when the flash panel is not broken, the zoom head automatically adjusts when the flash panel is down.

My Menu settings

To make surfing through all of the custom functions quicker, the SB-900 allows you to customize the Custom Functions menu to only include the settings that you change the most. There are three options in this menu.

▶ **Full.** This is the default setting. This option shows all of the available Custom Function settings.

2.32 Full menu

▶ **My Menu.** Selecting this option only displays the Custom Function options that you select.

▶ **Setup.** Use this option to select and set which Custom Function options appear in My Menu. To select the options to display in My Menu use the following steps:

2.33 My Menu

1. **Select Setup from the My Menu option in the Custom Functions menu.** Press the OK button to view the available Custom Function settings.

2. **Use the Selector dial to scroll though the settings.** A check box appears next to each available Custom Function setting that can be set to My Menu (if the option cannot be set, no box is shown). Press the OK button to select or deselect the option. When a check mark appears in the box, the option is set to My Menu.

2.34 When a custom setting is turned on a checkmark is shown.

3. **When you finish selecting the options, press Function button 1 to return to the Custom Functions menu.** Press Function button 1 again to exit the Custom Functions menu.

Firmware

This option displays the current version of the firmware that is installed on the SB-900. Firmware is a fixed version of software, which isn't user accessible. Firmware controls the functions of the SB-900 and can be updated to fix problems or to provide added functionality if needed. As of this writing, the SB-900 is the only Speedlight that

supports firmware updates. To update the firmware, a D700 or D3 camera body must be used. If your camera body doesn't support firmware updates your Speedlight must be taken to an authorized repair center.

Reset

This option resets all of the Custom Function settings back to the factory default settings.

The distance unit setting and My Menu are not affected by the reset.

SB-800 custom functions and settings

Similar to the SB-900, the SB-800 also has a series of custom functions that can be used to modify the flash settings to suit your needs. The Custom Functions menu system of the SB-800 is quite different from the SB-900. Not all of the custom functions or settings are available depending on whether the Speedlight is set to function as a hot shoe flash, master, remote, or in SU-4 mode.

To enter the Custom Function settings menu, press and hold the Select button for 2 seconds. Use the Multi-selector buttons to browse the available custom settings. Once the setting is highlighted, press the Select button to adjust the options for the setting. Use the Multi-selector to scroll through the available options. When the preferred setting is selected, press the SEL button again to save the setting.

ISO

The ISO setting Custom Function is available only when the SB-800 is disconnected from the camera or if the Speedlight is connected to an older Nikon film camera. For all Nikon cameras from the N8008 and up, the ISO information is communicated to the SB-800 and is set automatically.

Wireless Flash mode

This mode sets the SB-800 up for wireless operation. There are five options available in this Custom Function.

2.35 Wireless flash mode icon

▶ **OFF.** This turns off the wireless mode of the SB-800 and allows it to be used as an on-camera flash.

▶ **Master.** This sets the SB-800 up as a master flash unit allowing you to use the SB-800 to control any number of off-camera remote Speedlights in three groups.

 For more information on setting up the master flash to control remotes, see Chapter 4.

▶ **Master (RPT).** This allows the SB-800 to be used as a master flash unit using the Repeating Flash feature.

▶ **Remote.** This option sets the SB-800 up to be used as an off-camera wireless remote. You can set the Speedlight to three different groups (A, B, or C) on four channels.

▶ **SU-4.** This allows the Speedlight to be controlled as a wireless remote using the SU-4 feature, which is covered earlier in the chapter.

 When the SB-800 is in SU-4 mode attached the camera via hot-shoe the Speedlight defaults to Master mode.

Sound monitor

This Custom Function option is only available when the Speedlight is set to Remote. You can use this option to monitor the flash output when the Speedlight is being used as an off-camera remote Speedlight. The sound monitor can be turned on or off. There are three signals for this option.

2.36 Sound monitor icon

▶ **One beep.** The SB-800 is charged and ready to fire at full power.

▶ **Two short beeps.** After the SB-800 fires, the Speedlight beeps twice to indicate that the subject received proper flash exposure.

▶ **Eight short beeps.** When the SB-800 beeps a quick eight times after firing, the flash either fired at full power and the image may be underexposed or the remote sensor didn't detect the preflashes or Non-TTL Auto flash correctly. You should review your images to ensure that they're properly exposed.

Non-TTL Auto flash mode

When the wireless flash mode is set to Off or SU-4 mode, you can change the Non-TTL flash mode. The options for this Custom Function are

▶ **AA — Auto Aperture.** When using AA or Auto Aperture flash the output is determined by the aperture and ISO settings of the camera, which are automatically transmitted from the camera to the Speedlight. The flash fires and the Speedlight reads the reflected light from the subject using the non-TTL auto flash sensor on the front of the Speedlight.

2.37 Auto Aperture icon

▶ **A — Non-TTL auto flash.** In this mode, no aperture information is communicated between the camera and the Speedlight. In order to achieve a proper exposure using this mode, the aperture setting must be entered directly to the SB-800. You can do this by pressing the SEL button once

2.38 Non-TTL auto flash icon

quickly and using the Multi-selector +/- buttons. When using this mode, you can adjust the exposure by adjusting the aperture setting on the camera or the lens (with a non-CPU lens) without adjusting the setting on the Speedlight.

NOTE In SU-4 mode you can choose AA or A only if the flash is on camera, otherwise it's A only. If you're setting these custom functions with the flash off camera, this box will be blank if SU-4 mode is selected.

Standby

This Custom Function setting allows you to set the amount of time that the SB-800 stands idle before the Speedlight goes into Standby mode (sleep). There are six options for this setting.

▶ **Auto.** This setting syncs the SB-800 with the camera's exposure meter. When the camera goes to "sleep," the Speedlight goes into Standby mode.

▶ **40.** This activates Standby mode after the SB-800 is idle for 40 seconds.

▶ **80.** This activates Standby mode after the SB-800 is idle for 80 seconds.

▶ **160.** This activates Standby mode after the SB-800 is idle for 160 seconds.

▶ **300.** This activates Standby mode after the SB-800 is idle for 300 seconds.

▶ **– –.** This disables the Standby function altogether.

The flash can be awakened up by lightly tapping the Shutter Release button or by pressing the test fire button.

The Standby feature is disabled when the SB-800 is set to Remote mode.

Distance unit

This Custom Function option allows you to choose whether the distance settings on the SB-800 appear in imperial or metric units (you can choose feet or meters). This option is not available when the SB-800 is set to Remote mode.

Power zoom

The SB-800 has an automatic zooming flash head, which allows the SB-800 to adjust the light distribution based upon the focal length of the lens in use. As with the SB-900, the settings for this Custom Function option are a little counterintuitive. There are two options.

▶ **On.** This turns the power zoom *off*. This means you must adjust the zoom setting manually by pressing the Zoom button on the back of the SB-800.

▶ **Off.** This turns the power zoom *on*. The Speedlight automatically detects the focal length of the lens and adjusts the zoom head position.

 When a non-CPU lens is attached, the Speedlight zoom setting must be adjusted manually. With cameras that support non-CPU lens data, the Speedlight zoom head adjusts automatically to the specified setting.

 When the wide-angle flash panel is down, the zoom head is set to 17mm. When the SW-10H diffuser is attached, the power zoom function is disabled and the zoom head is set to 14mm.

Zoom position setting for wide-flash panel

If the wide-angle flash panel is broken off accidentally, the automatic power zoom function of the SB-800 may become disabled and stay set to the widest setting (17mm). If this situation arises, you can set this Custom Function option to On to allow the camera to automatically detect the focal length. This custom function setting only appears if the wide-flash panel is out or broken off.

2.39 Zoom position setting for wide-flash icon

 If this setting is turned on when the flash panel is not broken, the zoom head automatically adjusts when the flash panel is down.

LCD panel illuminator

The SB-800's LCD panel is illuminated by a bright blue LED backlight for easy reading in lowlight situations. You can choose to turn off the Custom Function option for the LCD illuminator when you shoot in the daylight to conserve energy.

2.40 **LCD panel illuminator icon**

 When the Speedlight is in the Custom Functions menu or the camera's LCD control panel illuminator is activated, the SB-800's LCD panel illuminator is automatically activated.

LCD panel contrast

This Custom Function allows you to control the contrast of the LCD panel. Making the contrast higher enables you to view the LCD better in bright light.

2.41 **LCD panel contrast adjustment indicator**

AF-Assist

This Custom Function setting is used to control whether the AF-Assist feature is on or off. The AF-Assist projects an array pattern using LEDs to give the scene some elements of contrast so that the AF can lock on to the subject when the light is dim. There are two options for this setting.

▶ **On.** This allows the AF-Assist illuminator light to come on when photographing with the SB-800 in low-light situations.

▶ **Off.** This disables the AF-Assist feature. You may want to use this setting when you don't want the AF-Assist LED array to distract your subject prior to snapping the shot.

2.42 **AF-Assist on**

This option is not available when the SB-800 set to Remote.

Flash Cancel

When the SB-800 wireless mode is set to Off, you can choose this Custom Function option to cancel the flash. Canceling the flash comes in handy if you are in a low-light situation, but you don't want to use flash. The AF-Assist array will help the AF to lock focus, but the flash doesn't fire. This can be handy

2.43 **This menu option allows you to turn the flash off while keeping the AF-Assist on.**

when photographing in low-light situations such as weddings, concert events, or at museums where flash photography isn't permitted.

SB-600 custom functions and settings

The SB-600 has far fewer custom settings than the SB-900 or SB-800. You can access the Custom Functions menu by simultaneously pressing the Zoom and – buttons and holding them down for about 2 seconds.

Use the + or – button to scroll through the options. Pressing the Mode or Zoom button turns each option on or off. Press the On/Off button to set the selection.

Wireless remote flash mode

This Custom Function option allows you to choose between normal flash operation and remote mode. There are two options for this setting.

▶ **Off.** This allows the flash to be used on camera as a hot shoe Speedlight.

▶ **On.** This allows you to set the SB-600 up as an off-camera remote.

OFF
↴

2.44 Wireless remote flash off

On
↴

2.45 Wireless remote flash on

For more information on setting up remotes, see Chapter 4.

Sound monitor

This Custom Function option is only available when the SB-600 is set to Remote. You can use this option to monitor the flash output when the Speedlight is being used as an off-camera remote Speedlight. The sound monitor can be turned on or off. The signals are as follows:

2.46 Sound monitor icon

▶ **One beep.** The SB-600 is charged and ready to fire at full power.

▶ **Two short beeps.** After the SB-600 fires, the Speedlight beeps twice to indicate that the subject received proper flash exposure.

▶ **Eight short beeps.** When the SB-600 beeps eight times quickly after firing, the flash has either fired at full power and the image may be underexposed or the remote sensor didn't detect the preflashes or Non-TTL Auto flash correctly. You should review your images to ensure that they're properly exposed.

Remote ready light

The SB-600 has auxiliary ready lights on the front of the Speedlight to assist in monitoring the flash output when the SB-600 is being used as a remote. When the Custom Function setting is On, the ready lights blink when the SB-600 is ready to fire.

On

rL

2.47 Remote ready light on

AF-Assist

This Custom Function setting is used to control whether the AF-Assist feature is on or off. The AF-Assist projects an array pattern using LEDs to give the scene some elements of contrast so that the AF can lock on to the subject when the light is dim. There are two options for this setting.

 NOTE AF-Assist is only available when the Speedlight is connected to the camera hot-shoe or an off-camera TTL cord.

▶ **On.** This allows the AF-Assist illuminator light to come on when photographing with the SB-600 in low-light situations.

2.48 AF-Assist ON, no flash

▶ **Off.** This disables the AF-Assist feature. You may want to use this setting when you don't want the AF-Assist LED array to distract your subject prior to snapping the shot.

2.49 AF-Assist OFF, no flash

This option is not available when the SB-600 is set to Remote.

Standby

Use this Custom Function option to allow the SB-600 to enter Standby mode when the Speedlight is inactive for a period of time. This can be set to Auto or -- --, which means that Standby is cancelled and the Speedight will remain active.

The Standby feature is disabled when the Speedlight is set to function as a remote.

Power zoom

The SB-600 has an automatic zooming flash head, which allows the Speedlight to adjust the light distribution based on the focal length of the lens in use. As with the other Speedlights, the settings for this Custom Function option are a little counterintuitive. There are two options for this setting.

▶ **On.** This turns the power zoom *off*. This means you must adjust the zoom setting manually by pressing the Zoom button on the back of the SB-600.

▶ **Off.** This turns the power zoom *on*. The Speedlight automatically detects the focal length of the lens and adjusts the zoom head position.

 When a non-CPU lens is attached, the Speedlight zoom setting must be adjusted manually. With cameras that support non-CPU lens data, the Speedlight zoom head adjusts automatically to the specified setting.

 When the wide-angle flash panel is down, the power zoom function is disabled and the zoom head is set to 14mm.

Zoom position setting for wide-flash panel

If the wide-angle flash panel is broken off accidentally, the automatic power zoom function of the SB-600 may become disabled and stay set to the widest setting (14mm). If this situation arises, you can set this Custom Function option to On to allow the camera to automatically detect the focal length. This Custom Function setting only appears if the wide-flash panel is out or broken off.

 If this setting is turned on when the flash panel is not broken, the zoom head automatically adjusts when the flash panel is down.

LCD illuminator

The SB-600's LCD panel is illuminated by a green LED backlight for easy reading in low-light situations. You can choose to turn off the Custom Function option for the LCD illuminator when you're shooting in daylight to conserve energy.

 When the Speedlight is in the Custom Functions menu or the camera's LCD control panel illuminator is activated, the SB-600's LCD panel illuminator is automatically activated.

Flash Photography Fundamentals

In this chapter, you learn the basic properties of flash photography. Most of these properties aren't specific to Nikon Speedlights, but can be applied to almost all photography that is done with a flash, whether you're using CLS or a studio strobe.

While using a flash, especially manually, may seem daunting at first, once you get a little bit of knowledge about how it works you will quickly learn that the Speedlight is one of the best tools available to you and that there lots of cool tricks you can use to make improvements to your images.

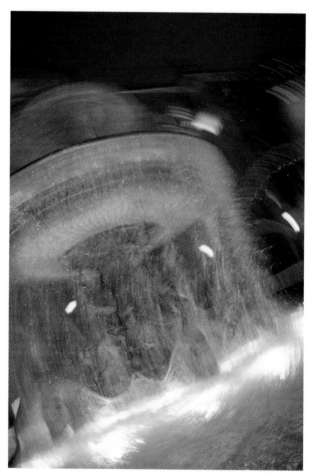

Using your Speedlight at night can add dramatic flare to your images.

Understanding Flash Exposure

In the past, flash photography was often only done by professionals. There were no TTL meters to control the flash output for you and determining the proper settings required using arcane mathematical equations and expensive flash meters. You also had to get the film processed before you could see if the calculations were correct. This was a major deterrent and kept most amateur photographers away from flash photography thinking it was too expensive and difficult to master.

The stigma flash photography received in those early years is why at first most people find flash photography a mysterious and scary thing. In recent years, people have been finding that flash photography isn't quite as scary as it used to be. This is mostly due to the fact that proprietary flash systems such as the Nikon CLS can do all of the metering and calculations for you, making it much easier and more accessible to the average photographer.

While allowing your camera and flash to control all of the settings for you can produce usable images, it's a good idea to understand how and why the flash works as it does. Making an effort to understand how the flash functions will help you to create better images in the long run.

Key Terms

Before you delve into the subject, there are a few lighting terms that are good to know because they come up frequently in any discussion of lighting techniques. These terms are pretty common in the lighting field and are used regardless of the type of lights that are being implemented, whether they are Speedlights or a constant light source. These terms are used across the board from still photography to motion picture lighting.

▶ **Key light.** This is also known as the main light. This is the light that will be providing most of the illumination for your subject. Placement of the key light determines the lighting pattern for the subject.

▶ **Fill light.** The fill light is your secondary light. As you may have surmised this light fills in the shadows. This isn't to be confused with fill flash although the same principles are at work.

▶ **Accent light.** These are lights that aren't necessary for the basic exposure, but add depth or separation of the subject from the background. Some common accent lights are

- **Background light.** This is a light that is aimed at the background. The background light is used to provide separation, or often it is used with filters to add a splash of color.

- **Rim light.** This is a light that is angled so that it lights only the extreme edge of the subject providing it with a bright highlight only on the edge of the subject. This helps to add drama to the image. The rim light is usually 1 to 2 stops brighter than the key light. Placement of the rim light is the key to making it work. This can be a very tricky technique to master.

- **Hair light.** This is exactly what it sounds like. There are two ways to use a hair light: The first is to place it behind the subject to give the hair a glowing backlight that provides separation from the background, especially if it's low key. The second is to use a boom stand to aim the light down on top of the head to provide some illumination without drawing any unnecessary attention to the hair.

▶ **Angle of light.** This is the angle at which the key light is placed in relation to the subject. The angle number is based on the camera position, which would be at 0 degrees. The angle of light also has an impact on your basic portrait lighting patterns.

 - **10 degrees.** At this position the light is placed just off to the side of the camera. This is where the light is positioned for the butterfly portrait lighting pattern.

 - **45 degrees.** This is the most common angle of light. The loop or Paramount lighting pattern is based on this angle.

 - **60 degrees.** This isn't a very common angle to use, but it does come in handy from time to time. The Rembrandt lighting pattern is achieved by placing the light at this angle.

 - **90 degrees.** At this angle the light is place directly to the side of the subject. This is how you achieve the split lighting pattern. This is also known as side lighting.

 - **180 degrees.** The light is placed directly behind the subject. This is reserved for accent lighting almost exclusively. This is known as backlighting.

▶ **Lighting ratio.** This is the difference between the light output between the key light and the fill light. Keep in mind the fill light could simply be light from the key bounced off a reflector onto the subject. The number of stops difference between the key and the fill determines the ratio number.

 - **1:1 ratio.** This means the key and the fill light are both emitting the same amount of light. This gives you flat lighting that is almost shadowless.

- **2:1 ratio.** This ratio means that there is two times or a 1-stop difference between the key and the fill. This is a nice general lighting ratio that gives enough shadow to create depth, but not enough to be overly dramatic.

- **4:1 ratio.** This gives you a 2-stop difference, which is just enough to give you nice dramatic shadows without losing too much detail in the shadow areas.

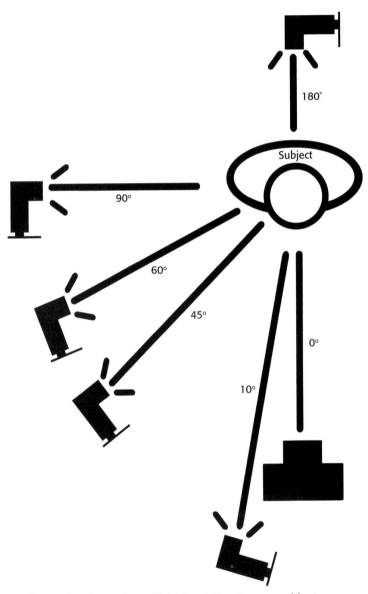

3.1 The angle of your Speedlight in relation to your subject determines the lighting pattern.

▶ **Broad lighting.** This refers to where the key light illuminates your subject. This term is usually used in conjunction with portrait photography. With broad lighting, the key light is placed so that it lights the side of the face that is facing the camera. This type of lighting is good for people with narrow faces and angular features.

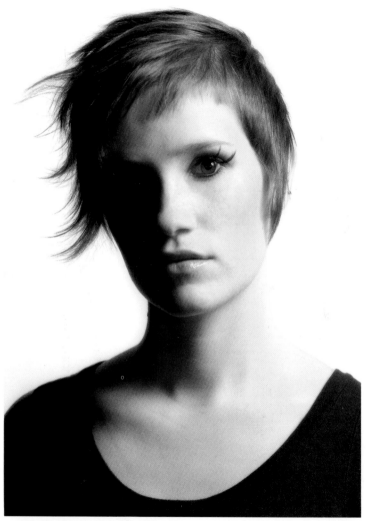

3.2 An example of broad lighting

▶ **Short lighting.** This is the opposite of broad lighting. In this scenario the key light is used to illuminate the side of the face that is facing away from the camera. This is a good type of lighting to use with a person who has a broad face and features.

3.3 An example of short lighting

▶ **High key.** This describes the tone of the image. High key images are very bright and usually have white or light colored backgrounds most often white. High key images are bright and usually convey an upbeat mood or even cleanliness.

3.4 An example of high key lighting

▶ **Low key.** This is when the tone of the image is darker. Low key images usually make use of high contrast and convey a more serious or somber mood and can add depth and drama to an image.

3.5 An example of low key lighting

▶ **Hard lighting.** This type of lighting comes from a small point source in relation to the subject and is characterized by high contrast and hard shadows. This type of lighting can be used to bring out texture or accentuate features.

3.6 An example of hard lighting

▶ **Diffused lighting.** The opposite of hard light, diffused lighting is soft and is often referred to as soft light. Using a soft box, umbrella, or bounce flash diffuses the light. Moving the light closer to the subject makes it more diffused. This type of light is often used in glamour photography.

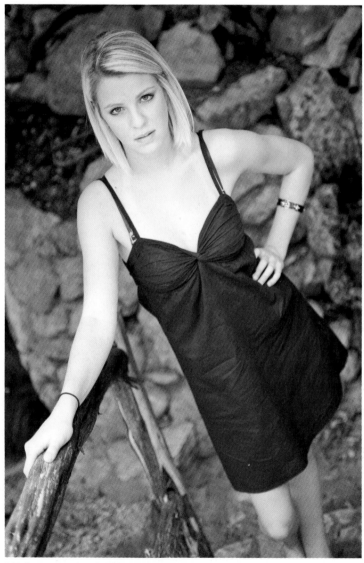

3.7 An example of diffused lighting

Basics of Using Flash

Although most of you will probably use Nikon's i-TTL metering system to determine your exposures, knowing the basics of flash exposure and the equations used to figure the settings is advisable. You can use these equations to manually set the flash exposure. This ensures that you get the exposure that *you* want instead of relying on the camera to tell you what it thinks the proper exposure is. Don't get me wrong, the i-TTL metering system is great and I use it most of the time, but being able to figure out the proper flash exposure just by knowing a few short equations is a great asset in the field if you have a tricky lighting situation or if for some reason the TTL ceases to function.

Achieving proper exposures

To determine the proper settings for your camera and flash to achieve a good exposure you must know a simple equation: GN / D = A. This equation has the three most important parts of flash exposure — Guide Number (GN), Distance (D), and Aperture (A). People usually ask, "What about shutter speed?" Well, shutter speed doesn't play a role in the actual flash exposure, but it does come into play, and I explain the role that shutter speed plays in the overall exposure later in this chapter when discussing flash sync modes.

Guide Number

The Guide Number (GN) is a numeric value that represents the amount of light that your Speedlight outputs at specific settings. The GN of the Speedlight isn't a fixed number, but it changes with the ISO setting and the zoom head position. Furthermore, each model of Speedlight has a different GN. Tables 3.1 and 3.2 give the GN for the SB-900 in both DX and FX format. Tables 3.3 and 3.4 give the GN for the SB-800 and SB-600. All GNs are at ISO 100 for each of the different zoom settings.

Table 3.1 SB-900 Guide Numbers — DX format (at ISO 100, M and Ft.)

Flash Output Level	Zoom Head Position (mm)																			
	10			12	14	16	17	18	20	24	28	35	50	70	85	105	120	135	180	200
	WP+BA	BA	WP																	
1/1	13 / 42.7	16 / 52.5	17 / 55.8	23 / 75.5	25 / 82.0	27 / 88.6	29 / 95.1	30 / 98.4	31 / 101.7	34 / 111.5	36 / 18.1	40 / 131.2	46 / 150.9	49.5 / 162.4	51 / 167.3	52.5 / 172.2	24.8 / 81.4	25.7 / 84.3	56.5 / 185.4	57 / 187
1/2	9.1 / 29.9	11.3 / 37	12 / 39.3	16.2 / 53.1	17.6 / 57.7	19 / 62.3	20.5 / 67.3	21.2 / 69.6	21.9 / 71.9	24 / 78.7	25.4 / 83.3	28.2 / 92.5	32.5 / 106.6	35 / 114.8	36 / 118.1	37.1 / 121.7	17.5 / 57.4	18.1 / 59.4	39.9 / 130.9	40.3 / 132.2
1/4	6.5 / 21.3	8 / 26.2	8.5 / 27.9	11.5 / 37.7	12.5 / 41.0	13.5 / 44.3	14.5 / 47.6	15 / 49.2	15.5 / 50.9	17 / 55.8	18 / 59.0	20 / 65.6	23 / 75.5	24.7 / 81.0	25.5 / 83.7	26.2 / 86.0	12.4 / 40.7	12.8 / 42.0	28.2 / 92.5	28.5 / 93.5
1/8	4.5 / 14.8	5.6 / 18.8	6 / 19.7	8.1 / 26.6	8.8 / 28.9	9.5 / 31.2	10.2 / 33.5	10.6 / 34.8	10.9 / 35.8	12 / 39.3	12.7 / 41.7	14.1 / 46.3	16.2 / 53.1	17.5 / 57.4	18 / 59.0	18.5 / 60.7	8.7 / 28.5	9 / 29.5	19.9 / 65.3	20.1 / 65.9
1/16	3.2 / 10.5	4 / 13.1	4.2 / 13.8	5.7 / 18.7	6.2 / 20.3	6.7 / 21.9	7.2 / 23.6	7.5 / 24.6	7.7 / 25.3	8.5 / 27.9	9 / 29.5	10 / 32.8	11.5 / 37.7	12.6 / 40.4	12.7 / 41.7	13.1 / 43.0	6.2 / 20.3	6.4 / 21.0	14.1 / 46.3	14.2 / 46.6
1/32	2.2 / 7.2	2.8 / 9.2	3 / 9.8	4 / 13.1	4.4 / 14.4	4.7 / 15.4	5.1 / 16.7	5.3 / 17.4	5.4 / 17.7	6 / 19.7	6.3 / 20.7	7 / 23.0	8.1 / 26.6	8.7 / 28.5	9 / 29.5	9.2 / 30.2	4.3 / 14.1	4.5 / 14.8	9 / 32.5	10 / 32.8
1/64	1.6 / 5.2	2 / 6.6	2.1 / 6.9	2.8 / 9.2	3.1 / 10.2	3.3 / 10.8	3.6 / 11.8	3.7 / 12.1	3.8 / 12.5	4.2 / 13.8	4.5 / 14.8	5 / 16.4	5.7 / 18.7	6.1 / 20.0	6.3 / 20.7	6.5 / 21.3	3.1 / 10.2	3.2 / 10.5	7 / 23.0	7.1 / 23.3
1/128	1.1 / 3.6	1.4 / 4.6	1.5 / 4.9	2 / 6.6	2.2 / 7.2	2.3 / 7.5	2.5 / 8.2	2.6 / 8.5	2.7 / 8.9	3 / 9.8	3.1 / 10.2	3.5 / 11.5	4 / 13.1	4.3 / 14.1	4.5 / 14.8	4.6 / 15.1	2.1 / 6.9	2.2 / 7.2	4.9 / 16.1	5 / 16.4

Table 3.2 SB-900 Guide Numbers — FX format (at ISO 100, M and Ft.)

Flash Output Level	Zoom Head Position (mm)																	
	14mm			17	18	20	24	28	35	50	70	85	105	120	135	180	200	
	WP+BA	BA	WP															
1/1	13 / 42.7	16 / 52.5	17 / 55.8	22 / 72.2	23 / 75.5	24 / 78.7	27 / 88.6	30 / 98.4	34 / 111.5	40 / 131.2	44 / 144.1	47 / 154.2	49.5 / 162.4	51 / 167.3	51.5 / 169.0	54 / 117.2	56 / 183.7	
1/2	9.1 / 29.9	11.3 / 37	12 / 39.3	15.5 / 50.9	16.2 / 53.1	16.9 / 55.4	19 / 62.3	21.2 / 69.6	24 / 78.7	28.2 / 92.5	31.1 / 102.0	33.2 / 108.9	35 / 114.8	36 / 118.1	36.4 / 119.4	38.1 / 125.0	39.5 / 129.6	
1/4	6.5 / 21.3	8 / 26.2	8.5 / 27.9	11 / 36.1	11.5 / 37.7	12 / 39.3	13.5 / 44.3	15 / 49.2	17 / 55.8	20 / 65.6	22 / 72.2	23.5 / 77.1	24.7 / 81.0	25.5 / 83.7	25.7 / 84.3	27 / 88.6	28 / 91.9	
1/8	4.5 / 14.8	5.6 / 18.8	6 / 19.7	7.7 / 25.3	8.1 / 26.6	8.4 / 27.6	9.5 / 31.2	10.6 / 34.8	12 / 39.3	14.1 / 46.3	15.5 / 50.9	16.6 / 54.5	17.5 / 57.4	18 / 59.0	18.2 / 59.7	19 / 62.3	19.7 / 64.6	
1/16	3.2 / 10.5	4 / 13.1	4.2 / 13.8	5.5 / 18.0	5.7 / 18.7	6 / 19.7	6.7 / 21.9	7.5 / 24.6	8.5 / 27.9	10 / 32.8	11 / 36.1	11.7 / 38.4	12.6 / 40.4	12.7 / 41.7	12.8 / 42.0	13.5 / 44.3	14 / 45.9	
1/32	2.2 / 7.2	2.8 / 9.2	3 / 9.8	3.8 / 12.5	4 / 13.1	4.2 / 13.8	4.7 / 15.4	5.3 / 17.4	6 / 19.7	7 / 23.0	7.7 / 25.3	8.3 / 27.2	8.7 / 28.5	9 / 29.5	9.1 / 29.9	9.5 / 31.2	9.8 / 32.1	
1/64	1.6 / 5.2	2 / 6.6	2.1 / 6.9	2.7 / 8.9	2.8 / 9.2	3 / 9.8	3.3 / 10.8	3.7 / 12.1	4.2 / 13.8	5 / 16.4	5.5 / 18.0	5.8 / 19.0	6.1 / 20.0	6.3 / 20.7	6.4 / 21.0	6.7 / 21.9	7 / 23.0	
1/128	1.1 / 3.6	1.4 / 4.6	1.5 / 4.9	1.9 / 6.2	2 / 6.6	2.1 / 6.9	2.3 / 7.5	2.6 / 8.5	3 / 9.8	3.5 / 11.5	3.8 / 12.5	4.1 / 13.5	4.3 / 14.1	4.5 / 14.8	4.5 / 14.8	4.7 / 15.4	4.9 / 16.1	

Table 3.3 SB-800 Guide Numbers (at ISO 100, M and Ft.)

Flash Output Level	Zoom Head Position (mm)										
	1 (with Nikon diffusion dome and wide flash adapter)	2 (with Nikon diffusion dome)	14 (with wide flash adapter)	17 (with wide flash adapter)	24	28	35	50	70	85	105
1/1	12.5 / 41	16 / 52	17 / 56	19 / 62	30 / 96	32 / 105	38 / 125	44 / 144	50 / 165	53 / 174	56 / 184
1/2	8.8 / 29	11.3 / 37	12 / 39	13.4 / 44	21.2 / 70	22.6 / 74	26.9 / 88	31 / 102	35.4 / 116	37.5 / 126	40 / 131
1/4	6.3 / 21	8.0 / 26	8.5 / 28	9.5 / 31	15.0 / 49	16 / 52	19 / 62	22 / 72	25 / 82	26.5 / 87	28 / 92
1/8	4.4 / 14	5.7 / 19	6.0 / 20	6.7 / 22	10.6 / 35	11.3 / 37	13.4 / 44	15.6 / 51	17.7 / 58	18.7 / 61	19.8 / 65
1/16	3.1 / 10	4.0 / 13	4.3 / 14	4.8 / 16	7.5 / 25	8.0 / 26	9.5 / 31	11 / 36	12.5 / 41	13.3 / 44	14 / 46
1/32	2.2 / 7	2.8 / 9	3.0 / 10	3.4 / 11	5.3 / 17	6.0 / 20	6.7 / 22	7.8 / 26	8.8 / 29	9.4 / 31	9.9 / 32
1/64	1.6 / 5	2.0 / 7	2.1 / 7	2.4 / 8	3.7 / 12	4.0 / 13	4.8 / 16	5.5 / 18	6.3 / 21	6.6 / 22	7.0 / 23
1/128	1.1 / 4	1.4 / 5	1.5 / 5	1.7 / 6	2.6 / 8.5	2.8 / 9	3.4 / 11	3.9 / 13	4.4 / 14	4.7 / 15	4.9 / 16

Table 3.4 SB-600 Guide Numbers (at ISO 100, M and Ft.)

Flash Output Level	Zoom Head Position (mm)						
	14 (with wide flash adapter)	24	28	35	50	70	85
1/1	14.0 45.9	26.0 85.3	28.0 91.9	30.0 98.4	36.0 118.1	38.0 124.7	40.0 131.2
1/2	9.9 32.5	18.4 60.4	19.8 65.0	21.2 69.6	25.5 83.7	26.9 88.3	28.3 92.8
1/4	7.0 23.0	13.0 24.7	14.0 45.9	15.0 49.2	18.0 59.1	19.0 62.3	20.0 65.6
1/8	4.9 16.1	9.2 30.2	9.9 32.5	10.6 34.8	12.7 14.7	13.4 44.0	14.1 46.3
1/16	3.5 11.5	6.5 21.3	7.0 23.0	7.5 24.6	9.0 29.5	9.5 31.2	10.0 32.8
1/35	2.5 8.2	4.6 15.1	4.9 16.1	5.3 17.4	6.4 21.0	6.7 22.0	7.1 23.3
1/64	1.8 5.9	3.3 10.8	3.5 11.5	3.8 12.5	4.5 14.8	4.8 15.7	5.0 16.4

To figure out the GN at ISO settings other than ISO 100, multiply the GN by an ISO sensitivity factor. Doubling the ISO setting halves the exposure time the same way that opening the aperture 1 stop does, so for this reason the ISO sensitivity factor is figured by multiplying some numbers that may be familiar to you and makes the process a bit easier to remember.

To figure out the adjusted GN, multiply the GN at ISO 100 by:

▶ **1.4 for ISO 200**

▶ **2 for ISO 400**

▶ **2.8 for ISO 800**

▶ **4 for ISO 1600**

▶ **5.6 for ISO 3200**

▶ **8 for ISO 6400**

Why do these numbers look so familiar? They are the same as the 1-stop intervals for aperture settings.

 If you plan to do a lot of manual flash exposures, I suggest making a copy of these GN tables and keeping it in your camera bag with the flash.

 If you have access to a flash meter, you can determine the actual GN of your Speedlight at any setting by placing the meter 10 feet away and firing the flash. Next, take the aperture reading from the flash meter and multiply by ten. This is the correct GN for your flash.

Aperture

The second component in the flash exposure equation is the aperture setting. As you already know, the wider the aperture, the more light that falls on the sensor. Using a wider aperture can allow you to use a lower power setting (such as 1/4 when in Manual mode) on your flash, or if you're using the automatic i-TTL mode, the camera fires the flash using less power. Using a wider aperture can also help you conserve battery power because the flash fires at a reduced level unless the ambient light is extremely low or the subject is very far away.

Distance

The third component in the flash exposure equation is the distance from the light source to the subject. The closer the light is to your subject, the more light falls on it. Conversely, the farther away the light source is, the less illumination your subject receives. This is important because if you set your Speedlight to a certain output, you can still achieve a proper exposure by moving the Speedlight closer or farther away as needed.

One thing to consider when taking distance into account is the *inverse square law*. This law of physics states that for a point source of light (in this case a Speedlight) the intensity of the light is inversely proportional to the square of the distance between the subject and the light source. While this may sound a bit confusing at first, simplified, this means that doubling the distance between the subject and the light source results in 1/4 the amount of illumination.

What this means to you is that if your Speedlight is set up 4 feet from your subject and you move it so that it's 8 feet away you need 4 times the amount of light to get the same exposure. Quadrupling the light is most easily accomplished by opening the aperture 2 stops or by increasing the flash illumination manually.

GN / D = A

Here's where the GN, aperture, and distance all come together. The basic formula allows you to take the GN and divide it by the distance to determine the aperture at which you need to shoot. You can change this equation to find out what you want to know specifically

▶ **GN / D = A.** If you know the GN of the flash and the distance of the flash from the subject, you can determine the aperture to use to achieve the proper exposure.

▶ **GN / A = D.** If you know the aperture you want to use and the GN of the flash, you can determine the distance to place your flash from the subject.

▶ **A × D = GN.** If you already have the right exposure, you can take your aperture setting and multiply it by the distance of the flash from the subject to determine the approximate GN of the flash.

An example of using this might be a scenario like this: You are photographing a senior portrait in your home studio. You already know you want to use a wide aperture of f/2.8 to soften the background. You determine what the GN of the Speedlight is at the settings you are using (zoom setting, output level, and ISO) from the tables 3.1 through 3.4 (depending on the Speedlight you're using) or the GN chart in the manual. You use a 50mm zoom setting (for your 50mm lens), and you decide that you want the flash to fire at 1/32 power. Checking your chart you get a GN of about 36. To determine how far you need to place your subject from the Speedlight, you plug the numbers into the equation. So you get GN (36) / A (2.8) = D (12.8 ft). You need to place the Speedlight about 13 feet from your model.

Although there is some math and physics involved here it is quite simple, and it's a very practical skill to have. In the future, you may step up to studio lighting and these same equations apply. This equation is also essential for setting up the Speedlight when using the Repeating flash mode, which is covered later in this chapter.

Flash sync modes

Flash sync modes control how the flash operates in conjunction with your camera. These modes work with both the built-in Speedlight and accessory Speedlights, such

as the SB-900, SB-800, SB-600, and so on. These modes allow you to choose when the flash fires, either at the beginning of the exposure or at the end, and they also allow you to keep the shutter open for longer periods, enabling you to capture more ambient light in low-light situations.

Sync speed

Before getting into the different sync modes, you need to understand *sync speed*. The sync speed is the fastest shutter speed that can be used while achieving a full flash exposure. This means if you set your shutter speed at a speed faster than the rated sync speed of the camera, you don't get a full exposure and end up with a partially underexposed image. With most Nikon cameras, you can't actually set the shutter speed above the rated sync speed (unless you're using Auto FP High-Speed Sync; more on that later) when using a dedicated flash because the camera won't let you; so no need to worry about having partially black images when using a Speedlight. But if down the line you're using a studio strobe or a third-party flash, this is a concern you should consider.

Limited sync speeds exist because of the way shutters in modern cameras work. As you already know, the shutter controls the amount of time the light is allowed to reach the imaging sensor. All dSLR cameras have what is called a *focal plane shutter*. This term stems from the fact that the shutter is located directly in front of the focal plane, which is essentially on the sensor. The focal plane shutter has two shutter curtains that travel vertically in front of the sensor to control the time the light can enter through the lens. At slower shutter speeds, the front curtain covering the sensor moves away, exposing the sensor to light for a set amount of time. When the exposure has been made, the second curtain then moves in to block the light, thus ending the exposure.

To achieve a faster shutter speed, the second curtain of the shutter starts closing before the first curtain has exposed the sensor completely. This means the sensor is actually exposed by a slit that travels the length of the sensor. This allows your camera to have extremely fast shutter speeds, but limits the flash sync speed because the entire sensor must be exposed to the flash at once to achieve a full exposure.

The sync speed for most recent Nikon cameras is usually 1/200 or 1/250 second. Some Nikon dSLRS such as the D70/D70s, D50, and D40 have a faster sync speed of 1/500 second. This is due to the fact that these cameras use a combination electronic/mechanical shutter (also known as a hybrid shutter) as opposed to the strictly mechanical shutters used in the other models. When using a combination shutter at speeds above 1/200 second, the camera controls the shutter speed electronically by *gating* the signal at the sensor instead of using the shutter curtain to block the light. Gating

the signal is essentially turning the sensor on for a specified amount of time. Basically, this is how this works:

1. **The mechanical shutter opens.** The mechanical shutter is limited to about 1/200 second. This allows the whole sensor to be exposed for a period of time.

2. **The electronic gate is opened.** Once the shutter is fully opened the camera activates the sensor so that it is light sensitive.

3. **The electronic gate is closed.** Once the sensor has been activated for the pre-determined amount of time (typically 1/200 to 1/4000 second) the sensor is deactivated.

4. **The mechanical shutter closes.**

Using these combination or hybrid shutters allows Nikon to reduce the wear and tear that faster shutter speeds can put on the shutter mechanism giving it a longer working life. When explaining the reasons behind the difference in sync speeds between the different camera models, I'm always asked this question: Why do the cheaper models have a higher sync speed, which is obviously better? The short answer is that electronic shutters have inherent problems that make them less desirable than using a mechanical shutter. In fact when Nikon first started making dSLR cameras the combination electronic/mechanical shutters were initially used. The top-of-the-line D1, D1X, and D1H cameras all use these types of shutters.

Some of the problems that occur with electronic shutters include:

▶ **Blooming.** This occurs when photographing an extremely bright point of light, such as in a sunset photo. The pixels around the bright spot are contaminated by extraneous light and cause a halo or streaking effect around the bright areas in the image.

▶ **Image quality and resolution.** The electronics that are used to gate the sensor must be built on to the chip. This leaves less room for pixels and circuitry that can be employed for noise reduction and higher sensitivity.

▶ **Exposure inconsistency.** The circuitry on the sensors is temperature and humidity sensitive. Sometimes this can affect the gating, causing exposures to fluctuate.

So the reason that hybrid shutters aren't commonly used in the newer cameras is that the downsides outweigh the benefit of having a moderately faster sync speed. That being said, most current Nikon camera bodies offer a feature that allows you to sync up to the top shutter speed of your camera. This is called Auto FP High Speed Sync and is covered in the following sidebar.

Auto FP High Speed Sync

As discussed earlier in this chapter, dSLR cameras use a focal plane shutter and the physical limitations of the shutter mechanism only allow you to use a maximum shutter speed of about 1/200 to 1/250 second.

Sometimes though, situations may call for a faster shutter speed. It's commonly used when shooting in brightly lit scenes using fill flash. An example would be shooting a portrait outdoors at high noon; of course, the light is very contrasty and you want to use fill flash, but you also require a wide aperture to blur out the background. At the sync speed 1/250 second, ISO200, your aperture needs to be at f/16. If you open your aperture to f/4, you will then need a shutter speed of 1/4000. This shutter speed/aperture combo is possible using Auto FP.

So how does this feature work? Instead of firing a single pop, the flash fires multiple times at lower powers as the shutter curtain travels across the focal plane of the sensor (hence the Auto FP). The only drawback is that your flash power, or GN, is diminished, so you may need to take this into consideration when doing Manual flash calculations.

Although this is a great feature it does have its price. First of all, as mentioned earlier the flash power is diminished so the working distance of your flash is greatly reduced. For example when shooting in bright sunlight your flash will probably only work up to a distance of about 12 feet when using a shutter speed of 1/8000 at ISO 200 at f/1.4.

Other problems are battery consumption and temperature. Obviously, popping off multiple flashes uses up more energy from your battery not to mention that flash bursts generate intense heat and could potentially cause the flash head to melt (although this is very unlikely). For these reasons, most of the built-in flashes on cameras that offer Auto FP High Speed Sync are limited to 1/320 second at most.

 All Nikon CLS compatible cameras offer Auto FP High Speed Sync with the exception of the D3000, D5000, D40/D40x, D50, D60, and D70/D70s.

Front-curtain sync

Front-curtain sync is the default sync mode for your camera whether you are using the built-in flash or one of Nikon's dedicated Speedlights. With Front-curtain sync, the flash is fired as soon as the shutter's front curtain fully opens. This mode works well with most general flash applications.

One thing worth mentioning about front-curtain sync is that although it works well when you're using relatively fast shutter speeds, when the shutter is slowed down (also known as *dragging the shutter* when doing flash photography), especially when photographing moving subjects, your images have an unnatural-looking blur in front of them. Ambient light recording the moving subject creates this.

When doing flash photography at slow speeds, your camera is actually recording two exposures, the flash exposure and the ambient light. When you use a fast shutter speed, the ambient light usually isn't bright enough to have an effect on the image. When you slow down the shutter speed substantially, it allows the ambient light to be recorded to the sensor, causing what is known as *ghosting.* Ghosting is a partial exposure that is usually fairly transparent looking on the image.

Ghosting causes a trail to appear in front of the subject because the flash freezes the initial movement of the subject. Because the subject is still moving, the ambient light records it as a blur that appears in front of the subject, creating the illusion that it's moving backward. To counteract this problem, you can use the rear-curtain sync setting, which I explain later in this section.

3.8 A shot using Front-curtain sync with a shutter speed of 1 second. Notice that the flash freezes the hand during the beginning of the exposure and the trail caused by the ambient exposure appears in the front, causing the hand to look like its moving backward.

Red-eye reduction

This is a common problem that most of us have encountered in a picture at one time or another — that unholy red glare emanating from the subject's eyes that is caused by light reflecting off the retina (this also happens with animals and can be varying colors from red, green, blue, or even yellow). Fortunately, all Nikon dSLRs offer a Red-Eye Reduction flash mode. When this mode is activated, the camera fires some pre-flashes (when using an accessory Speedlight) or turns on the AF-Assist Illuminator (when using the built-in flash), which causes the pupils of the subject's eyes to contract. This stops the light from the flash from reflecting off of the retina and reduces or eliminates the red-eye effect. This mode is useful when taking portraits or snapshots of people or pets when there is little light available.

Slow sync

Slow sync essentially tells your camera to do a shutter drag and is only available in Programmed Auto or Aperture Priority mode. When set to the default the camera sets the shutter speed to the default sync speed of your camera. Sometimes when using a flash at sync speed when the background is very dark, the subject is lit but appears to be in a black hole. Slow Sync mode helps take care of this problem. In Slow Sync mode, the camera allows you to set a longer shutter speed (up to 30 seconds) to capture the ambient light of the background. Your subject and the background are lit, so you can achieve a more natural-looking photograph.

When the camera is set to Shutter Priority or Manual exposure mode you can do a shutter drag without setting the flash mode to Slow Sync simply by selecting a slow shutter speed.

When using Slow Sync, be sure the subject stays still for the whole exposure to avoid *ghosting*. Ghosting is a blurring of the image caused by motion during long exposures. Of course, you can use ghosting creatively.

Slow Sync can be used in conjunction with Red-Eye Reduction for night portraits.

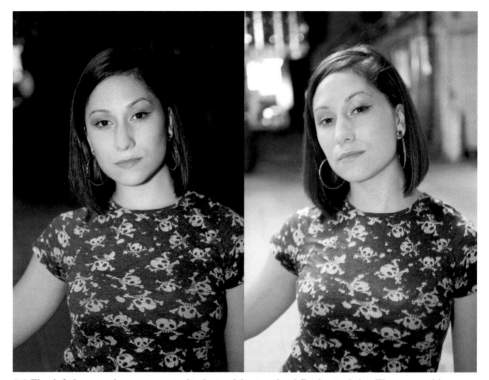

3.9 The left image shows a portrait shot with standard flash at night. The second image was shot with Slow Sync. Notice the background and the subject are more evenly exposed when using Slow Sync.

Rear-curtain sync

As discussed earlier, by default the flash fires as soon as the front shutter curtain opens. When using Rear-curtain sync, the camera fires the flash just before the *rear* curtain of the shutter starts moving. This mode is useful when taking flash photographs of moving subjects. Rear-curtain sync allows you to more accurately portray the motion of the subject by causing a motion blur trail behind the subject rather than in front of it, as is the case with Front-curtain sync. Rear-curtain sync is most often used in conjunction with Slow Sync.

When Rear-curtain sync is selected while using Aperture Priority or Programmed **NOTE** Auto mode, Slow Sync mode is automatically activated.

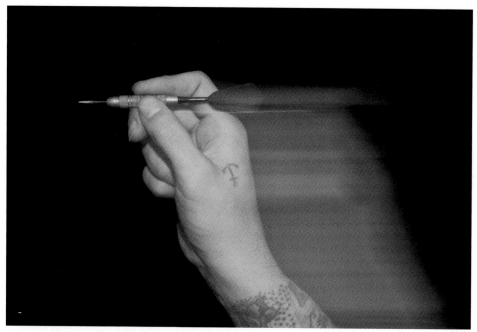

3.10 A picture taken using Rear-curtain sync flash

Flash Exposure Compensation (FEC)

When you photograph subjects using flash, whether you use an external Speedlight or your camera's built-in flash, there may be times when the flash causes your principal subject to appear too light or too dark. This usually occurs in difficult lighting situations, especially when you use TTL metering. Your camera's meter can get fooled into thinking the subject needs more or less light than it actually does. This can happen when the background is very bright or very dark, or when the subject is off in the distance or very small in the frame.

Flash Exposure Compensation (FEC) allows you to manually adjust the flash output while still retaining TTL readings so your flash exposure is at least in the ballpark. With most cameras, you can vary the output of an attached Speedlight or your built-in flash's TTL setting from −3 Exposure Value (EV) to +1 EV. This means if your flash exposure is too bright, you can adjust it down 3 full stops under the original setting.

Or, if the image seems underexposed or too dark, you can adjust it to be brighter by 1 full stop. This can be adjusted on most cameras by pressing the Flash mode button and rotating the Sub-command dial. Please note that not all cameras operate this way. Check your camera's owner's manual for adjusting FEC on specific camera models.

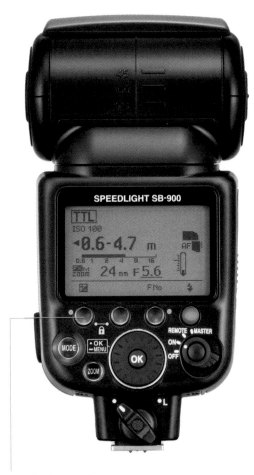

Function button 1

3.11 Function button 1 on the SB-900

Additionally, FEC can be applied directly via the Speedlight itself. On the SB-800 and SB-600, FEC can be applied simply by pressing the buttons marked plus (+) or minus (–). On the SB-900, FEC can be applied by pressing Function button 1 and rotating the selector dial.

 FEC can only be applied when the flash is set to i-TTL, i-TTL BL, Auto Aperture, and Non TTL Auto flash. When the flash is set to Manual, Distance (GN) Priority, or Repeating flash, FEC is not applied, rather you are setting the flash output manually.

Understanding Color Temperature

Light, whether it is sunlight, from a light bulb, fluorescent, or from a flash, all has its own specific color. This color is measured using the Kelvin scale. This measurement is also known as *color temperature*. The white balance allows you to adjust the camera so that your images look natural no matter what the light source. Because white is the color that is most dramatically affected by the color temperature of the light source, this is what you base your settings on, hence the term *white balance*. The white balance can be changed in the camera's Shooting menu or by pressing the WB button on the camera and rotating one of the Command dials. See your camera's user manual for more information if you're not sure how to change your camera's WB setting.

The term *color temperature* may sound strange to you. "How can a color have a temperature?" you ask. Once you know about the Kelvin scale, things make a little more sense.

What is Kelvin?

Kelvin is a temperature scale, normally used in the fields of physics and astronomy, where absolute zero (0K) denotes the absence of all heat energy. The concept is based on a mythical object called a *black body radiator*. Theoretically, as this black body radiator is heated, it starts to glow. As it is heated to a certain temperature, it glows a specific color. It is akin to heating a bar of iron with a torch. As the iron gets hotter it turns red then yellow then eventually white before it reaches its melting point (although the theoretical black body does not have a melting point).

The concept of Kelvin and color temperature is tricky as it is the opposite of what you likely think of as "warm" and "cool" colors. For example, on the Kelvin scale, red is the lowest temperature increasing through orange, yellow, white, and to shades of blue, which are the highest temperatures. Humans tend to perceive reds, oranges, and yellows as warmer and white and bluish colors to be cold. However, physically speaking, the opposite is true as defined by the Kelvin scale.

White balance settings

Now that you know a little about the Kelvin scale, you can begin to explore the white balance settings. The reason that white balance is so important is to ensure that your images have a natural look. When dealing with different lighting sources, the color temperature of the source can have a drastic effect on the coloring of the subject. For example, a standard light bulb casts a very yellow light; if the color temperature of the light bulb is not compensated for by introducing a bluish cast, the subject can look overly yellow and not quite right.

In order to adjust for the colorcast of the light source, the camera introduces a color-cast of the complete opposite color temperature. For example, to combat the green color of a fluorescent lamp the camera introduces a slight magenta cast to neutralize the green.

 By keeping your WB setting at Automatic when using your Speedlight, you can reduce the amount of images taken with incorrect color temperatures. Although the flash WB setting is 5500K, the actual color temperature of the light emitted from the flash varies with the flash duration. The flash communicates this information to the camera allowing the camera to automatically adjust the color temperature setting for a more accurate WB.

Mixed lighting

When using a Speedlight, you often introduce a second light source into the scene (unless you're using the Speedlight as your only light source). The first light source is your ambient light, which can be almost any type of light. As you know, all light sources have different color temperatures and when introducing a second light source such as a Speedlight you have two lights with different color temperatures that can cause your images to have different white balances in the same image. This is known as mixed lighting.

When using TTL BL the effects of mixed lighting are usually more pronounced because the camera is attempting to balance light from the Speedlight with the ambient light. When shooting in mixed lighting, one option is to shoot with a custom WB setting that is approximately in between the color temperature settings of the two light sources. The best and easiest way to deal with mixed lighting is to place a filter over the flash head. This changes the color temperature of the flash to match the ambient light. The SB-800 and SB-900 Speedlights come with color-balancing filters that allow you to compensate for both tungsten and fluorescent lighting (the two most common light sources). You can purchase the SJ-1 Color Filter Set for the SB-600.

 The SJ-1 Color Filter Set also works with the SB-800 and includes filters for tungsten and fluorescent lighting as well as color filters for special effects. The SB-900 requires a special filter set, the SJ-3, and the SB-R200 Speedlight requires the SJ-2 filter set.

 For more information on using color filters, see Chapter 5.

3.12 This image was shot in mixed light with no filter. Notice that the colors shift from cool to warm across the frame. The left side was lit with flash and the right was lit with a standard incandescent light bulb.

Using Repeating Flash

Repeating flash (RPT) is an interesting option that allows you to use stroboscopic flashes from your Speedlight to record multiple images during a single exposure. This is an easy way to record a sequence shot in one frame.

To use this feature effectively, a number of calculations and some planning are required. Remember the GN / D = A equation? You're going to need it to use the Repeating flash feature properly.

 The SB-800 and SB-900 are the only Speedlights that offer the Repeating flash option. RPT is also available for use with the built-in flash on certain camera models such as the D300, D700, and D90. See your camera's owner's manual for specific details.

 The SB-900 or SB-800 can be used as a Master with RPT mode. This allows the SB-600 to perform repeating flashes.

First, you need to go over a couple of terms that are related to RPT flash mode.

▶ **Times.** This is the number of times you want the Speedlight to flash during a single exposure.

▶ **Frequency.** This is how many times the Speedlight flashes per second. This is represented in hertz (Hz). For example 10 Hz is 10 times per second.

▶ **Flash output level.** This is the same as setting your flash output when using the Speedlight in Manual mode.

The reason these terms are important is because you need to understand how to use them to determine the proper shutter speed and aperture to use.

First, you need to determine what flash output level you want to use. This is where the GN / D = A equation comes into play. As discussed in the beginning of the chapter, the flash output level is the determining factor of how far the subject should be from the Speedlight, or if you prefer you can determine the output level based on the subject distance.

 The flash output level is also a factor in determining the maximum number of repeating flashes per frame. The Speedlight will not allow you to enter a number higher than the maximum amount.

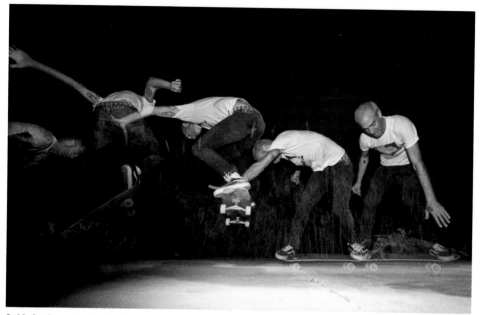

3.13 An image shot using repeating flash

I find the easiest way to start is to decide what aperture you want to use and how far you want the subject to be. From there determine the GN (A × D = GN). Next, refer to tables 3.1, 3.2, and 3.3 to determine the proper output level from the GN.

The next step is setting the number of flashes. The number of flashes is based on personal preference and differs depending on what you are trying to do. Keep in mind the maximum number of flashes per frame is dependent on the flash output level and the frequency (Hz) setting. Table 3.5 shows the maximum number of flashes allowed per setting.

After deciding the number of times you want the flash to fire, you need to set the frequency of flashes. The frequency determines the rate or speed at which the flashes are fired. A higher frequency causes the Speedlight to fire the flashes at faster intervals; conversely, a lower frequency fires the flashes at slower intervals. For shorter shutter speeds a higher frequency is usually recommended.

The last step in the process is determining the correct shutter speed to use for the number and frequency you have set. This requires another equation: shutter speed = number of flashes / frequency (Hz). For example, for 16 flashes at a rate of 30 Hz, your shutter speed needs to be at least 1/2 second (16 / 30 = 0.533). For 20 flashes at 5 Hz, your shutter speed needs to be at least 4 seconds (20 / 5 = 4).

Table 3.5 Maximum Number of Flashes

Frequency (Hertz)	Flash Output Level												
	M1/8	M1/8-1/3EV	M1/8-2/3EV	M1/16	M1/16-1/3EV	M1/16-2/3EV	M1/32	M1/32-1/3EV	M1/32-2/3EV	M1/64	M1/64-1/3EV	M1/64-2/3EV	M1/128
1	14	16	22	30	36	46	60	68	78	90	90	90	90
2													
3	12	14	18	30	36	46	60	68	78	90	90	90	90
4	10	12	14	20	24	30	50	56	64	80	80	80	80
5	8	10	12	20	24	30	40	44	52	70	70	70	70
6	6	7	10	20	24	30	32	36	40	56	56	56	56
7	6	7	10	20	24	26	28	32	36	44	44	44	44
8	5	6	8	10	12	14	24	26	30	36	36	36	36
9	5	6	8	10	12	14	22	24	28	32	32	32	32
10	4	5	6	8	9	10	20	22	26	28	28	28	28
20	4	5	6	8	9	10	12	14	18	24	24	24	24
30													
40													
50													
60													
70													
80													
90													
100													

 You can always use the Bulb setting and close the shutter when the flash is done firing.

If the shutter speed is set too fast for the RPT settings, the Speedlight will only fire while the shutter is open. This means that if the required shutter speed is 4 seconds and the shutter speed is set for 2 seconds, the Speedlight will stop firing after 2 seconds regardless of whether it has fired the specified number of flashes.

To set the Repeating flash on the SB-800, follow these steps:

1. **Press the Mode button until RPT appears in the top-left corner of the LCD.**

2. **Press the SEL button.** This highlights the flash output level setting. Using the +/- buttons, set the desired flash output level. When the level is set, press the SEL button again. This readies the frequency to be set.

3. **Use the +/- buttons to set the flash frequency.** When you've set the desired frequency press the SEL button. This highlights the number of flashes.

4. **Use the +/- buttons to set the number of flashes.** When you finish, press SEL. This highlights the aperture setting.

5. **Press the SEL button to exit.** This applies your settings.

 If the flash isn't attached to a camera you must set the aperture setting on the flash before applying your settings. When attached to the camera, the flash automatically detects the aperture setting.

To set the Repeating flash on the SB-900, follow these steps:

1. **Press the Mode button until RPT appears in the top-left corner of the LCD.**

2. **Press the Function button 1 to select the flash output level.** Rotate the selector dial to change the output level. The SB-900 allows you to adjust the output in 1/3 EV steps for example 1/32, 1/32+.3EV, 1/32+.7EV, etc.... unlike the SB-800 that only allows 1 EV changes.

3. **Press the Function button 2 to select the number of flashes.** Use the selector dial to change the settings.

4. **Press the Function button 3 to select the frequency.** Repeatedly press the Function button 3 or use the selector dial to change the settings.

5. **Press OK to save the settings.**

 The Repeating flash feature is also available with the built-in flash on certain camera models. You can usually find this setting in your camera's Custom Settings menu submenu e - Bracketing / flash labeled Flash cntrl for built-in flash. If you're unsure whether your camera's built-in flash offers this feature, check the owner's manual.

Using Bounce Flash

Bounce flash is a simple technique that photographers use to improve the lighting on their subject. This invaluable technique requires no accessories or adapters. All you need is a Speedlight with a tilting flash head, which is standard on all current Speedlights.

Basically bounce flash is exactly what it sounds like — you're bouncing the light from the flash off of something (usually a ceiling or wall) onto the subject. Why would you want to do this? The answer is quite simple: it improves your flash photos 100 percent. On-camera flash gives a harsh and flat lighting that I like to compare to the "deer in headlights" look. The full-frontal lighting from an on-camera flash can be very unnatural looking to the human eye because we are used to lighting that comes from above or at an angle (like the sun). Another downside to using an on-camera Speedlight straight on is the harsh shadows that you get behind your subject when near a wall.

Bouncing the flash redirects the light making it look much more natural, and it also diffuses the light, which gives a softer lighting effect that is more pleasing to the eye and gives softer shadows with less contrast. Another benefit of bounce flash is that it prevents red-eye without the need to use the red-eye reduction feature.

More often than not, bounce flash is achieved with the Speedlight mounted on-camera. The flash head is tilted up and the flash is bounced from the ceiling onto the subject. Another effective bouncing technique is to position your subject near a wall and by rotating the flash head to the side the flash can be bounced off of the wall with a very pleasing effect that is similar to sidelight with an off-camera flash. This technique can be employed if the ceiling is too high to be used to effectively bounce flash.

 The SB-400 flash head only tilts upward for ceiling bounce flash. To bounce the flash off of a wall, the camera will need to be held in the portrait orientation.

Bounce flash is not limited to on-camera flash applications, either. You can utilize the Advanced Wireless Lighting features of Nikon CLS and still use the bounce flash technique with excellent results. Most often this would be applied in a studio-type setup. The Speedlight is usually placed on a stand facing away from the subject and fired at a reflector that bounces the light back onto the subject. As with bouncing from a ceiling or wall, this scatters the light making it much more diffuse. Using a reflector to bounce the light is also much more efficient than bouncing from the ceiling or wall because less light is lost due to reflectance. This technique works particularly well for using the Speedlight as a fill light.

Although bounce flash is a simple and straightforward technique, there are a few things you should be aware of and some pitfalls to avoid.

▶ **Loss of light.** When bouncing flash you typically lose 2 to 3 stops of light depending on the subject distance, bounce distance, and the color and reflectivity of the surface being bounced from. Using i-TTL metering compensates for the loss, but when using the flash manually you will want to keep this in mind and dial up the output as needed.

NOTE When manually calculating the flash-to-subject distance for manual bounce flash exposures using the GN / D = A equation, calculate the distance by estimating the distance from the Speedlight to the surface you are bouncing from and from the surface to the subject.

▶ **Angle of incidence.** One of the most basic laws of physics is that the angle of incidence is equal to the angle of reflection. Take a look at your subject and the distance between you and the subject and the ceiling before shooting. Adjust the flash head angle so that the light is bounced onto the subject and not behind or in front of it. This is a pretty easy concept to visualize.

▶ **Colored surfaces.** Light bounced from colored surfaces transmits the color to the subject. Stick with bouncing from neutral surfaces for best results or adjust your WB accordingly.

▶ **Ceiling height.** Bounce flash is best with ceiling height of 8 to 10 feet. The higher the ceiling the less effective the flash is. Ceilings that are higher than 12 feet may not bounce enough light back onto your subject to illuminate it properly.

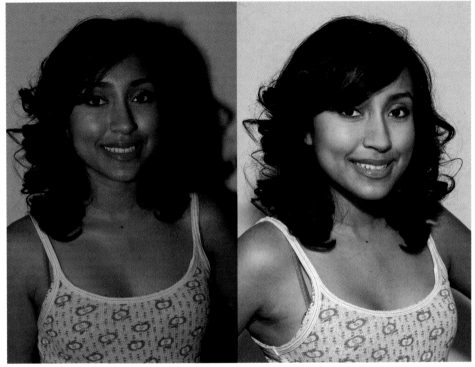

3.14 The picture on the left shows an image shot with straight flash; the picture on the right shows an image shot using flash bounced from the ceiling.

Fill Flash

Fill flash is a handy flash technique that allows you to use your Speedlight as a secondary light source to fill in the shadows rather than as the main light source, hence the term *fill* flash. Fill flash is used mainly in outdoor photography when the sun is very bright creating deep shadows and bright highlights that result in an image with very high contrast and a wide tonal range. Using fill flash allows you to reduce the contrast of the image by filling in the dark shadows, thus allowing you to see more detail in the image.

You also may want to use fill flash when your subject is backlit (lit from behind). When the subject is backlit, the camera's meter reads the bright part of the image, which is behind your subject and tries to keep the bright areas from being overexposed. This results in a properly exposed background while your subject is underexposed and dark. On the other hand, using the spot meter to obtain the proper exposure on your

subject overexposes and blows out the background. The ideal thing is to use fill flash to provide an amount of light on your subject that is equal to the ambient light of the background. This brings sufficient detail to both the subject and the background resulting in a properly and evenly exposed image.

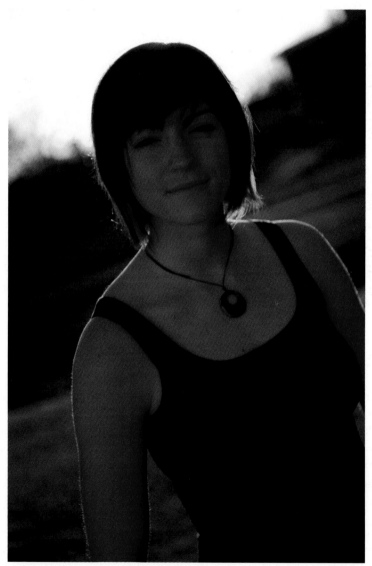

3.15 A picture taken without fill flash

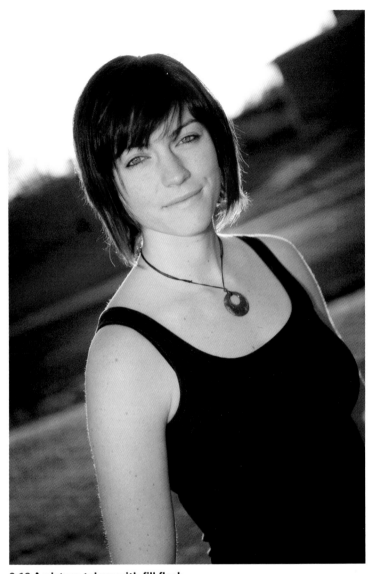

3.16 A picture taken with fill flash

All of Nikon's dSLR cameras offer i-TTL BL (Nikon calls this Balanced Fill Flash or, in laymen's terms, automatic fill flash) with both the built-in flash and all CLS-compatible Speedlights. When using a Speedlight, the camera automatically sets the flash to do fill flash (as long as you're not in Spot metering mode). This is a very handy feature because it allows you to concentrate on composition and not have to worry about your flash settings. If you decide that you don't want to use the i-TTL BL option you can set

the camera to Spot metering mode, or if you are using an SB-900, SB-800, or SB-600 simply press the Speedlight's Mode button to set it to TTL.

Of course, if you'd rather control your flash manually, you can still do fill flash. It's actually a simple process that can vastly improve your images when used in the right situations.

To execute a manual fill flash, follow these steps:

1. **Use the camera's light meter to determine the proper exposure for the background or ambient light.** A typical exposure for a sunny day is 1/250 second at f/16 with an ISO of 200. Be sure not to set the shutter speed higher than the rated sync speed of your camera.

2. **Determine the flash exposure.** Using the GN / D = A formula, find the flash output level setting that you need to properly expose the subject with the flash.

3. **Reduce the flash output.** Setting the flash output level down 1/3 to 2/3 stops allows the flash exposure to be less noticeable while filling in the shadows or lighting your backlit subject. This makes your images look more natural as if a flash didn't light them, which is the ultimate goal when attempting fill flash.

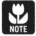

Use your LCD to preview the image and adjust the flash output level as needed.

Simple Light Modifiers

One of the easiest and most economical ways to get better lighting from an on-camera Speedlight is to use a diffuser or a bounce device. These are simple modifiers that diffuse the light coming from the Speedlight. I swear by these devices, and I don't recommend shooting without one.

Diffusion Domes

The SB-900 and SB-800 both come with a simple diffusion dome (the SW-13H and SW-10H, respectively) that slides right over top of the flash head. These diffusers are best utilized in conjunction with bounce flash. One difference is when using the diffusion dome you can simply tilt the flash head to the 60-degree setting and shoot without worrying about adjusting the bounce angle. The reason for this is because the diffusion dome spreads the light in a wider pattern allowing more light to be projected forward even though the flash head is tilted upward.

 With the SW-10H diffusion dome in place, the SB-800 flash zoom head is automatically set to 14mm. With the SW-13H diffusion dome in place, the SB-900 zoom head is automatically set to 14mm FX or 10mm DX.

If you have an SB-600 you can find a diffusion dome for that as well. The Sto-Fen Omni-Bounce is similar to the diffusion domes provided by Nikon for the SB-900 and SB-800. Sto-Fen also makes a diffuser that fits the SB-800 as well as one for the SB-900. These things cost less than $20 and are worth every penny. Sto-Fen also offers the Omni-Bounce in colors for shooting in mixed lighting. Sto-Fen also offers an Omni-Bounce for the SB-400 that is designed a little different that the ones for the other Speedlights but operates using similar principles.

Bounce Diffusers

These simple diffusers create a bounce-flash effect without the need of a ceiling. LumiQuest has been making these devices since before most people knew about bounce flash. They are easy to use and compact. These devices attach to the flash head with Velcro. The flash head is pointed up and the bounce diffuser redirects the light back onto the subject in the front.

My favorite is the simple Pocket Bouncer. It folds up flat so it fits right in your pocket and it doesn't take up much space in your camera bag (unlike some of the other flash diffusers).

This is a quick and simple device that you can use to bounce flash in situations where you have nothing to bounce from.

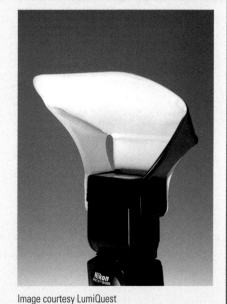

Image courtesy LumiQuest

SB.1 The LumiQuest Pocket Bouncer

These types of diffusion domes are simple, compact, and easy to use. There are many manufacturers of diffusion domes, some are small and compact and some a bigger in size. The Gary Fong Lightsphere II is a popular diffusion dome, but it's very large and bulky. It fits over top of the flash head, which is positioned straight up at a 180-degree angle. The weight of the diffuser causes the flash head to constantly reposition itself to the 90-degree flash head position (which I can't imagine is good for the locking mechanism). The Lightsphere works well when the camera is in the horizontal position, but tends to cast a strange shadow when shooting portraits indoors with the camera in the vertical position. For these reasons I hesitate recommending the Lightsphere for most use. There are many other more compact designs that work just as well.

Bounce cards

A bounce card is a very simple device that redirects some of the light from the flash forward when the flash head is tilted up. A bounce card is used to give a little fill to your subject when doing a bounce flash. Although bounce flash is much better than direct flash, it sometimes can leave your subject's eyes in shadows (due to the shadow cast by the brow ridge) and often causes the subject's eyes to lack a *catch-light,* which is highlight that appears in the eye. Catchlights are very important in portraiture as they give your subjects's eyes a sparkle that makes them look vibrant and alive. Eyes without catchlights are often referred to as "dead eyes."

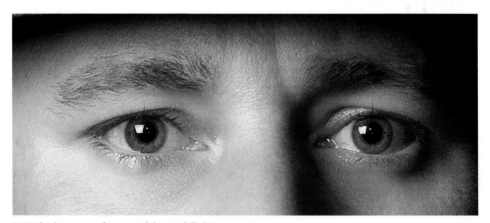

3.17 A close-up of eyes with catchlights

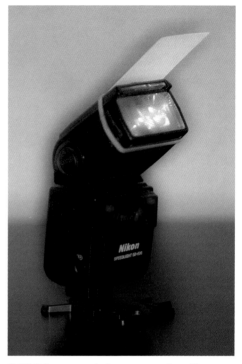

You can also use the bounce card outdoors to add a catch-light without adding fill flash by pointing the flash head straight up.

Both the SB-900 and SB-800 are equipped with a bounce card built right into the flash head. To access the bounce card, pull out the wide-angle diffusion panel on the flash head. The bounce card should slide right out with it. Next, carefully slide the diffusion panel back in (unless you want to use it). You may need to hold onto the bounce card slightly so that it doesn't slide back in with the diffusion panel.

Even if your flash isn't equipped with a bounce card, never fear. You can make one for as little as 1 cent. All you need is a rubber band and an index card. Even a business card with a white back will work.

3.18 A homemade bounce card on the SB-600

Speedlights versus Studio Strobes

If you bought this book, it's more than likely that you have at least one Speedlight. Studio strobes are another option that is available to photographers. Studio strobes come in two kinds: the pack and head type, and monolights. Pack and head strobes have a central power pack that draws power from an AC plug and the heads are attached to it separately via cables. Monolights are very similar but have the power pack built right into the heads. For all practical purposes these two types are the same, and I refer to them throughout the rest of the book simply as studio strobes.

Speedlights and studio strobes each have their own strengths and weaknesses. Both can be used effectively with most subjects, and most professional photographers own both Speedlights and studio strobes.

Some of the pros and cons of each system include:

▶ **Portability.** Speedlights are relatively small. I can fit three or four Speedlights in my camera bag. Studio strobes are much larger and usually need their own large carrying case to protect them from damage while being transported.

▶ **Power.** Speedlights run on AA batteries. You don't have to rely on household current and long extension cords to power these flashes. You can power studio strobes with accessory batteries, but they weigh more than the strobes themselves in some cases. That's one more piece of equipment, per strobe, that you have to worry about.

▶ **Ease of use.** After you set up your Speedlights you can control the output of each flash centrally from the Commander unit on your camera whether it's the built-in flash or an SB-900, SB-800, or SU-800. With studio strobes you need to make adjustments on the power pack or the strobe heads individually.

▶ **TTL.** With studio strobes, you don't have the advantage of TTL metering. When using the Nikon version of TTL (i-TTL), the camera automatically adjusts the exposure according to the desired flash output and adjusts distance to the subject as calculated from the lens distance setting. This automatic adjustment is a huge advantage of using Speedlights — you can just basically set up your Speedlights for i-TTL, set the groups and channels, and start shooting. Your Nikon camera does the rest. With studio flashes, you have to set up the output for each flash manually.

Of course, studio strobes also have a few advantages over Speedlights in some situations.

▶ **Power.** Studio strobes often offer the photographer more flash power and more light with which to work. In other words, you can illuminate your subjects from greater ranges (Speedlights are limited to less than 100 feet). Many studio strobe models easily provide more light output, which is an advantage if your studio work consists of illuminating large objects (such as automobiles), or even large group portraits. Additionally, you won't have to change batteries every 150 flashes as you do when using Speedlights.

▶ **Recycle time.** Recycling time is the amount of time it takes the flash to be ready for another photo. Speedlights typically take .1 to 6 seconds between shots depending on the output and battery charge, where studio strobes can fire multiple bursts in that same time frame.

▶ **Accessories.** Studio strobes offer a much wider range of light-modifying acces-
sories. Barn doors, snoots, softboxes, umbrellas, gels, and diffusers are stan-
dard studio strobe accessories. Although most of these accessories are available
for Speedlights, they are often not widely available, and you may have to special
order them. Photographers often rely on mixing and matching these accessories
to gain more lighting effects for their work.

▶ **Modeling light.** Studio strobes have the ability to illuminate the subject before
the flash is fired using a modeling light. A modeling light is a second light ele-
ment in the strobe head that when turned on, simulates the light output of the
flash, allowing the photographer to preview the lighting effect and adjust it as
needed. Although some Speedlights and cameras offer a modeling light feature,
the modeling light isn't continuous so as to allow you to preview the effect at all
times.

| NOTE | The modeling light from a Speedlight fires a quick 2.5-second series of flashes. It shows you a quick preview of the lighting, but it doesn't provide constant lighting so you can see what you are doing.

Advanced Wireless Lighting

One of the most amazing attributes of the Nikon Creative System is the Advanced Wireless Lighting (AWL) feature. As you probably already know this feature allows you to use any number of Speedlights off-camera to create a limitless amount of lighting possibilities. The AWL feature can be infinitely tweaked and you can add as little or as much light as you desire. You can do all of this by controlling it from one central Speedlight, right on your camera's hot shoe.

This is likely most important feature of the whole Creative Lighting System because it enables you to progress from straight ahead on-camera flash shots to being able to create professional looking lighting patterns. Because the Speedlight output can be controlled completely automatically, you can experiment with moving the lights and creating different effects without worrying about changing the settings of your Speedlights every time you move them.

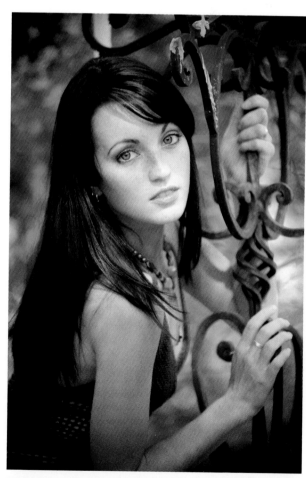

The Advanced Wireless Lighting feature of Nikon's CLS makes it easy to get studio type lighting even outdoors.

Flash Setup for Advanced Wireless Lighting

As with any type of photography, when you use AWL you need to do some planning ahead of time. Generally when using remote flashes you have a specific goal that you want to achieve, whether it is a stylized portrait or a simple product shot for an online auction. There are many practical applications for using the AWL feature of the CLS. These are just a few.

▶ **Portraits.** When shooting portraits, you can set up the Speedlights to achieve particular lighting patterns and you can move them closer for a softer light source or further away for harder light.

▶ **Action.** When shooting action photography, you can set up your Speedlight at the location you know where the action is. This leaves you free to move around capturing different angles without changing the direction or output of your light.

▶ **Architecture.** Placing Speedlights in darkened corners or areas can help to get a more evenly illuminated scene.

▶ **Products.** AWL allows you to move your Speedlights around to get the most pleasing light on your subject. You can use the Speedlights to bring out the texture of an object or to fill in dark shadows.

Probably the first thing you need to do is to determine how many lights you need to get your shot lit the way you want it. At the very least you'll need two Speedlights, one as a remote and one as a Master. The Master or Commander can be a built-in Speedlight (some cameras do not allow this function) or it can be an SB-900, SB-800, or SU-800. For a remote you will need at least one SB-R200, SB-600, SB-800, or SB-900.

Generally, most photographers use a two-light setup, one light is the main or key light and one light, called a fill light, is used to fill in the shadows. For larger subjects you may need more lights, and any number of Speedlights can be grouped together for use as a main light as well as the fill.

Even for a simple subject such as a portrait, you can easily require up to four Speedlights: one main light, one fill light, one background light, and one hair or accent light. If you include one Speedlight as a Commander, that can be five Speedlights for a single portrait! Of course, you can get amazing results using a built-in flash as a Master and one Speedlight. How many Speedlights you need depends solely on your needs (and budget).

How AWL Works in a Nutshell

To use the Advanced Wireless Lighting feature, you need a CLS-compatible camera and at least one SB-600, SB-800, or SB-900. Although most Nikon dSLR cameras are compatible with CLS, not all of them share the same functions.

Basically, the Nikon CLS is a communication device. When set to i-TTL, the camera body relays information to the Commander unit. The Commander unit tells the remotes what to do. The shutter opens and the Commander triggers the remotes to fire. Sounds fairly simple, doesn't it? And, in all actuality, it is for you, but it's definitely a great feat of electronic engineering.

Broken down into more detail, the whole system is based on pulse modulation. *Pulse modulation* is a technical term for the Speedlight firing rapid bursts of light in a specific order. Using these pulses, the Commander unit, be it an SB-900, SB-800, SU-800, or a built-in Speedlight, conveys instructions to the remote units.

The first instruction the Commander sends out to the remotes is to fire a series of monitor preflashes to determine the exposure level. These preflashes are read by the camera's i-TTL metering sensors, which combine readings from all of the separate groups of Speedlights along with a reading of the ambient light.

The camera tells the Commander unit what the proper exposure needs to be. The Commander unit then, via pulse modulation, relays specific information to each group about how much exposure to give the subject. The camera then tells the Commander when the shutter is opened, and the Commander unit instructs the remote flashes to fire at the specified output.

All of this is done in a split second. Of course when you press the Shutter Release button, it looks like the flashes fire instantaneously. There's no waiting for the shutter to fire while the Speedlights do their calculations.

When you're ready to use your Speedlights wirelessly, there are quite a few decisions to make. This is the workflow that I generally follow when preparing to shoot using AWL.

▶ **Choose a Master flash.** The first thing that I do is to decide how I'm going to control my remote Speedlights. Generally, I use an SU-800 because it's the easiest Commander to set up. If I want a fill light from the front, I often use an

SB-800 or SB-900. When I want to travel light, I usually rely on the built-in flash (depending on the camera body). Other considerations are how many groups of flashes I need. The D70 built-in flash only controls one group; the D80, D90, D200, D300, and D700 flash controls two groups; while the SU-800, SB-800, and SB-900 can control three separate groups.

▶ **Select a channel.** The CLS has four communication channels (1-4). These channels allow more than one photographer in the same vicinity to use their Speedlights wirelessly without worrying about the Speedlights being triggered by the other person's Master. In the unlikely event you are working near another photographer using Nikon CLS, just ask which channel he or she is using and use a different one.

The D70 built-in flash works as a Commander only on channel 3.

Be sure that the Master and all remote Speedlights are set to the same channel.

▶ **Set up groups.** Generally, you want to set your main lights to one group, the fill lights to one group, and any peripheral lights, such as hair and background lights to another group. You want to do it this way so you can adjust the output of the specific lights based on their functions. Your main light is the brightest; probably pretty close to whatever TTL reading your camera comes up with. The fill lights need to be a little under what the TTL reading is, so by setting them to a separate group you can adjust them without altering the exposure of your mains. The background lights may or may not need adjusted depending on the darkness of the background, whether you're shooting high key or low key, and so on. You want the lights in separate groups to enable you to make the necessary adjustments without affecting the other two exposures.

▶ **Choose flash modes.** The last thing I do when setting up is to decide which flash mode(s) I want to use. You aren't constrained to using one flash mode; you can set a different mode for each group if you like. For example, you can have group A set to Auto Aperture, group B set to TTL, and Group C can be set to M. Generally, I start out with all of the groups set to TTL. This usually gives a good ballpark exposure, and I can fine-tune the output for each group as needed.

Setting Up a Master or Commander

The Master or Commander flash is the *brain* of the AWL feature. This is where you control the settings and flash modes for the output of each group of remote Speedlights as well as set the channel the Speedlights are communicating on. Although a Master and Commander essentially do the same job there is one big difference between these two terms: When used as a *Master*, the flash is actually fired during the exposure; whereas, when used as a *Commander*, the Speedlight controls the remotes by firing a pre-flash but without firing a flash during the actual exposure.

▶ **SB-900.** Can be used as a Master or Commander.

▶ **SB-800.** Can be used as a Master or Commander.

▶ **SU-800.** Can be used as a Commander only.

▶ **Built-in flash.** With cameras that support AWL with the built-in flash the built-in flash can be used as a Master or Commander, with the exception of the D70 and D70s with which the built-in flash can only function as a Master.

> **CAUTION** Not all Nikon dSLRs support the Master or Commander mode with the built-in flash. As of this writing, the D40/D40x, D50, D60, D5000, and D3000 cameras don't offer this feature. A separate Speedlight or SU-800 is needed to use the AWL feature.

SB-900

Each Speedlight is set to Master mode differently. The SB-900 is by far the easiest. Simply turn the power switch to On, then press the Lock Release button in the center of the switch and continue to rotate the switch until it is in Master mode.

SB-800

Setting the SB-800 to Master mode requires a trip to the Custom Settings menu.

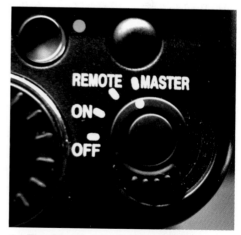

4.1 The SB-900 switch set to Master position

1. **Enter the Custom Settings menu on the Speedlight.** Press the Select button (SEL) for two seconds to get there.

2. **Use the + or − and the left and right zoom buttons to select the Wireless settings menu.** The menu has the icon of a flash with an arrow next to it. Press the Select button to access the options.

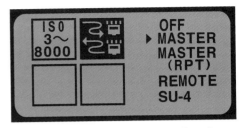

4.2 The SB-800 wireless settings icon in the Custom Settings menu

3. **Use the + or − button to select the Master option.** Press the Select button to set as Master, and then press the On/Off button to exit the Custom Settings menu.

Built-in flash

Because there are quite a few Nikon dSLRs that allow you to use the built-in flash as a Master, I'm not going to cover the specifics for each camera. For all the cameras it's quite similar so I'm just going to give a brief overview. If you get stuck, I recommend checking out your camera's manual for details on the settings for your particular camera model.

1. **Enter the Custom Settings menu on your camera by pressing the Menu button.**

2. **Use the Multi-selector to scroll down to the specific menu setting.** On the higher-end models (D200-D3), the option resides in the CSM Bracketing/Flash submenu.

3. **Select Commander mode from the menu options.** Pressing the OK button or the Multi-selector right will take you to the Commander setting submenu. This is where you will set the modes, groups, and so on.

Setting the Flash Mode

After your flash is set to Master, you need to decide which flash mode you want to use for each individual group as well as the Master flash. All of the flash modes are discussed in detail in Chapter 2. If you skipped that chapter, you should probably go back and read it now.

Using AWL, you have the choice of a few different flash modes.

▶ **TTL.** This is the full i-TTL mode. The camera and Speedlights determine the output settings for each group of Speedlights.

▶ **AA/A.** This is Auto Aperture or non-TTL Auto flash. If you are using a non-CPU lens without entering non-CPU lens data in your camera or if your camera doesn't support non-CPU lens data, this mode is automatically set to non-TTL Auto flash.

▶ **M.** This is Manual mode. The photographer determines the output settings.

▶ **RPT.** This allows the remote Speedlight to fire in the Repeating flash mode. The RPT mode is set in the CSM.

▶ **– –.** When this setting is selected, the flash is cancelled for that group and the Speedlight will not fire.

While assigning the groups a flash mode, to save time you should also set the channel that the Master will use to communicate with the remote Speedlights.

SB-900

To assign the flash modes to each group on the SB-900, first be sure that your SB-900 is set to Master.

1. **Press Function button 1 to access the groups to ready them for change.** When the group is ready to be set, its icon is highlighted. To scroll through the groups, press Function button 1 repeatedly or use the Selector dial. The options include M (Master), A, B, and C.

2. **When the desired group setting is highlighted, press the Mode button to cycle through the different flash modes.** When the desired flash mode is displayed, press Fn. 1 to continue with the next group or press the OK button to set.

3. **Repeat Step 2 until all of the groups and Master are set to the desired flash mode.**

If any of the channels have been set to Manual, you also need to set the output level. You can do this by pressing Function button 2 when the group is highlighted. You can continuously press Function button 2 to scroll through the settings or you can use the Selector dial to do it more quickly. When in TTL or A mode, pressing Fn. 2 allows you to adjust the Flash Exposure Compensation (FEC).

To set the channel, be sure that you have exited the Group flash mode settings and press Fn. button 2. This highlights the channel numbers in the upper-right corner of

the LCD. You can press Fn. 2 repeatedly to cycle through the channels (1-4) or you can use the Selector dial. Once the channel is set to the correct number, press the OK button to set it.

SB-800

To set the flash modes on the SB-800, first be sure that the SB-800 is in Master mode.

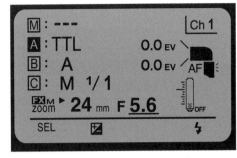

4.3 Press Fn. button 1 to change the group flash modes.

1. **Press the Select button to cycle through the options.** When the desired group is highlighted, it's ready for change.

2. **Press the Mode button to cycle through the flash modes.** Use the +/- to set the output when in M or apply FEC when in TTL or A mode.

3. **Repeat Step 2 until all of the groups are set.**

4. **When finished, press the Select button repeatedly until none of the groups are highlighted.**

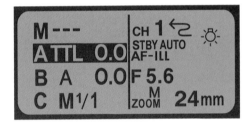

4.4 Press the Select button to change the group flash modes for the SB-800.

To set the channel, simply press the Select button until the channel number is highlighted. Use the + or − button on the Multi-selector to cycle through the channel numbers (1-4).

SU-800

To set the flash modes on the SU-800:

1. **Press the Select button.** When the Group flash mode is flashing, it's set for change.

2. **Press the Mode button to cycle through the flash modes.** Use the left or right arrow button to set the flash output or adjust the FEC. When finished, press the Select button to adjust the next group.

3. **Repeat Step 2 until all of the groups are set.**

4. **When finished, press the Select button repeatedly until none of the groups is flashing.**

To set the channel on the SU-800, press the Select button until the channel number is flashing. Press the left or right arrow buttons to cycle through the channel numbers (1-4).

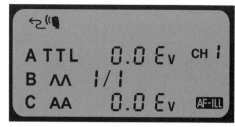

4.5 Press the Select button to change the Group flash modes on the SU-800.

Setting Up Remotes

Remote flashes, also referred to as slaves, are the Speedlights that are used off-camera. In order to be fired wirelessly, each Speedlight must be set to Remote mode.

SB-900

Setting up the SB-900 to function as a remote is as simple as flipping the switch to Remote. Be sure that you press the Lock Release button in the center of the switch to enable the switch to be set to Remote.

SB-800

To set the SB-800 to Remote, you need to enter the Custom Settings menu. Follow these steps to set the SB-800 as a remote.

1. **Press and hold the Select button for about two seconds to enter the Custom Settings menu.**

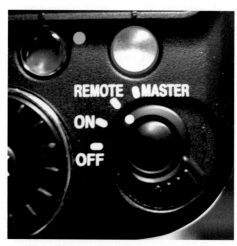

4.6 The SB-900 switch set to Remote

2. **Use the Multi-selector to navigate through the Custom Settings menu settings until the wireless settings icon is highlighted.** Press the Select button to enter the Wireless settings menu.

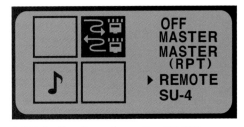

4.7 Selecting Remote on the SB-800

3. **Use the +/- buttons on the Multi-selector to highlight REMOTE.** Press the Select button to set.

4. **Press the On/Off button to exit the Custom Settings menu.** The SB-800 is now set to Remote.

SB-600

To set the SB-600 as a remote, you need to enter the Custom Settings menu. Follow these steps to set the SB-600 as a remote.

1. **Press and hold the Zoom and – buttons simultaneously for two seconds to enter the Custom Settings menu.**

2. **Use the + or – buttons to cycle through the Custom Settings menu options until the wireless settings icon is displayed.**

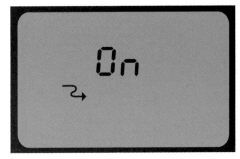

4.8 The SB-600 Remote set to On

3. **Press the Mode or Zoom button to toggle between On and Off.**

4. **Once the setting is set to On, press the On/Off button to set and to exit the Custom Settings menu.** The SB-600 is now ready to use as a remote.

Setting Up Remote Groups

To properly function as remotes, your Speedlights must be set to Groups. Depending on your Master, you can control up to three separate groups of Speedlights. Any number of Speedlights can be assigned to each group. The group settings are A, B, and C.

To control all three flash groups, an SU-800, SB-800, or SB-900 must be used as a Master. When using a camera that allows the built-in flash to act as a Master, you are limited to controlling only Groups A and B. The exception to this is the D70/D70s, which only allows you to control Group B on channel 3.

SB-900

To assign an SB-900 to a group, first be sure to set the SB-900 to Remote mode, as described in the previous section. Press Fn. button 1 to cycle through the groups. The selected group is highlighted. You can also press Fn. 1 and use the Selector dial to cycle through the group settings. When the desired group setting is selected, press the OK button to set.

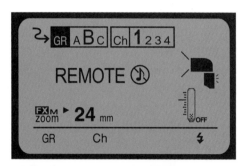

4.9 Setting groups on the SB-900

SB-800

To assign an SB-800 to a group, first set the SB-800 to Remote mode. Press the Select button until GROUP is highlighted. Them use the +/- buttons of the Multi-selector to cycle through the groups. When the desired group is selected, press the Select button until no settings are highlighted on the LCD.

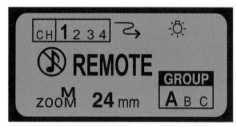

4.10 Setting groups on the SB-800

SB-600

To assign an SB-600 to a group, first set the Speedlight to Remote mode. Press the Mode button until the group letter begins flashing. You can then use the + or – button to choose the desired group. Press the Mode button once more to set.

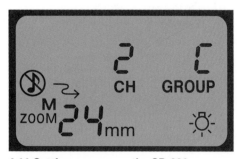

4.11 Setting groups on the SB-600

Making Adjustments on the Fly

Once you have the Master and remotes set up with the proper groups, channels, and flash modes, you're ready to shoot. More often than not, with whatever flash mode you're using, you're not going to get exactly what you want. Even when using the great i-TTL metering, it's pretty much just going to get you close. You almost always have to fine-tune the output on the Speedlights to get the exact lighting that you're after.

As I've said previously, one of the greatest features of using the Advanced Wireless Lighting of Nikon's CLS is the ease with which you can make adjustments to each group without having to visit each and every remote. All of these fine-tuning output adjustments can be done right from the Master flash.

SB-900

To adjust the output of the remote groups when using the SB-900 as a Master flash, do the following:

1. **Press Function button 1.** This highlights the group to be changed. Press Function button 1 repeatedly until the specific group is highlighted. You can choose the Master (M) or groups A, B, or C.

2. **Once you have the desired group highlighted, press Function button 2 to adjust the output.** When the Flash mode is set to TTL or A, you can adjust the FEC ±3 EV in 1/3-stop steps. When using M mode, you adjust the flash output from 1/1 (full power) down to 1/128, also in 1/3-stop steps. You can repeatedly press Fn. 2 to cycle through the settings or you can rotate the Selector dial.

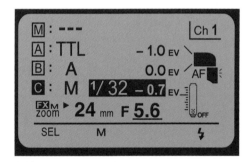

4.12 Adjusting the flash output using the SB-900 as a Master

3. **Repeat Step 2 until you have all of the groups and the Master flash option set to the correct output level.**

4. **Press the OK button to set.**

SB-800

To adjust the output of the remote groups when using the SB-800 as a Master flash, do the following:

1. **Press the Select button.** The group that is highlighted is ready to be adjusted.

2. **Use the + or – button on the Multi-selector to adjust the output levels.** When the Flash mode is set to TTL or A, you can adjust the FEC ±3 EV in 1/3-stop steps. When using M mode, you adjust the flash output from 1/1 (full power) down to 1/128 in 1-stop steps.

3. **Repeat Step 2 until you have all of the groups and the Master flash option set to the correct output level.**

4. **When finished, press the Select button until no settings are highlighted.**

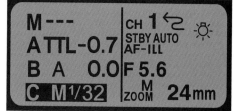

4.13 Adjusting the flash output using the SB-800 as a Master

SU-800

To adjust the output of the remote groups when using the SU-800 as a commander, do the following:

1. **Press the Select button.** When the group is flashing, it is ready to be adjusted.

2. **Use the left and right arrow buttons to adjust the group output.** When the Flash mode is set to TTL or A, you can adjust the FEC ±3 EV in 1/3-stop steps. When using M mode, you adjust the flash output from 1/1 (full power) down to 1/128 in 1-stop steps.

3. **Repeat Step 2 until you have all of the groups set to the correct output level.**

4. **When finished, press the Select button until no settings are highlighted.**

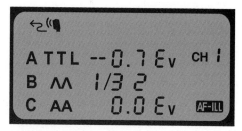

4.14 Adjusting the flash output using the SU-800 as a Commander

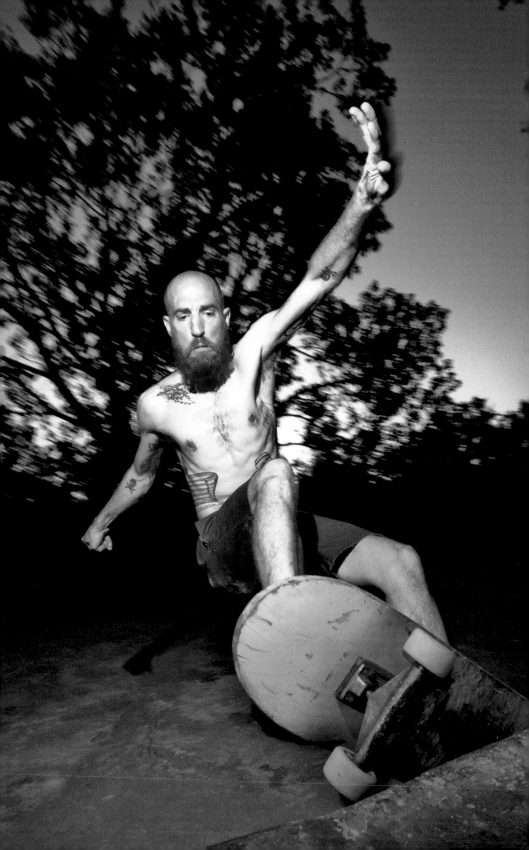

Setting up a Portable Studio

One of the great things about Nikon Speedlights is that they are small and portable. This allows you to easily transport your lighting equipment to any location and photograph your subjects in their environment without having to worry about the quality of the available light. With some careful planning you should be able put together what I like to call a *portable studio*. A portable studio should be just that — portable. You should be able to fit everything you need into a minimum amount of space and be able to transport it quickly with minimal effort.

Having a portable studio allows you to get professional looking images anywhere.

Introduction to the Portable Studio

A portable studio should include at a minimum, but should not be limited to, at least one Speedlight, a reflector of some sort to fill in the harsh shadows created by strobes, an umbrella or softbox to soften the light for a more pleasing effect, and one or more light stands.

One of the hardest things to do when putting together a portable studio is knowing when to say when. Sometimes the tendency is to push the envelope. You end up acquiring a lot of gear and it can be too much to lug around all at once.

Ideally, your portable studio should have three Speedlights (key, fill, and background), three light stands, and at least two light modifiers (umbrellas or softboxes). A reflector is another key piece for your portable studio.

Equipment

The following sections cover some of the most practical equipment that can be used with a portable studio. The focus is on portability and ease of transport and doesn't necessarily focus on all available equipment. The key is to get the maximum potential from your setup with the minimum amount of equipment (although you want to be sure you have everything you need). A good idea is to purchase one piece of equipment that can double as something else. For example, a diffusion panel can double as a reflector. This cuts down on the amount of equipment you need to carry.

Stands

Light stands are an underestimated part of any studio. Obviously, you need a light stand to hold your Speedlight. These allow you to place the Speedlight wherever you want it and to adjust it to the proper height.

There are a few different grades of light stands, and you should choose the type of light stand you need not for the Speedlight itself but for the type of modifier you intend to use. If you plan on only using a medium-sized umbrella, you don't need to buy a heavy-duty stand; but if you're planning on attaching a medium-sized softbox, you should definitely buy a sturdier stand. Stands run from simple lightweight stands to extra heavy-duty ones. Of course, as the stand gets sturdier the price goes up. For

most applications a standard medium-duty stand should work. These stands can be found for about $40 to $50. For a simple background or accent light, a lightweight stand usually does the trick.

Additionally, light stands come in two varieties: free sliding and air cushioned. Free-sliding stands are locked in place by a clamp that is usually a quick-release lever type (older stands may lock down with a screw mechanism). These stands, as their name implies, slide up and down freely when the mechanism is unlocked. If the mechanism comes unlocked when your Speedlight is attached, it will come crashing down pretty quickly. Air-cushioned stands are sealed at the bottom creating a sort of pneumatic tube in which the air is compressed and let out slowly when the locking mechanism is unlocked. This causes the light stand to collapse at a slower rate avoiding a crash if the stand is accidentally unlocked.

Air-cushioned stands cost a little more than free-sliding stands, but can be worth it if you're using heavier light modifiers or if you're simply nervous about your Speedlight crashing down (although this is a pretty rare occurrence). Personally, I use free-sliding stands with my Speedlights to cut down on weight because air-cushioned stands are generally heavier. With my studio flashes I use air-cushioned stands because I generally put a lot more weight on them.

Light stands also come in different heights. The standard heights range up to 6, 8, or 10 feet. There are taller stands available up to 30 feet, but I've never found a need for a stand taller than about 10 feet. An 8-foot stand is good for most applications.

Brackets and multiclamps

Another very important piece of equipment that goes along with your light stands is a bracket or multiclamp. These devices attach to the top stud of the light stand and allow you to attach an umbrella or softbox to the stand. The other function of these is to allow you to tilt the Speedlight and modifier to angle the light. There are different types of these devices; some are made specifically for umbrellas and some are made to adapt to softboxes.

I use a Photoflex Shoe Mount Multiclamp on my light stands to attach my umbrellas and Speedlights. To attach a small softbox, I use a Photoflex LiteDome xs Accessory Hardware/Adjustable Shoe Mount. There are other manufacturers of these types of accessories as well. Do a quick Internet search for more options.

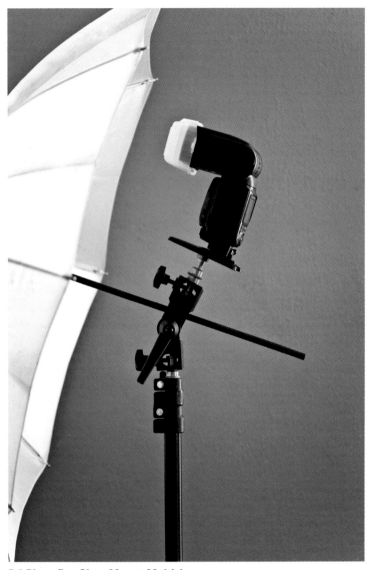

5.1 Photoflex Shoe Mount Multiclamp

Umbrellas

Umbrellas are by far the lightest and most portable studio-type lighting modifier you can get. They are exactly like a rain umbrella except they are coated with a material that maximizes reflectivity. Umbrellas are used to soften and diffuse the light from your Speedlight. If you are already familiar with the various pieces of studio photography equipment, you likely already know that umbrellas do the same thing that a softbox does. What you may not know is that umbrellas are more affordable and are easier to use than softboxes, as an accessory for your Nikon Speedlight.

There are three basic types of umbrellas available:

▶ **Standard.** This common type of umbrella is black outside (to prevent light loss) and the inside has a reflective surface that is usually silver, but can also be gold (to add warmth). These umbrellas are designed so that you point the Speedlight into the umbrella and bounce the light onto the subject resulting in a soft nondirectional light source.

▶ **Shoot-through.** These are probably the most affordable types of umbrellas. They are made out of a one-piece translucent silvery nylon. You can shoot through this umbrella giving the light a harder more directional look. You can also use these umbrellas for bouncing, but you will lose a substantial amount of output.

▶ **Convertible.** The convertible umbrella has a removable black cover on the outside. You can use these umbrellas to bounce light or as a shoot-through when the outside covering is removed.

Photographic umbrellas come in various sizes usually ranging from 27 inches all the way up to 12½ feet. The size you use depends on the size of the subject and the degree of coverage you want. For standard headshots, portraits, and small to medium products, umbrellas ranging from 27 inches to about 40 inches supply plenty of coverage. For full-length portraits and larger products, a 60- to 72-inch umbrella is generally recommended, but a better option is to use two lights with two medium umbrellas.

The larger the umbrella, the softer the light falling on the subject from the Speedlight is. It is also true that the larger the umbrella, the less light that falls on your subject. Generally, small to medium umbrellas lose about a stop and a half to two stops of light. Larger umbrellas generally lose two or more stops of light because the light is spread over a larger area.

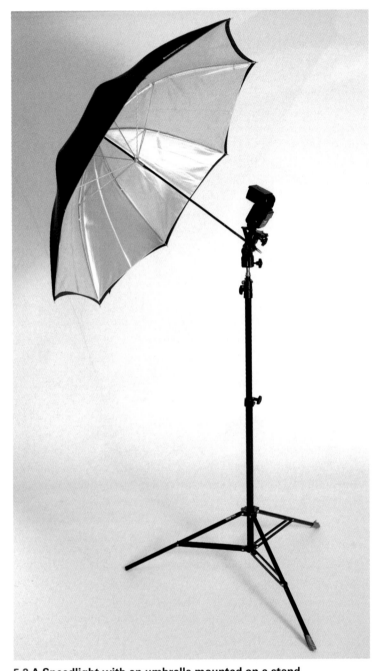

5.2 A Speedlight with an umbrella mounted on a stand

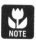 For umbrellas larger than about 32 inches you may need to use a bracket that holds two Speedlights to illuminate the subject properly

Smaller umbrellas tend to have a much more directional light than do larger umbrellas. With all umbrellas, the closer you have the umbrella to the subject the more diffuse the light is.

For setting up a portable studio, I'm convinced that the umbrella is the way to go. They fold up nice and small, are simple to use, and are relatively inexpensive.

Choosing the right umbrella is a matter of personal preference. Some criteria to keep in mind when choosing your umbrella include the type, size, and portability. You also want to consider how it works with your Speedlight. For example, regular and convertible umbrellas return more light to the subject when bounced, which can be advantageous because a Speedlight has less power than a studio strobe. And, the less energy the Speedlight has to output, the more battery power you save. On the other hand, shoot-through umbrellas lose more light through the back when bouncing, but are generally more affordable than convertible umbrellas.

Softboxes

Softboxes, as with umbrellas, are used to diffuse and soften the light of a strobe to create a more pleasing light source. Softboxes range in size from small 6-inch boxes that you mount directly onto the flash head to large boxes that usually mount directly to a studio strobe. Softboxes come in a variety of shapes — anywhere from a small, square-shaped softbox to a very large, octagonal softbox designed to simulate umbrellas (some people prefer the octagonal catchlights these create over the square or rectangular ones from a softbox).

Flash-mount softboxes

The small flash-mounted softboxes are very economical and easy to use. You just attach it directly to the flash head and use it with your flash mounted on the camera or on a flash bracket. You can also use it mounted on a stand, but it is less effective. This type of softbox is good to use while photographing an event, informal portraits, wedding candids, or just plain old snapshots of your friends and family. You generally lose about 1 stop of light with these and should adjust your flash output level accordingly if using your Speedlight in Manual mode. For shooting small still-life subjects or simple portraits, this may be all you need to get started with your portable studio.

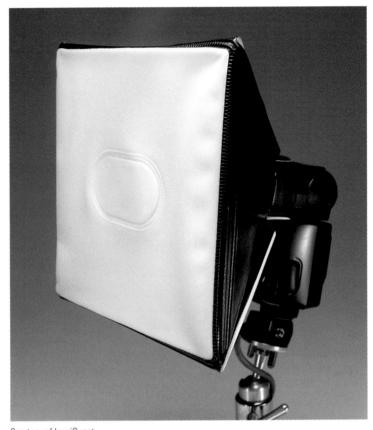

Courtesy of LumiQuest
5.3 LumiQuest Softbox III

Stand-mounted softboxes

When photographing in a studio type of setting you really need a larger softbox that is mounted, along with your Speedlight, onto a suitable light stand. For a larger softbox, you need a sturdier stand to prevent the lighting setup from tipping over. Bogen/Manfrotto, manufacturer of high-quality stands and tripods, has a basic 6-foot stand that works well for this application.

The reason that you may want to invest in a softbox rather than an umbrella for your portable studio is that softboxes provide a more consistent and controllable light than umbrellas do. Softboxes are closed around the light source thereby eliminating unwanted light from being bounced back onto your subject, but more importantly they reduce the amount of light lost, increasing the efficiency of your Speedlight. The diffusion material gives less of a chance of creating hotspots on your subject. A *hotspot* is an overly bright spot on your subject caused by uneven lighting.

Softboxes are generally made for use with larger studio strobes. They attach to these strobes with a device called a speedring. Speedrings are specific to the type of lights to which they are meant to attach. Some companies, such as Chimera, manufacture a type of speedring that mounts directly to the light stand and allows you to attach one or more Speedlights to the light stand as well. You attach the softbox to the speedring, mount the speedring to the stand, attach the Speedlight with the flash head pointed into the softbox, and you're ready to go.

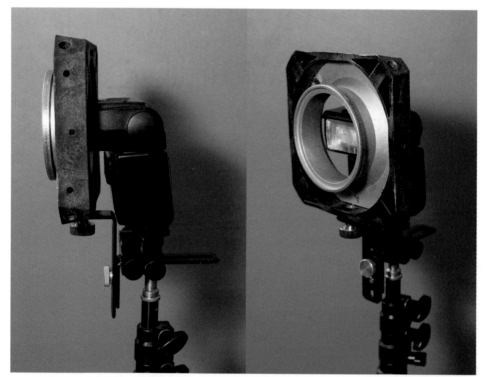

5.4 A Speedlight with a speedring bracket. The softbox is normally attached to the speedring, but here is removed to better show the detail.

Stand-mounted softboxes come in a multitude of shapes and sizes ranging from squares to rectangles to ovals to octagons. Most photographers use standard square or rectangular softboxes. However, some photographers prefer to use oval or octagonal ones for the way that they mimic umbrellas and give a more pleasing round shape to the catchlights in the eyes. This is mostly a matter of personal preference. I usually use a medium-sized rectangular softbox.

As with umbrellas, the size of the softbox you need to use is dependent on the subject you are photographing. Softboxes can conveniently be taken apart and folded up — most of them come with a storage bag that can be used to transport them.

Reflectors and diffusers

In my opinion, a reflector and/or a diffuser are a must have in any portable studio. A reflector can often be used in place of a fill light especially in low-key settings and a diffusion panel can be used as a much more portable version of a softbox.

Diffusion panel

A diffusion panel consists of a translucent material attached to a frame that is usually made of PVC tubing. Diffusion panels, like umbrellas and softboxes, soften or diffuse light. Diffusion panels are very easy to use. Simply place the panel in between the subject and the light source. It's generally preferable to place the diffusion panel relatively close to your subject. You can easily control the quality of the light output from your Speedlight when using a diffusion panel by moving the Speedlight closer to or farther away from the panel. Place the Speedlight closer to the panel for a harder and more directional light source or move the Speedlight farther away to achieve a softer, less directional light.

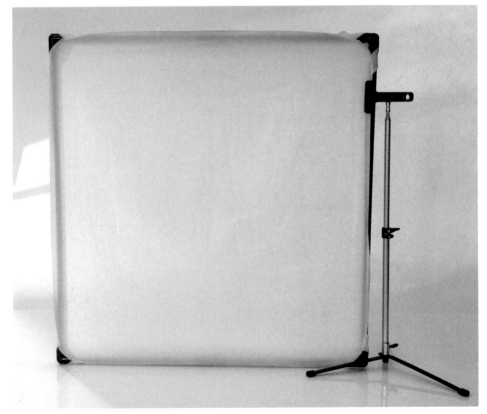

5.5 A diffusion panel

Diffusion panels are available at most photography stores, but you can make one yourself for much less money (if you're crafty enough). All you need is a bit of white ripstop nylon and some PVC tubing and you're on your way. Type "homemade diffusion panel" into your favorite Internet search engine to find many different tutorials on how to build one of these for yourself.

Diffusion panels have a downside, however. Unlike a softbox, which is enclosed, a diffusion panel has no sides; therefore, a large portion of the light from your Speedlight is lost. A softbox prevents the light from scattering around the room and is a more efficient way to control your light.

Reflectors

Reflectors are another very important part of any studio. As mentioned earlier, reflectors are used in conjunction with your key light. The reflector bounces some of the light from your key light back onto your subject, which fills in the shadows. This reduces the contrast a little and ensures that you retain some detail in your shadow areas.

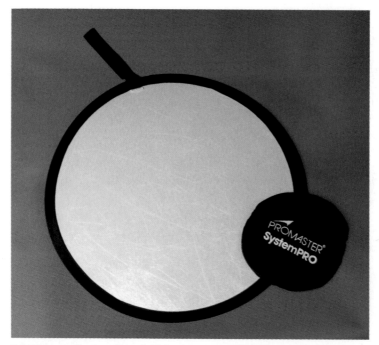

5.6 These reflector discs fold up to a convenient and portable size.

You can buy a fold-up reflector from your local photography store or you can use any number of things as a reflector. The most common is using a piece of white foamcore (available at any art supply store). You can also use white poster board, or some folks even use the lid from a Styrofoam cooler.

I recommend buying a fold-up reflector. These are sturdier and last much longer than the alternatives listed earlier, which can easily get dirty, fold, tear, or break.

Professional reflector discs are available in a multitude of sizes from about 2 to 6 feet and are usually circular or rectangular in shape (circular is most common). They fold up to less than half their open size. I have a small 22-inch reflector that folds up to 9 inches and fits perfectly in my camera bag and is great for doing on-location portraits. These store-bought discs usually have a white side and a silver side for more reflectivity. You can also find them in a shiny gold color that adds a nice warmth to the subject.

Reflectors can also be used as a bouncing surface for your Speedlight. Just as with the ceiling or wall bounce, this will give you a more pleasing and diffuse light.

A 5-in-1 reflector disc is probably the single most versatile lighting modifier you can buy. A 5-in-1 reflector disc has five panels in one kit. The basic disc is a translucent material that can be used as a diffusion panel. The 5-in-1 kit comes with a cover that zips on over the top of the diffusion panel. The cover is reversible and each side is covered with a different material: opaque white for bouncing; reflective silver, which can be used to bounce flash or to reflect light from a constant light source such as the sun; reflective gold, which is used in the same way as the silver but adds warmth; and black, which is used to *flag* or block light from the subject.

Unless you have an assistant who comes with you on every shoot, I recommend buying a reflector holder to support your reflector. I use the Photoflex LiteDisc Holder. This is an accessory that attaches to a light stand and has clamps to hold the reflector in position. This enables you to place the reflector exactly where you need while keeping your hands free so that you can operate your camera.

Backdrops

In photography, backdrops (also called backgrounds) are usually used to isolate the subject, which allows the subject to stand out without distracting elements in the background. Backgrounds can also be used to compliment the color of an object or to accent a certain feature of the person whose portrait you are taking.

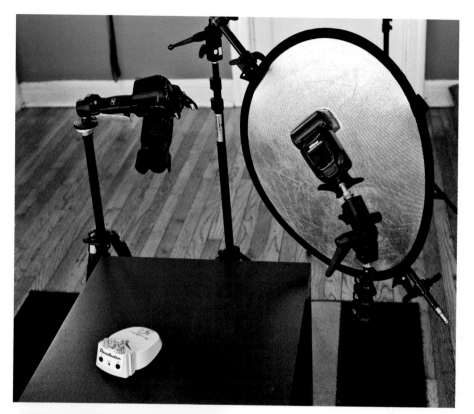

5.7 This is a simple lighting setup in which the reflector is used to bounce light onto the subject. The D90's built-in flash acts as the commander and the SB-600 is bounced from the reflector.

Backgrounds come in almost as many colors and materials as you can imagine. The following sections discuss some of the different types and applications.

Seamless paper

The most common type of background material is paper. Seamless paper backdrops are inexpensive and come in hundreds of colors. Standard rolls of background paper range in size from 3 feet to 12 feet wide, and can be as long as 100 feet. The great thing about using paper as a background is that if it gets dirty or torn you can cut it off and pull more down from the roll.

5.8 A seamless paper background

I recommend starting out with a roll of gray paper. This is a neutral color that can be used with almost any subject. You can easily change the color of the background by using colored gel filters on your Speedlight.

Vinyl

These backdrops are a little more expensive than paper, but they are far more durable and can be easily wiped down if they get dirty. The color selection is limited with the most common colors being white, black, or gray. They are available in both gloss and matte surfaces.

Muslin

Muslin is an inexpensive lightweight cotton material. When used for backdrops, it is usually dyed different colors with a mottled pattern to give the background a look of

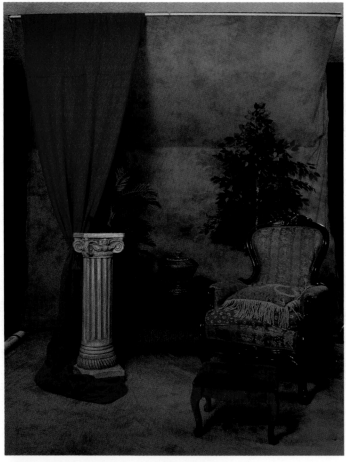

5.9 A muslin backdrop in a studio setting

texture. You can purchase muslin at most well-stocked photography stores or online. If you have very specific needs, there are companies that dye muslin fabric to a custom color of your choice.

Muslin is very convenient to use. It's very lightweight, it stores easily by wadding it into a small bundle (to avoid patterned creasing), and it's durable. You can drape it over your background stand or you can easily tack it to a wall. For a portable studio, this flexibility is very advantageous because the muslin doesn't take up too much valuable space when traveling.

Muslin is very versatile, and although it's much more suited to portraits, it can be used successfully for product shots as well.

Canvas

Canvas backdrops are very heavy duty. They are usually painted a mottled color that is lighter in the center and darkens around the edges, which helps the subject stand out from the background. These types of backdrops are almost exclusively used for portraits.

When considering a canvas backdrop, in addition to the weight factor, you should consider the cost as well — they are expensive. Although you can get them in lighter-weight smaller sizes, I generally don't recommend using canvas backdrops for a portable studio as they are unwieldy and not very versatile.

Background stands

Background stands, amazingly enough, hold up your backgrounds. Most background stand kits have three pieces: two stands and a crossbar. The crossbar slides into a roll of paper or other backdrop and is held up by the stands. The crossbar has two holes, one at either end, that slide over support pins on the top of the stand. The crossbar is usually adjustable from 3 to 12½ feet to accommodate the various widths of backdrops. The stands are adjustable in height up to 10½ feet. Most kits also come with either a carrying case or a bag for maximum portability.

There are varying degrees of quality in background stands. The more sturdy the stand, the more expensive it is. For a portable studio, a decent medium-weight background stand kit suffices.

Filters

Filters, sometimes referred to as gels, are pieces of colored acetate that are placed over top of the flash head and allow you to change the color of the light from your Speedlight. There are two different kinds of color filters, special effect and color

correcting. Special effects filters as used for still photography with the Speedlights are colored filters that are usually used to change the color of the background. These filters come in hundreds of colors. Color-correction filters are for matching the color of the flash output with the color of the ambient light.

Nikon offers a few filter sets for use with Speedlights, and the SB-900 and SB-800 come with the both tungsten and fluorescent color-correction filters in the box. The filter kits come with blue, red, yellow, and amber filters as well as TN-A1 and TN-A2 filters, which are used when shooting flash in tungsten lighting, and FL-G1 and FL-G2 filters for shooting flash under fluorescent lighting.

▶ **SJ-1.** The SJ-1 filter kit comes with 20 filters, two of each color with the exception of blue and red, which have four of each. The SJ-1 kit is for use with both the SB-800 and SB-600 Speedlights.

▶ **SJ-2.** This filter kit is for use with the SB-R200 macro Speedlights. This kit comes with one of each of the eight colors.

▶ **SJ-3.** This is the filter kit especially for the SB-900. This kit comes with the same amount of colors as the SJ-1 set. The filters for the SJ-3 include simple barcodes that are read by a sensor in the flash head so that the flash knows which filter is installed.

Attaching the filters

Using the filters is quite simple. With the SB-800 and SB-600 you simply fold the tab at the crease and slide the tab into the slot where the wide-angle diffusion panel is stored.

5.10 Slide the filter tab between the diffusion panel and the flash head.

The SB-900 has its own special filter holder that comes with the flash, the SZ-2 color filter holder. As with the SJ-1 filters, you fold these along the crease at the tab. You then place the filter into the filter holder. Be sure that the tab is on the bottom of the filter holder where you find a piece of black vinyl adhered. This is important as it allows the sensor on the SB-900 to read the code on the filter. Snap the SZ-2 over top of the flash head and you're all set.

The SB-R200 also has a filter holder, the SZ-1. Simply place the filters in the filter holder and snap it into place on the Speedlight.

5.11 Close-up of a filter used with the SB-900. Notice the positioning hole in the filter tab. This hole lines up with a projection in the filter holder, which ensures proper seating of the filter.

Settings

When using color filters, be sure to have your WB set properly. These settings can differ depending on which camera and Speedlight combination you're using.

SB-900

The SB-900 is equipped with a sensor built in to the flash head. This sensor reads the codes that are printed on the tabs of the filters that come with it and the filters in the SJ-3 filter kit. The SB-900 then relays the filter color information to the camera body so a more accurate WB can be achieved. Please note that your camera must be equipped with filter detection. As of this writing only the D3, D700, and D90 use the filter detection technology. When using one of these camera bodies, the camera adjusts the WB for more accurate colors. Your camera's WB must be set to Auto or Flash to take advantage of this technology.

For most other cameras, use the following settings:

▶ **FL-G1/FL-G2.** Set your WB to Fluorescent. Since fluorescent lamps are available in different color temperatures it's a good idea to shoot a few test shots and fine-tune the WB setting as needed.

▶ **TN-A1.** Set your WB to the Incandescent setting, adjust FEC to +1 EV, and fine-tune the WB setting to +3.

▶ **TN-A2.** Use the Direct sunlight WB setting, adjust the FEC to +0.3 EV, and fine-tune the WB setting to +3.

▸ **Red, blue, yellow, amber.** With these filters set your WB to Auto, Flash, or Direct sunlight. When using the amber filter, dial in +0.7 EV FEC.

 WB fine-tuning is not available on the D1 or D50 camera bodies.

The SB-900 manual states that the Fluorescent color-correction filters are not compatible with any cameras other than the D90, D3, and D700, and that none of the color correction filters is compatible with the D50 or D1. I find that using the Fluorescent and Tungsten WB settings with the respective filters works well. You may have to fine-tune your WB setting for best results.

SB-800/SB-600

The filters that come with the SB-800 as well as the filters that are in the SJ-1 filter kit actually have the recommended WB setting printed right on the tab. Also printed on the tab is the amount of FEC you should apply (if any).

▸ **FL-G1.** Use the Fluorescent WB setting and add +0.3 EV FEC.

▸ **TN-A1.** Use the Incandescent WB setting and add +1 EV FEC.

▸ **All other filters.** Use the Auto WB setting. When using the Amber filter add +0.7 EV FEC.

Using filters

As mentioned earlier there are two types of filters available for use with the Color correction and Special effect. This section covers a little bit on how and why you should use these filters.

Color correction

Different types of light sources have different colors. The two most common types of lighting are incandescent (also called tungsten) and fluorescent. Incandescent lights emit a light that is very amber in color while most fluorescent lights cast a sickly green light. I say most because in recent years fluorescent lamps have been available that are color corrected to match daylight or a number of other colors (cool-white, warm-white, and so on). This discussion focuses on standard fluorescent lamps.

Your Speedlight puts out a light that is about 5500K, which is about the same as direct sunlight. This color temperature appears quite blue when compared to the color temperature of an incandescent or fluorescent lamp.

When using flash indoors you run into a situation that photographers call *mixed lighting*. This is because you're mixing two types of lighting, usually flash and incandescent. What happens with mixed lighting is that the output from your flash lights the main subject with a color temperature of 5500K, but the ambient light in the background is at a different color temperature. This causes your subject to look blue and your background to appear orange or green (depending on the light source).

The way to overcome this problem is to place a filter over your flash head to change the color of the flash output to match the ambient light.

Special effects

Using colored filters allows you to add or change the color of the background (or the subject if you desire). Most often, gels are used to add a splash of color to the background or even to completely change the color of the background altogether. You can use multiple Speedlights with the same color filter to get a very saturated color, or you can use multiple Speedlights with different color filters to add more than one color to the background.

The Nikon filter packs aren't the only option you have for filters. There are a few other companies that manufacture color filters, the top two being Roscoe and Lee Filters. These companies make filters in every color of the rainbow, including many color-correction filters.

 The SB-900 requires Nikon filters to communicate the color filter information to the camera.

Both Roscoe and Lee produce sample packs of filters that include swatches with all of the filters they offer. These sample filter swatches are just about the right size to cover the flash head. Unfortunately, due to the high volume of requests, these filter packs, which used to be free, are now hard to find. Of course, you can always buy standard filter sheets and cut them down to the size you need (and if you're real ambitious you can always cut them the same shape as the Nikon filters).

 Filter sample packs can often be obtained from specialty light stores, especially those that cater to motion pictures and live music lighting. I get mine from a lighting supply house for less than $5.

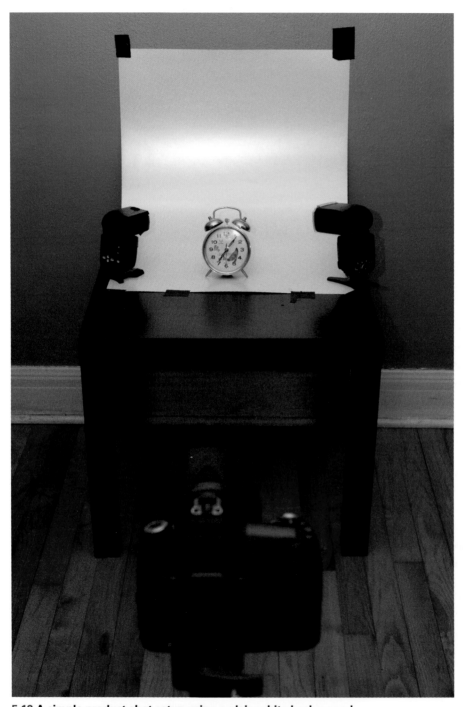

5.12 A simple product shot setup using a plain white background.

Not only can you use gels to change the color of your background, you can use them to change the color of the subject as well. Below is a series of images shot with and without filters. The previous page shows that the Speedlights are placed behind the subject to avoid having filtered light fall on the subject. While the setup on the following page shows that the Speedlights were aimed directly on the subject instead of the background resulting in the subject changing color.

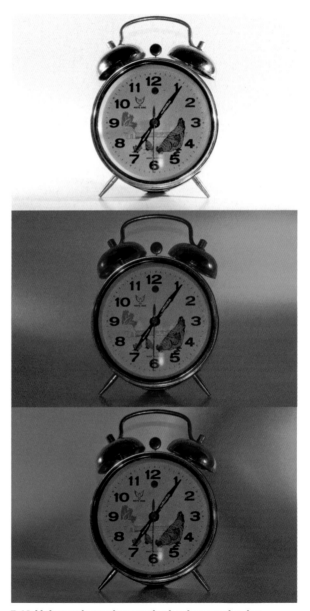

5.13 Using gels to change the background color

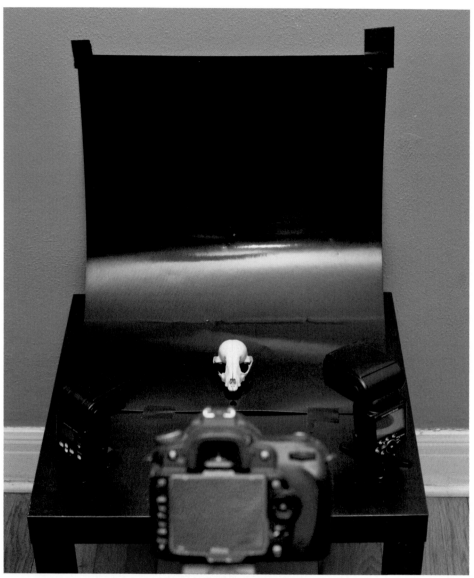

5.14 A simple shot setup using a plain black background.

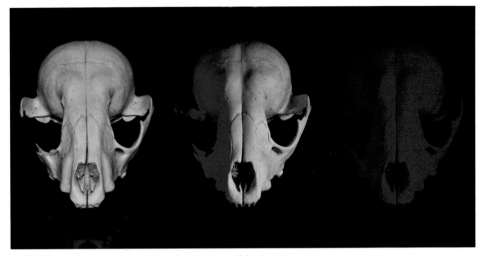

5.15 Filters were used to add color to the subject.

Transporting Your Portable Studio

The main reason to have a portable studio is so that you can travel with it, right? Well now you have all of this gear: cameras, lenses, tripod, light stands, umbrellas, not to mention your Speedlights. That's a lot of stuff. How do you transport all of these supplies easily? You need to find some sort of case, of course.

I assume that most of you already have a camera bag to carry your camera and lenses, so I'm not going to cover all of the many different kinds of camera bags that are available.

Many light stand kits and background stand kits come with carrying cases, but these usually aren't very big or durable and they can't fit all of your gear. Personally, when I'm traveling I like to carry as few bags as possible. For many years I traveled the country flying to hair salons to photograph hair models for the stylists' portfolios, and I needed to bring a portable studio with me. The first few trips out I had many different cases and bags for my equipment and more often than not I had to pay extra to fly with all this extra baggage. I decided that I needed to consolidate all of my equipment.

I checked out the camera store in my area and online and there were some great cases, but they were either too large for my needs or they didn't have enough storage space for all of the equipment I needed. At my local Army surplus store I found the perfect case — a 46-inch tactical rifle bag. This soft-sided bag is made out of durable ballistic nylon and is padded to help protect your equipment. It has two storage areas, a large one for your stands and tripod and a smaller one that fits umbrellas perfectly.

5.16 The perfect solution for carrying my portable studio is actually a gun case, but it holds everything I need in one bag.

It also has three large removable pouches that perfectly fit your Speedlights and other small accessories like clamps and things. It has a convenient hand carrying strap as well as a shoulder strap.

I couldn't ask for a more perfect bag and as an added bonus it was affordable, too — less than $70.

Of course, this solution might not be ideal for your portable studio equipment, but there are quite a few other options. There are many different types of bags and cases to hold lighting equipment from simple unpadded roll-up bags for light stands to partitioned hard cases that can hold any number of stands, umbrellas, and Speedlights. You are sure to find something that will work for your setup. The choice really depends on your budget, the level of protection you need, and size requirements. However, I have found the rifle bag option to be the most versatile option. It's relatively inexpensive, the padding provides some level protection, and it fits just the right amount of equipment without being too large.

5.17 The rifle bag even has removable compartments that fit Speedlights and other small accessories.

Advanced Flash Techniques

Now that you're familiar with the layout, buttons and functions of your Speedlights, it's time to get out there and use them in the real world. This chapter goes into a few of the most common types of photography that you will likely be attempting. This chapter isn't meant to be an all encompassing photographic workshop but to simply offer insights on how to approach the subject as well as different tips and tricks that I have learned in my years of working with the Nikon Creative Lighting System.

Mastering advanced techniques will afford you the opportunity to get even more creative with your images.

Action and Sports Photography

For the most part when shooting any type of action, flash isn't generally used. Most sports take place outside where there's plenty of light or indoors where you're generally too far away from the action for the flash to have much of an effect on the subject, which is why most people don't think about using flash when photographing action. However, a great reason to use flash when photographing any type of action outside is a technique that's been discussed numerous times throughout this book: fill flash. When shooting outdoors in the sunlight, you can get very dark shadow and very bright highlights. Your Speedlight can help to fill in these shadows, giving your subject less contrast.

Your Speedlight is going to be best utilized if you can get fairly close to the subject. If your Speedlight is any farther than 15 to 20 feet away from your subject, you may want to try getting the shot without using a Speedlight or try a different vantage point or angle.

Setup

Although most sports are shot without flash, there are sports such as skateboarding and BMX and other similar sports that follow the exception rather than the rule. These days almost every great shot you see of these types of sports is shot with a flash.

For figure 6.1 I used a Speedlight to light Darin, the skateboarder, but I also kept the background in mind when choosing my settings. Although it was nearing dusk, there was still enough light in the sky to give it a normal dull-blue appearance. I was looking to get a very dynamic image, and I wanted to underexpose the background to give the skies more punch and to give the image a darker nighttime appearance.

I first set my camera to Spot meter. I then aimed the lens at the brightest spot in the sky, which was just over the horizon. I took the reading then I subtracted two stops from it and I had the exposure I was looking for, which was 1/500 second.

I used two Speedlights to achieve this shot — the D700 built-in flash as a commander and an SB-800 as a remote. I set the built-in flash to Commander in CSM e3, I set the mode to "– –" so that the commander wouldn't add any exposure, and I set Group A to TTL. Next I set the SB-800 to function as a remote and used the AS-19 Speedlight stand to hold it. I positioned the SB-800 on the lip of the ramp near the center off to the left of the camera. I used the built-in wide-angle diffuser to soften the light just a bit and to give flash a little more coverage.

The first couple of shots I took with straight TTL weren't quite bright enough to make the subject really stand out so I adjusted the Flash Exposure Compensation in the Commander mode menu to +2 EV. This gave me just the amount of light that I was looking for, perfectly exposing the subject and allowing him to "pop" from the background.

6.1 In this image the ambient background was slightly underexposed and the Speedlight was used to allow the subject to "pop" from the background. The exposure was set manually while the Speedlight was set to TTL with some FEC added.

I also used a fisheye lens to give extreme perspective distortion, giving the image more impact. I shot this with a 16mm f/2.8 Fisheye lens made in Russia by Zenitar. When using an ultrawide or fisheye lens with a Speedlight, there is a tendency for the flash to cause flaring in your images, so the Speedlight should be set up behind the area of the lens coverage if at all possible.

CAUTION Care must be taken when using an ultrawide lens to give your image some perspective distortion for effect. This ultrawide lens makes it look like I'm standing farther away from the action than I really am; the rider was actually less than a foot from my lens. Although ultrawide lenses can add some great flare to your photos, you need to be extremely careful when getting this close to the action.

Tips and tricks

In addition to employing a Speedlight to add punch, you can also add some interest to your action photographs with the use of Slow sync flash. With Slow sync flash you combine the use of the flash, which freezes the subject, and a slow shutter speed, which captures some of the ambient light and allows you to capture some of the movement conveying a sense of action.

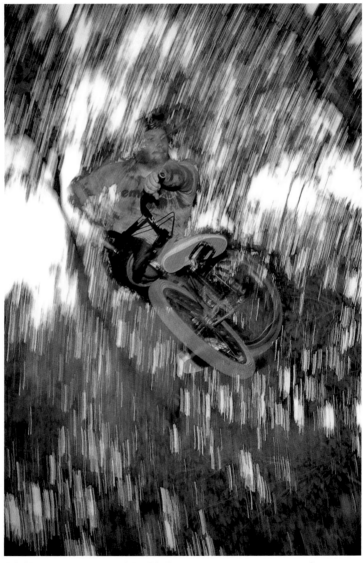

6.2 Slow sync was used in this image to capture a sense of movement. Using Aperture Priority and selecting a small aperture allowed me to get a slow shutter speed.

For figure 6.2 I was at the 9th street dirt jumps in Austin, Texas, which is a world-famous spot that attracts BMX riders of all skill levels, from amateur to professional. At the best of times, 9th street is a very difficult place for shooting. The whole place is under the cover of trees, so the light is fairly dim, and you're generally shooting up into the canopy of the trees, so the background is very mottled with extreme bright spots from the sky showing through the darkness of the leafy tree branches. For this reason it's almost a necessity to use a flash to separate the rider from the background. Shooting without a flash gives you an image where the rider just blends in with the foliage, which isn't great.

The setup for this shot was simple. I used an SB-600 mounted to the hot shoe of a D90. I set the flash mode to Slow sync with the camera in Aperture Priority. I closed down the aperture to f/9, which gave me a relatively slow shutter speed of 1/15 second, and I panned along with the rider. The slow shutter speed allowed the ambient light to become a blur in the background, and the flash brought out the details of the rider.

When your camera is set to Shutter Priority or Manual mode, Slow sync can **NOTE** only be used in conjunction with Rear-curtain sync. In either of these two exposure modes you choose the shutter speed so you will, in effect, be in Slow Sync mode by default. The camera flash info will not display "Slow" only "Rear."

Some other handy tips for shooting action include:

▶ **Scope out the area to find where the action is.** Getting a great action shot is being at the right place at the right time. Before you break out your camera and start shooting, take some time to look around to see what's going on.

▶ **Stay out of the way!** Be sure you're not getting into anybody's way. It can be dangerous for you and the person doing the activity. Be sure your Speedlight isn't going to blind the athlete.

▶ **Practice makes perfect.** Action photography is not easy. Be prepared to shoot a lot of images. After you get comfortable with the type of event you're shooting, you learn to anticipate where the action will be and you'll start getting better shots.

Concert Photography

Concert photography is another type of photography that flash isn't often used for. For the most part the more famous performers and larger venues don't allow flash photography.

Although I try to use flash sparingly (if I'm allowed) when shooting concerts, some-times it's inevitable, especially at smaller venues where the lighting is almost nonexis-tent. Sometimes the stage lights can oversaturate the colors of your image resulting in a loss of a detail, so using a little flash can help cut through the saturation.

Setup

More often than not, if I'm using my Speedlight at a concert, I'm also using Slow sync. This allows some of the ambient light into the scene so your images don't look too "flashed." If you're not careful, the flash can take all of the life out of your image, causing it to look flat and lifeless.

As described in the previous section on action photography, using Slow sync can also allow you to capture a sense of movement in a still photograph by introducing some motion blur and ghosting.

Below, I caught the bass player for the New York hardcore band Agnostic Front in midjump. Using Slow sync with the Speedlight on-camera, I captured the movement yet I still froze the subject.

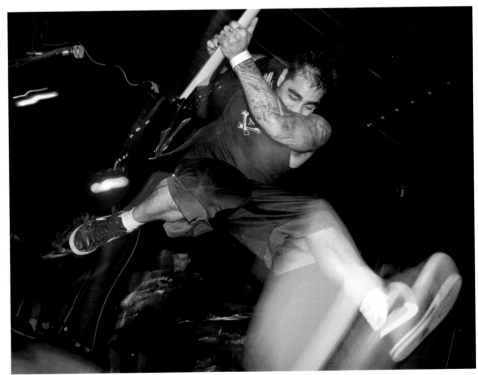

6.3 Using Slow sync allows you to capture a sense of movement.

Tips and tricks

A fun trick you can try when using Slow sync is zooming the lens in or out while the camera is making the exposure. This is another great way to add some movement and interest to a photograph.

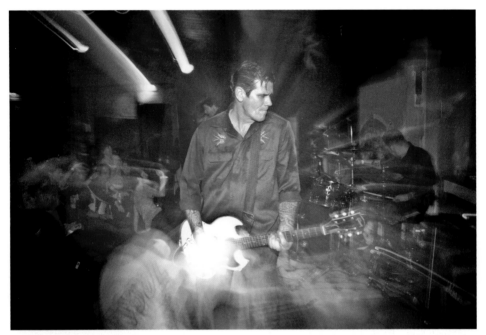

6.4 Using Rear-curtain sync in conjunction with Slow sync and zooming your lens out allows you to create an interesting effect.

Above, I used an SB-900 on-camera in the hot-shoe mount. I set the Flash mode to Rear-curtain sync. With Rear-curtain sync selected in low light when using Aperture Priority or Programmed Auto, the camera automatically defaults to Slow sync as well. For this shot the shutter speed was a slow 0.8 seconds. I started the exposure at 70mm and while the exposure was being made I zoomed out to 28mm. At the end of the exposure, the flash popped, freezing the image of TSOL's guitarist Ron Emory. As you can see, the slow shutter speed also allows the ambient light to register, adding bright vibrant colors to the scene.

Some other things you might want to think about when shooting concerts include:

▶ **Experiment.** Don't be afraid to try different settings and long exposures. Long exposures enable you to capture much of the ambient light while freezing the subject with the short bright flash.

▶ **Call the venue before you go.** Be sure to call the venue to ensure that you are able to bring your camera in. If they do allow photography, be sure to confirm that they allow your type of equipment. I've been at an event that allowed photography but didn't allow "pro-level" equipment. The management's idea of pro-level equipment and my idea of pro-level equipment didn't quite mesh, therefore, my camera gear had to be stashed in the car.

▶ **Bring earplugs.** Protect your hearing. After spending countless hours in clubs without hearing protection, my hearing is less than perfect. You don't want to lose your hearing. Trust me.

▶ **Take your Speedlight off of your camera.** If you can, use your built-in flash as a commander to get the Speedlight off of your camera, or invest in an SC-29 TTL hot-shoe sync cord. When you're down in the crowd, your Speedlight is very vulnerable. The shoe mount is not the sturdiest part of the flash. Back before wireless flash, I had a couple of Speedlights broken off at the shoe, which can be an expensive fix. Using the Speedlight off-camera is not only safer but also provides more control of the light direction because you hold it in your hand. This reinforces the suggestion to experiment — move the Speedlight around; hold it high; hold it low; or bounce it. This is digital, and it doesn't cost a thing to experiment!

Macro Photography

Macro photography, sometimes referred to as close-up photography, brings the subject up close to the viewer, revealing details that aren't normally seen by the naked eye.

By definition, macro photography reproduces the image on the sensor at exactly the same size or bigger than the actual object. The magnification of macro lenses is often referred to as a ratio: 1:1 being life size, 1:2 being half size, 2:1 being twice the size, and so on. Recently most manufacturers have blurred the distinction between true macro photography and close-up photography by marketing lenses that are 1:2 or 1:4 as macro lenses.

Technically macro photography can be difficult. The closer you get to an object, the less depth of field you get, and it can be difficult to maintain focus. When your lens is less than an inch from the face of a bug, just breathing in is sometimes enough to lose focus on the area that you want to capture. For this reason, you usually want to use the smallest aperture your camera can handle and still maintain focus. I say usually, because a shallow depth of field can also be very useful in bringing attention to a specific detail.

When using flash for macro photography, you want to get the flash as close to the axis of your lens as possible. You do this in an effort to achieve good, strong, flat lighting, which results in maximum detail. Traditionally for macro photography, a ring flash is used. A ring flash attaches to the end of the lens and has a flash tube that forms a ring around the end of the lens. Nikon has taken the ring flash one step further and created a Speedlight setup designed especially for macro and close-up photography, the R1 and R1C1. These kits place the SB-R200 Speedlights directly on the end of the lens using a special adapter (SY-1). The great thing about this setup is that you can attach up to four SB-R200s with the adapter ring, or on a stand, you can use up to eight. You can position them to shape the light similarly to that of setting up lights for portrait photography. You can also use the SB-R200s off-camera if you desire.

Setup

For figure 6.5 I simply attached two SB-R200s to the SY-1 attached to a Nikon 105mm f/2.8 VR macro lens and used an SU-800 in closeup mode to trigger the SB-R200s. To ensure that the electronic components were in focus, I set the camera to Aperture Priority and used a very small aperture of f/32. The SB-R200s were used in the TTL mode. This type of lighting setup is perfect for technical images such as this where you need to see details unimpeded by shadow areas.

When using a built-in flash, SB-900, or SB-800 to control the SB-R200s, the setup is the same as if you were using any other Speedlight as a remote. The SU-800 as a controller for macro lighting offers a different option. First of all, you need to switch the SU-800 to close-up mode by opening the battery chamber. Inside the chamber is a switch that when flipped to the up position (there is a flower icon) puts the SU-800 in close-up mode.

In close-up mode the settings are very different than your normal settings for wireless flash. By default in TTL, the SU-800 allows you to control the lighting ratio using two groups of flashes (A and B) This is referred to as "dual-light" in the Nikon literature. Using the left and right arrows, you can adjust the lighting ratio from 1:1 to 1:8 or 8:1. In addition to setting the ratio, you can also adjust the flash exposure compensation (FEC) of the TTL reading for both groups at once by pressing the Select button until the EV setting appears on the LCD. When it's blinking, it's ready to be adjusted by pressing the left or right arrow button.

If you don't want to use the lighting ratios you can press the A<->B button to select to control Group A or Group B singly using TTL. You can also choose to have both Groups A and B controlled using Manual exposure.

6.5 TTL was used to get an even exposure. An SU-800 set to Close-up mode with a lighting ratio of 1:1 was used to trigger the SB-R200s.

You can also add a third group, Group C, by pressing and holding the Select button for about 2 seconds. This is referred to by Nikon as "triple-light". The settings for Group C appear at the bottom of the LCD. When using 3 Groups in close-up mode Group C can only be set manually; no TTL metering is available. To adjust the output of Group

C, press the Select button until the Group C output level is flashing; you can then use the left and right arrow buttons to change the settings. Pressing the A<->B button still allows you to control A or B singly with TTL while still having Group C being controlled in Manual.

Tips and tricks

One of the best tips I can offer is to take advantage of the lighting ratios. If all of your Speedlights are firing at the same output, the lighting on your subject is going to appear flat and lifeless. Of course, sometimes this flat lighting is exactly what is called for. For example, if you are photographing a circuit board or something else of a technical nature, you probably don't want shadows and textures in your photo. Good flat lighting is excellent in those situations. When you're photographing things of a more artistic nature — flowers, insects, or even small inanimate objects — shadows and textures can definitely add some interest to your image. This isn't to say that flat lighting can't be used artistically; it absolutely can, as seen below. The important thing is to experiment and try out different methods. Keep in mind that the SB-R200 can be moved around to different positions on the SY-1 so you can try different lighting patterns.

6.6 A lighting ratio of 1:1 was used to achieve balanced flat lighting. Using TTL metering usually yields the best results when flat even lighting is required.

If you don't have an R1 or R1C1 kit, you can still easily do macro photography using a Speedlight. More often than not I use an SB-600 or SB-800 for close-up and macro photography because, to be honest, it's too much of a chore to put all the attachments of the R1C1 macro lighting kit on the camera. Most of the time I use an SU-800 or the built-in flash as a commander and hold the Speedlight up next to the lens exactly where an SB-R200 would be positioned. Another easy option if you don't have a built-in flash or if yours doesn't offer AWL control is an off-camera TTL cord such as Nikon's SC-29.

> When using the built-in flash as a commander for close-up photography, be sure to use the SG-3IR infrared panel to reduce any exposure from the built-in flash. The SG-3IR is included with the R1 kit or can be purchased separately for about $13.

6.7 A dedicated macro lighting setup isn't a necessity to get good macro shots using a Speedlight.

Above, I held an SB-800 in my hand next to the lens hood. The SB-800 was triggered using an SU-800. In addition to the SB-800 as the main light I also set up an SB-600 in the background pointed straight up to the ceiling to add some light to the background, which was appearing muddy and dim in the initial shots. The SB-800 was set to TTL with FEC set to +1 EV.

Night Photography

While photographing in the daylight is a pretty straightforward proposition, taking photographs at night comes with a whole different set of obstacles to overcome. Low-light situations sometimes require extra equipment such as fast lenses and tripods.

Speedlights are a big help when photographing subjects at night, but even using a Speedlight can be tricky because although Speedlights by definition are meant to enable you to take photos in low light they don't really give the best quality light, therefore your images can suffer.

The main trouble is that while the Speedlight lights up your subject sufficiently, the background just doesn't have enough ambient light to make an impact on the exposure, therefore your subjects often look as if they are in a black hole, so to speak.

When doing night flash photography, you want to try to get an evenly exposed image, allowing the background lights and colors to shine through while achieving a good sharp exposure on the subject.

Setup

For figure 6.8 to compensate for the black hole effect, I used Slow sync flash. Using Slow sync allows you to use a slower shutter speed to capture some of the ambient light in the background. This brings out the details of the background so you don't have a completely black background with a brightly lit subject. In the photography trade, this is often referred to as dragging the shutter.

The camera was set to Programmed Auto and the exposure settings were f/7.1 at 0.4 seconds. Often when I'm just shooting random or candid shots, I'll set the camera to this mode so I can forget about the settings and concentrate on capturing whatever scene that presents itself. I took this shot at a street fair in downtown Austin.

Tips and tricks

Sometimes when photographing subjects at night you come across a situation where different parts of the scene have different levels of lighting. You can use your Speedlight to add some illumination to areas that aren't as brightly lit.

6.8 Dragging the shutter allows you to capture some of the ambient light in the scene. Setting the Speedlight to TTL and Slow sync allows you to focus on composition while capturing interesting scenes.

As you can see in figure 6.9, the Texas state capitol building is brightly lit while the underground rotunda that's in the foreground of the shot has much less light and is about 2 stops underexposed. In order to get a balanced exposure, I use two Speedlights fired into the rotunda to illuminate the scene.

6.9 The foreground of this image is underexposed and would benefit from some added light.

I used an SU-800 on my D700 to control two Speedlights, an SB-800 and SB-900. I set both of the Speedlights to fire as one single group. At first I tried using the TTL mode, but the rotunda being a fairly large structure still wasn't getting enough light from the Speedlights. In the end I decided to go a different route; I turned off the SU-800 and set both Speedlights to Manual mode. Because the exposure time was a fairly long 4 seconds, I simply tripped the shutter and fired both Speedlights at full power twice by pressing the test fire button. Adding light to a scene in a situation like this is often called *painting with light*. What you're doing is adding light only to certain parts of the scene without changing the exposure on the main subject.

A couple additional low-light shooting tips include

▶ **Bring a tripod.** Even when using flash, handholding your camera at night can sometimes cause your images to be blurry. A tripod gives your camera the stability it needs to get sharp images in the dark. A tripod was necessary to get the shot in figure 6.10.

6.10 Painting with light allowed me to add some light to the scene to achieve an even exposure. Painting with light requires a long shutter speed. Use Manual exposure mode on your camera to set the shutter speed and aperture using the cameras light meter as a starting point for your exposure settings.

▶ **Use a higher ISO setting.** Sometimes when using Slow sync, the shutter speed will be much longer than you want it to be. Adjusting the ISO sensitivity to a higher setting will give you a faster shutter speed.

Portrait Photography

Portrait photography can be one of the easiest or one of the most challenging types of photography. Almost anyone with a camera can do it, yet it can be a complicated endeavor. Sometimes simply pointing a camera at someone and snapping a picture can create an interesting portrait; other times elaborate lighting setups may be needed to create a mood or to add drama to your subject.

A portrait, simply stated, is the likeness of a person — usually the subject's face — whether it is a drawing, a painting, or a photograph. A good portrait should go further than that. It should go beyond simply showing your subject's likeness and delve a bit deeper, hopefully revealing some of your subject's character or emotion.

You have lots of things to think about when you set out to do a portrait. The first thing to ponder (after you find your subject, of course) is the setting. The setting is the background and surroundings, the place where you'll be shooting the photograph. You need to decide what kind of mood you want to evoke. For example, if you're looking to create a somber mood with a serious model, you may want to try a dark background. For something more festive, you may need a background with a bright color or multiple colors. Your subject may also have some ideas about how they want the image to turn out. Keep an open mind and be ready to try some other ideas that you may have not considered.

There are many different ways to evoke a certain mood or ambience in a portrait image. Lighting and background are the principal ways to achieve an effect, but there are other ways. Shooting the image in black and white can give your portrait an evocative feel. You can shoot your image so that the colors are more vivid giving your photo a live, vibrant feeling, or you can tone the colors down for a more ethereal look.

Indoor

Indoor portraits are shot indoors, of course. More often than not when shooting inside there isn't enough available light to make a good exposure. This is where flash comes into play. Of course, you can just pop up the built-in flash and shoot away, or you can slide a Speedlight into the hot shoe and similarly just snap off some shots. Of course, the Speedlight gives you enough light to properly expose the subject, simple as that, but the picture will be more of a snapshot and less of a portrait.

Lighting plays a key role in any portraiture. The lighting sets the mood of the image. You can use low-key lighting that gives you a lot of shadows and adds an air of mystery to your portrait, or you can use bright lighting that brings out the details of the facial features and can add a festive air to your shots.

When shooting indoors you pretty much have complete control of the lighting. You can choose a simple lighting setup using one Speedlight, or you can use multiple Speedlights to create different effects to add texture and ambience to your portraits.

The simplest way to use a Speedlight for indoor portraiture is to employ bounce flash. Simply mounting your Speedlight into the hot shoe and tilting or rotating the flash head so that the light reflects off of a ceiling or wall onto your subject is often enough to get a nice portrait.

 For more on bounce flash, see Chapter 3.

Of course, you can also create more elaborate lighting setups. For all intents and purposes, you can create the same types of portraits in your living room as a pro can in the studio.

6.11 For this shot, I employed three Speedlights. An SB-900 was used on camera as a master, an SB-600 (Group A) was camera left, and an SB-800 (Group B) camera right. All Group flash modes were set to TTL and to the Master flash –1.3 EV of FEC was applied.

Outdoor

The main difference between outdoor portraits and portraits taken indoors and in studios is the use of lighting. For an outdoor portrait taken during the day, the sun, being the brightest light source, is generally used as your key light. Your Speedlight is used to fill in the sometimes harsh shadows created by the bright sun.

I find the best way to use the Speedlight for outdoor portraits is to set it to the Balanced Fill-Flash setting. The camera meter takes a reading of the overall brightness of the scene and uses this reading to provide just enough light from the flash to fill in the shadows without looking like flash was used.

6.12 For this outdoor portrait I used an SB-900 on camera with the SW-15H diffusion dome add fill and to get nice even lighting.

When shooting outdoors, paying close attention to the way the light is falling on your subject is important. Finding a location that has good lighting and makes an attractive background is the key to a successful outdoor portrait.

Keep in mind that when shooting outdoor portraits the best time is usually in the early morning or early evening. The light at this time usually gives off a nice warm glow and is much softer and diffused than the light is when the sun is high in the sky. You will hear some photographers refer to this time as the golden hour.

Although the sun is usually used as your main light in an outdoor portrait, there are ways around it. You can adjust your exposure settings so that the effect of the sun is minimized and you can use the Speedlight as the main light. This usually gives you an underexposed background that can give your portraits a more dramatic look. This trick usually works best when the sky is in the background.

6.13 Slightly underexposing the background gives you more saturated colors in the sky which can yield interesting results.

To achieve this effect is relatively simple. You will need to set your camera flash sync speed to Auto FP (High-speed sync). This is done in the Custom Settings menu of your camera; see your camera's owner manual if you can't find it on your own. Next meter on the brightest area of the scene; you can either take a note of the exposure settings then set them using Manual exposure mode or you can use the AE-L feature on your camera. Setting your Speedlight to AA seems to yield the most predictable results, but TTL can also be used. When using TTL, some FEC is usually necessary. I find that +1.3 EV usually does the trick. Of course, you can also set the flash output manually if you wish. Next, just focus and snap the picture as normal. Check the image review and adjust the output if you think you need to.

Pet Portraits

This is one of my favorite types of photography. I love animals and trying to capture the personality of a pet in a still image is often challenging but is fun and rewarding as well. For the most part, the techniques for pet photography are the same as for people portraits. You can still use bounce flash or you can set up elaborate lighting schemes. Using fill flash outdoors is also another technique that can be used.

For figure 6.14 I went for a studio portrait look for my Boston terrier Henrietta. I set up a roll of seamless white paper for the background. The lighting setup was deceptively simple. I used the built-in flash of the D90 to control an off-camera SB-900. The SB-900 was attached to a stand and fired through a softbox set up at camera right. The SB-900 was set to Group A and set to TTL mode. A reflector was placed on the left side to add some fill light. This is an example of a nice clean portrait shot that appears to have elaborate lighting, but in actuality only took minutes to set up.

 See Chapter 5 for more details on softboxes and other lighting modifiers.

6.14 Simple lighting schemes can yield brilliant results.

For figure 6.15 I simply popped up the built-in flash set to TTL and snapped a shot of my dog Maddie. The i-TTL balanced fill-flash feature works excellent in situations like this.

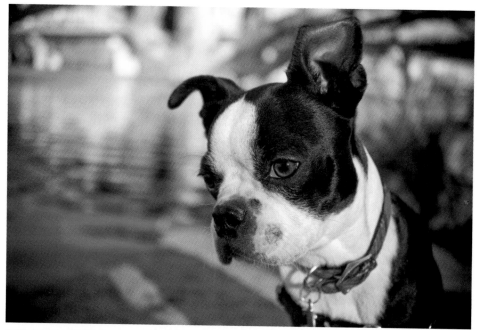

6.15 A little fill flash goes a long way. Sometimes letting the camera take care of all the settings is the easiest way to shoot pet portraits.

Some other handy tips for taking pet portraits include:

▶ **Be patient!** Animals aren't always the best subjects; they can be unpredictable and uncooperative. Have patience and shoot plenty of pictures; you never know what you're going to get.

▶ **Bring some treats.** Sometimes animals can be compelled to do things with a little bribe.

▶ **Get low.** Because we're used to looking down at most animals, we tend to shoot down at them. Sometimes getting down low and shooting from the animal's perspective can add an interesting perspective.

Special Effects Photography

Your Speedlight can be used to add a few special effects to your images. There are the simple effects such as attaching filters to add color to your images or effects that are in conjunction with the camera settings such as Slow and Rear-curtain sync.

One of the most interesting aspects of flash photography is that it gives you the ability to freeze a split second in time, allowing you to view things that happen too quickly for us to perceive. Harold "Doc" Edgerton, the inventor of the electronic flash, was also the first person to use flash for high-speed, stop-action photography. It's likely that you've seen his images; they are some of the most iconic images in photography. Doc was the first person to photograph the crown resulting from a milk drop. This image was displayed in the Museum of Modern Art's very first photography exhibit, although Doc himself insisted that he was not an artist, only an engineer.

The reason why Speedlights can seemingly freeze time is due mostly to the *flash duration*, which is quite simply the amount of time that the flash is actually lit. When using a Speedlight, the shutter speed is irrelevant when it comes to making the exposure. The flash duration supercedes the shutter speed because there generally isn't enough ambient light to affect the exposure (of course, using Slow sync changes this). So the flash duration, in effect, acts as the shutter speed. The lower the output setting of the Speedlight, the shorter the flash duration. Table 6.1 gives you the approximate flash duration times at the manual output settings.

Table 6.1 Flash Duration

Output level	SB-900	SB-800	SB-600
M 1/1	1/880 sec.	1/1050 sec.	1/900 sec.
M 1/2	1/1100 sec.	1/1100 sec.	1/1600 sec.
M 1/4	1/2550 sec.	1/2700 sec.	1/3400 sec.
M 1/8	1/5000 sec.	1/5900 sec.	1/6600 sec.
M 1/16	1/10,000 sec.	1/10,900 sec.	1/11,100 sec.
M 1/32	1/20,000 sec.	1/17,800 sec.	1/20,000 sec.
M 1/64	1/35,700 sec.	1/32,300 sec.	1/25,000 sec.
M 1/128	1/38,500 sec.	1/41,600 sec.	N/A

Why is flash duration important, you may wonder? Well, because the flash duration is so quick, you can freeze the movement of very fast-moving subjects such as the wings of a hummingbird or the crowning of a milk drop as it hits a surface, as shown in figure 6.16.

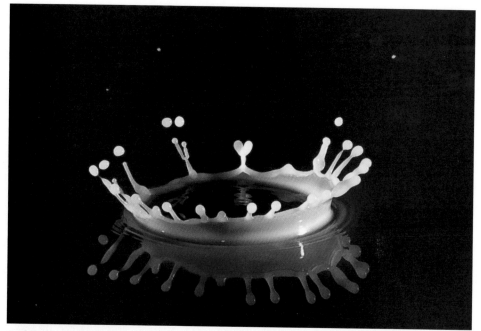

6.16 Short flash durations allow you to capture high-speed events. Shots like these require a dim environment so the ambient light doesn't contaminate the image causing ghosting.

Setup

To shoot the above photo, the light setup was the easy part; the hard part was getting the timing right to capture the exact moment of impact. It helps to have an assistant to drop the liquid while you concentrate on snapping the photo. There are triggers you can buy or build to make this easier; the North Carolina School for Science and Mathematics has a helpful Web site that describes some of the different types of triggers that can be used. The Web site is http://courses.ncssm.edu/hsi/pacsci/fpaper. html.

The lighting setup was simple; I used one SB-600 and triggered it using an SU-800. The output was controlled manually and was set to the lowest power setting to achieve the fastest flash duration. If the flash duration isn't short enough, the image will blur the same as if you were photographing a moving subject and used too slow of a shutter speed. If you plan on using the built-in flash to trigger, be sure to use an SG-3IR to block the output because even when set to "− −", the built-in flash can add some exposure when shooting close up. The Speedlight was placed at camera right aimed where the drop was to fall.

Tips and tricks

In the below figure, I used a couple of different special effects techniques in one shot. The image is a simple drop of water falling into a sink half full of water. All you have to do here is allow the tap to drip and you have a predictable subject, which makes it much easier than dropping milk from a dropper.

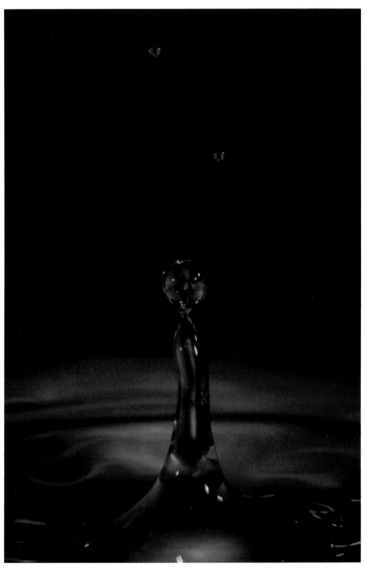

6.17 Adding color filters to your Speedlights can yield interesting results.

I used two Speedlights and an SU-800 for this setup. For the main light I used an SB-900 with a blue filter. This Speedlight was set manually to an output setting of M 1/32 and placed at camera right just out of the frame. The idea here is to get the Speedlight as close to the subject as you can so you can use a lower setting for a quicker flash duration.

The second Speedlight was an SB-800 aimed at the background with a red filter attached. This Speedlight was also set manually to M 1/64. The idea here is to use a setting to get an equal or shorter flash duration than the main light. If the flash duration of the background is slower than that of the main light, it can cause some ghosting and blurring.

The combined colors of the gels gave the water an interesting appearance that is similar to fire. Incorporating two or more flash techniques into one photograph can sometimes yield very interesting results.

Still-Life and Product Photography

Still-life scenes have been around for a long time; artists through the centuries have been using arrangements of objects as subjects for their compositions. For all practical purposes, still-life and product photography is basically the same.

Whether photographing a still-life scene for art's sake or a product to use the image to post on eBay, lighting is the key to making the image work. You can set a tone using creative lighting to convey the feeling of the subject. You can also use lighting to show texture, color, and form to turn a dull image into a great one. And remember, if your product looks better on eBay, more people will be inclined to buy it.

When practicing for product shots or experimenting with a still life, the first task you need to undertake is to find something to photograph. It can be one object or a collection of objects. Remember if you are shooting a collection of objects, try to keep within a particular theme so the image has a feeling of continuity. Start by deciding which object you want to have as the main subject then place the other objects around it, paying close attention to the balance of the composition.

The background is another important consideration when photographing products or still-life scenes. Having an uncluttered background in order to showcase your subject is often best, although you may want to show the particular item in a scene. An example of this would be possibly photographing a piece of fruit on a cutting board with a knife in a kitchen.

Diffused lighting is essential in this type of photography. You don't want harsh shadows making your image look like it was shot with a flash. The idea is to light it so it doesn't look as if it was lit. You want to use an umbrella or softbox to soften the shadows. If none of these is available, bouncing the flash off of the ceiling or a nearby wall can do the trick.

Even with diffusion, the shadow areas need some filling in. You can do this by using a second Speedlight as fill or by using a fill card. A *fill card* is a piece of white foam board or poster board used to bounce some light from the main light back into the shadows lightening them a bit. When using two or more Speedlights, be sure that your fill light isn't too bright, or it can cause you to have two shadows. Remember, the key to good lighting is to emulate the natural lighting of the sun.

Setup

For figure 6.18 I knew that I wanted some directional yet soft lighting. I grabbed an SB-900, placed it in a Photoflex shoe mount bracket, and attached it to a small 2 × 2 foot softbox. This is the main light. Smaller softboxes allow you to get a diffused light source but still give you some directionality. Initially, I placed the light source on a light stand and angled it down, but I was getting a shadow from the guitar neck that I didn't like. I lowered the stand so that the softbox was on the same level as the amp but was still getting a shadow. I then removed the softbox from the stand and set it on the floor. The natural position of the softbox was angled up so it lit up the face of the amp nicely.

With only the main light in place, the amp was casting a shadow over the guitar body. Obviously, some fill was needed. I didn't want the fill to create any shadows or to add too much light to the scene. I just wanted to fill in the shadow while not lighting it too much to keep the dimensionality that the shadow area creates. I grabbed a piece of white foam core and faced it into the shadow area. I then aimed an SB-800 at the foam core to bounce the light to make it very diffused.

Everything was looking pretty good, except that the top of the amp was too dark as was the top edge of the guitar. I grabbed an SB-600, placed it on a light stand, and raised it about 3 feet above the amp's height. I pointed the flash head straight up and bounced the light from the ceiling for a nice diffused fill.

I used an SU-800 to command the three Speedlights. The SB-900 main light was set to Group A, TTL. This setting is a no-brainer for getting a great exposure from your main light without doing any calculations.

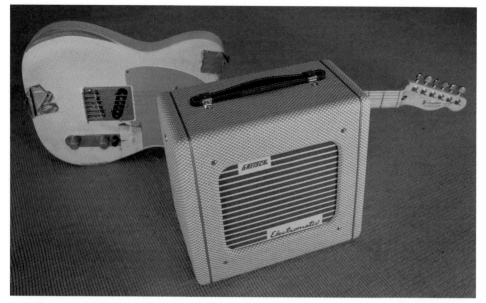

6.18 Using multiple Speedlights at different settings adds depth to your still-life images.

The SB-800 used for the fill light was a little more tricky. I set the SB-800 to Group B, TTL, but the exposure was too much. Even setting the FEC to –3 EV still resulted in an overly bright image. I switched Group B on the SU-800 to Manual mode 1/8. This was the perfect amount of light to fill the shadows but still keep the area low key.

The SB-600 was set to Group C, TTL. The exposure was spot on, but it was taking away too much of the shadows on top of the amp, and along with the shadows went the dimension. The image was looking flat. From the SU-800 I set the FEC to –1 EV and there it was the perfect balance of highlight and shadow.

Tips and tricks

One type of photography that can fall into this category is food photography. Photographing food is very fun but can be a bit tricky at times. Food often has lots of different textures and can cast weird shadows. Often when photographing food I'm on location at a restaurant, and bringing in tons of lighting equipment such as umbrellas and stands is simply out of the question. I usually just bring a couple of Speedlights and a reflector and just wing it.

For food I try to keep the lighting simple. On large commercial shoots there's generally a food stylist and an art director there to keep the food looking fresh, but I generally don't have these luxuries so I try to get the shots done as quickly as I can. I usually end up using only one Speedlight and bouncing it to diffuse the light.

6.19 Bouncing is an easy technique to get great lighting.

Here, I simply set up an SB-900 on the AS-21 Speedlight stand. I pointed the flash head straight up and I had an assistant hold a reflector up above the plate with the smoked mussel on it. The SB-900 was controlled by an SU-800 and was set to TTL mode. The fact the light was bounced from a close source allowed the light to be fairly hard and directional to bring out some texture. Simply bouncing the light from the ceiling would have given the image a much more diffused light.

For figure 6.20, I use another simple lighting setup. I used one SB-600 controlled with an SU-800 set to TTL. The Speedlight was on the table to the left of the drink perpendicular to it. I had forgotten my reflector so I grabbed a drink menu, opened it, and set it in front of the flash head. Bouncing the light from the drink menu gave me a nice directional yet diffused wrap-around lighting that gave the image a nice soft look but allowed the texture in the whipped cream to be evident.

6.20 Sometimes you need to improvise to get the right light.

Some more tips for interesting still life images include:

▶ **Keep it simple.** Don't try to pack too many objects in your composition. Having too many objects for the eye to focus on can lead to a confusing image.

▶ **Use items with bold colors and dynamic shapes.** Bright colors and shapes can be eye-catching and add interest to your composition.

185

▶ **Vary your light output.** When using more than one light on the subject, use one as a fill light, setting it to fire at a lower power in order to add a little depth to the subject by creating subtle shadows.

Wedding and Engagement Photography

Wedding photography is one of the most challenging and nerve-wracking types of photography that can be undertaken. There are a lot of things going on and you get one chance to get it right. Wedding photography can be very complicated, and there isn't enough room in this book to cover all of the facets. There are many great books dedicated solely to wedding photography, and if you plan on doing much of this type of photography I suggest you do some research into some of these books.

In this section, I concentrate on a few flash techniques that will give your wedding images some added flair. When shooting weddings, most often you are not allowed to shoot flash during the ceremony so as not to distract from the bride and groom's biggest moment. Before and after the ceremony you can usually use your Speedlight as much as you like. Generally when photographing weddings, I like to shoot both with and without flash so that my images don't all look the same. I actually have the Function button on my cameras programmed to be a flash cancel button so I can cancel the flash in a split second if I see a shot that would look best in natural light. One of the tricks of being a good wedding photographer is knowing when and when not to use your Speedlight.

First and foremost — and I cannot stress this point enough — *use a diffuser*. The SB-800 and SB-900 come with a diffusion dome, so use it. I can honestly say that I almost never shoot without the diffusion dome on my Speedlight. If you're using the Speedlight mounted to the hot shoe of your camera, put on the diffusion dome and aim the flash head up to the 60-degree position for the best results. This softens the light and allows some of the light to bounce from a ceiling when indoors. When outdoors it's okay to point the flash head straight forward just as long as there is nothing close to the subject in the background such as a wall. If there is something directly behind your subject, you will get the nasty black shadow that I'm sure you've seen in many shots.

There are many types of diffusers on the market today, from simple ones like the Sto-Fen Omni-Bounce to miniature softboxes made by LumiQuest. One of the most popular ones is the Gary Fong Lightsphere. I admit that I was taken in by the great marketing technique and I bought one, but I can honestly say that I didn't find it to work any better than the diffuser that came with the Speedlights (I use a Sto-Fen Omni-Bounce for my SB-600). As a matter of fact, the Lightsphere is so big and bulky that it causes the flash head to drop down all the time. Save your money and pass on this product.

Setup

I used a wide-angle lens to add a little interest to the shot. The obvious perspective distortion that is unwanted in traditional portraits works in our favor here, giving the portrait an interesting aspect.

6.21 Using unconventional techniques can give you dynamic images.

To make this shot even more dynamic I underexposed the background and overexposed the subject a little. I used a similar trick to the one we talked about earlier in the action photography section. Using the camera's spot meter, I took a reading off of the brightest part of the sky. I manually set the exposure for 1/500 second at f/8. The aperture of f/8 was chosen because this is the aperture at which this lens appears the sharpest, and I wanted to carry the depth of field through to the background.

The camera was also set to Auto FP high-speed sync to allow the fast shutter speed. I used one SB-800, off-camera, controlled by the D300's built-in flash. The SB-800 was set to Group A, TTL mode +1 EV. The SB-800 was held in my left hand above my head and aimed down at the couple.

Sometimes when shooting group portraits at a wedding you come across the problem of not being able to evenly light the whole group when using the Speedlight in the hot shoe, especially if the group is large. With the SB-900 you can set the flash pattern to Even and that should help out some, but for bigger groups you often need to get the Speedlight off-camera and use two or more.

For figure 6.22, I used two Speedlights — one SB-800 and one SB-600. I placed one on the left side and one on the right side. Because I try to travel as light as possible when shooting weddings, I didn't have any light stands, so I placed the Speedlights on the nearest stable object that was high enough. Luckily there were candle holders mounted on the posts for the roof, so I was able to place the Speedlights there. I used the built-in flash to control the off-camera Speedlights, setting them both to Group A TTL. I dialed in –0.7 EV FEC to give the shot a more natural look, balancing it a little better with the ambient lighting.

Tips and tricks

After the ceremony and the group shots, you usually have the reception. This is where people are getting more relaxed and you can let loose and try some more creative things with your flash. One great technique is dragging the shutter by using Slow sync. Of course, as discussed before, Slow sync allows more ambient light to add to the exposure.

6.22 Group portraits should be evenly lit. Applying FEC is a good technique to help ensure that the ambient light is properly balanced with the flash.

As with other types of photography, you can use this technique to show motion and to keep the ambience of the scene. Shooting straight flash often gives you the black hole effect referred to in the night photography section. This technique works best when shooting candid shots, and I don't recommend using Slow sync for the more important shots because you can sometimes have ghosting and blurring.

Figure 6.23 illustrates Slow sync in use. As the bride and her bridesmaid were messing around on the dance floor, I snapped this shot. The ambient light warms up the scene, whereas simply using straight flash would have given the whole image a cooler colorcast. As you can see there is some ghosting, which gives the image a feeling of movement.

6.23 Slow sync allows ambient light to be a part of the image.

Some other things to consider when using flash at a wedding include:

▶ **Use FEC.** Don't be afraid to dial in some flash exposure compensation. When photographing the bride, it is usually necessary to up the FEC by +1 to +2 EV to ensure that the dress looks white. The camera meter is thrown off by all the white and tends to underexpose. The opposite is true of the groom; the black tends to cause overexposures, so dialing the FEC down to –1 to –1.7 EV is usually advisable. When photographing them both together, be sure to check your histogram and adjust it appropriately.

▶ **Bounce your flash.** This is probably the easiest and one of the most important flash techniques you can use. Bounce off of ceilings, bounce off of walls, bounce off of whatever you can. Bouncing softens the light and makes the images appear more natural.

▶ **Have extra batteries on hand.** This may seem like a no-brainer, but be sure to have enough batteries on hand. Losing shots because your flash is dead isn't an option when shooting a wedding.

Posing Considerations

Humans convey a lot of expressions and emotions through body language, so it goes without saying that how a person is posed can make a huge impact on the general mood or feeling of the image, so it goes without saying that knowing how to pose your subjects without looking uncomfortable is very important. Posing your model can be one of the most daunting tasks for a photographer.

Sometimes in order to get the right pose, your model may have to bend like a contortionist into awkward positions. One thing to remember about posing is that your models or clients expect you to know what you're doing. You need to be confident and assertive. Acting timid or being afraid to ask your model to do what you need will get you nowhere in the portrait business. Remember, your models rely on you to know what you're doing.

Getting Started

One of the easiest ways to get started with learning posing is to study poses from other photographers or artists. This is as simple as opening a fashion magazine or even looking on the Internet. I keep a folder on my desktop to which I frequently save a small copy of an image that I think is an interesting pose. If I feel particularly uninspired during a photo shoot, I can just open the folder to get some ideas and creative juices flowing.

Some of my favorite poses don't even come from other photographers, but from artists. Alberto Vargas and Gil Elvgren were two artists who painted pinup girls in the 1940s. Their work is iconic and fun. Check these guys out for some inspiration.

AA.1 This pose is reminiscent of a 1940s pinup girl.

When posing your model or client, keep an eye on everything from stray hairs to clothing bunching up in weird ways and limbs jutting out in awkward fashion. Before you trip the shutter, take your time to *really* look closely at everything in the frame.

AA.2 The hands and arms accentuate the angle of the pose in this shot.

Also pay close attention to the hands. Hands can subliminally reveal a lot of information about how a person is feeling. You want to make a conscious effort to tell your model or client to relax the hands. When the hands are relaxed, the model will look and feel more relaxed. Clenched or tense hands can make your portraits look forced or make the model look uncomfortable.

Hands are an extension of the arms and arms too can have an emotional impact on your image. For example, having your subjects cross their arms can show strength and determination or even obstinacy depending on the facial expression.

Have your model hold his or her hands up above their head for a few seconds before taking the shot. This minimizes the appearance of veins in the hand that can show up when the hands are down at the sides for a length of time.

Positioning the Head and Neck

Simple adjustments, such as having the head tilted slightly or resting on an object, can add an artistic effect to any portrait. There are actually a few decisions to make when positioning the head, the first being what type of pose do you and your subject want for the portrait.

For me, the eyes are the most important part of any portrait. Eye contact is a focal point where you need to ask your subjects to focus their gaze toward the camera. For some portraits, you want subjects to direct their eyes in another direction.

When taking portraits, I often have subjects try to focus their eyes in a few directions by first looking directly toward my lens, and then asking them look to the left, right, slightly up, or slightly down.

AA.3 Sometimes, looking away from the camera can create a powerful portrait.

AA.4 Looking up and slightly left

When shooting portraits either indoors or outdoors, consider adding fill flash to create a catch light in your subject's eyes. The eyes are an important component in your overall posing, and attention to detail, such as including catch light, adds to the quality of your portraits.

AA.5 Looking up and turning slightly right

In addition to paying close attention to the eyes, other areas of the head are important as well. You already know about tilting the head, but also remember the hair. For individuals with long hair, make sure you have enough room in your frame to showcase that part of the person.

AA.6 Pay close attention to hair and positioning the head to where the hair is a complimentary part of the composition.

When the head is straight up and down looking directly into the lens, it can convey strength or even hostility. Titling the head to the side a bit usually makes the image more relaxed, especially when the subject is smiling as it helps to portray kindness and empathy in some cases.

AA.7 In a traditional portrait the head is positioned straight up and down and conveys seriousness.

It is an often overlooked part of the portrait: Pay attention to your subject's neck. Necks often reflect weight or age of a subject. To achieve a pleasing portrait, you may consider either hiding portions of the neck with clothing, or positioning the portrait to reduce the amount of the person's neck included in the portrait. While we're on the subject, a good technique to use to reduce double chins is to have your subject slightly tip their head upward.

Additional Tips

There is a lot of ground that could be covered when it comes to posing because there are so very many types of portraits. However, some tips and suggestions cross all of the different styles. The following list has some of my favorite general posing tips:

▶ **One foot behind.** One of the first things I do is have the person put one foot behind the other. This helps distribute the weight evenly and gives a more relaxed appearance. Having the person lean back slightly is also helpful.

▶ **Come in at an angle.** You almost never want the subject to face straight ahead (unless you're a police photographer). Angle the subject slightly away from the camera with one shoulder closer to the camera.

▶ **Tilt the head.** Tilt the head a bit to avoid having the model look static to give the portrait a casual feel. Of course, if the subject isn't casual you probably don't want to do this. For example, you would want to portray a CEO of a corporation with strength and character so keeping the head straight would be ideal.

▶ **Watch the hands!** I can't stress this enough. Also try to keep the hands at an angle. It looks odd if the flat side of the back of the hand or the palm faces the camera. A 3/4 view or the side of the hand is preferable.

Some things to be aware of when composing your portrait:

▶ **Try not to sever limbs!** Be sure not to frame the image in the middle of a knee joint or elbow. Don't cut off the toes or fingers. If the foot or hand is in the image, try to get all of it in the frame.

▶ **Watch out for mergers.** Be aware of the background as well as the subject. Oftentimes you can get so involved with looking at the model you can forget about the rest of the photograph. You don't want your model to look like a tree is sprouting out of her head or a lamp has suddenly grown out of her shoulder.

▶ **Fill the frame.** Make your subject the overwhelming part of the image. Too much background can distract from the subject of the image.

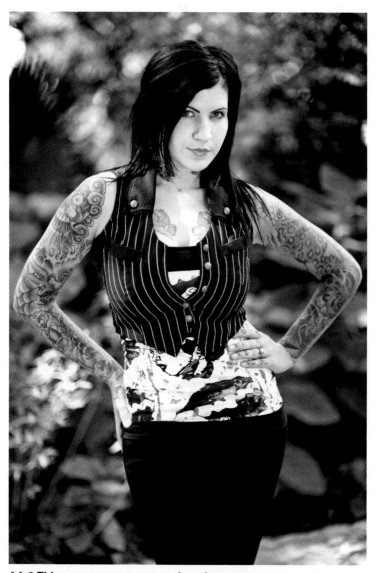

AA.8 This pose suggests strength and empowerment.

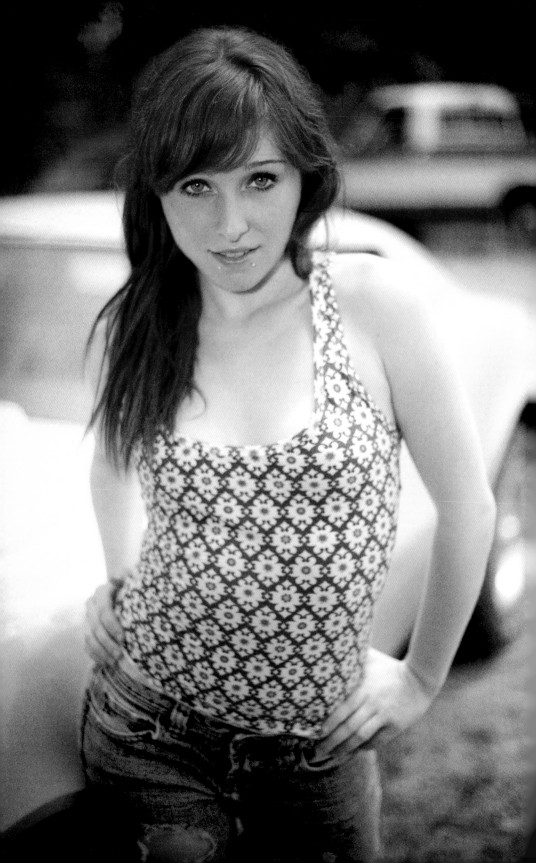

Resources

There is a lot valuable information available on the Internet for photographers. This appendix is a resource to help you discover some of the many ways to learn more about the Nikon Creative Lighting System and about photography in general.

Informational Web Sites

With the amount of information on the Web, sometimes it is difficult to know where to look or where to begin. These are a few sites that I suggest you start with when looking for reliable information about your CLS or photography in general.

Nikon

When you want to access the technical specifications for Nikon Speedlights, cameras, or lenses visit the Nikon Web site http://nikonusa.com.

Nikonians.org

This site is a forum where you can post questions and discussion topics for other Nikon users on a range of photography-related topics. Find it at www.nikonians.org.

Photo.net

The Photo.net site, at http://photo.net, is a large site containing resources from equipment reviews, to forums on a variety of topics, to tutorials, and more. If you are looking for specific photography-related information and aren't sure where to look, this is a great place to start.

J. Dennis Thomas's Digital Field Guide Companion

This is a blog that I publish. I post different tips and tricks as well as updates from Nikon and lots of other tidbits of information. You can find my blog at www.deadsailor productions.com.

Workshops

There are a multitude of different workshops that offer training for photographers. Here is a list of some of the different workshops that are available to you.

Ansel Adams Gallery Workshops

http://anseladams.com

Brooks Institute Weekend Workshops

http://workshops.brooks.edu

Great American Photography Workshops

www.gaphotoworks.com/

Mentor Series Worldwide Photo Treks

http://mentorseries.com

Photo Quest Adventures

http://www.photoquestadventures.com/

Summit Series of Photography Workshops

http://photographyatthesummit.com

Santa Fe Photographic Workshops

http://santafeworkshops.com

Online Photography Magazines and Other

Some photography magazines also have Web sites that offer photography articles and often information that isn't even found in the pages of the magazine. The following is a list of a few photography magazines' Web sites as well as some other photo related sites where you may find useful content.

Digital Photographer

http://digiphotomag.com

Digital Photo Pro
http://digitalphotopro.com

Flickr
http://flickr.com

Outdoor Photographer
http://outdoorphotographer.com

Photo District News
http://pdnonline.com

Popular Photography & Imaging
http://popularphotography.com

Shutterbug
http://shutterbug.net

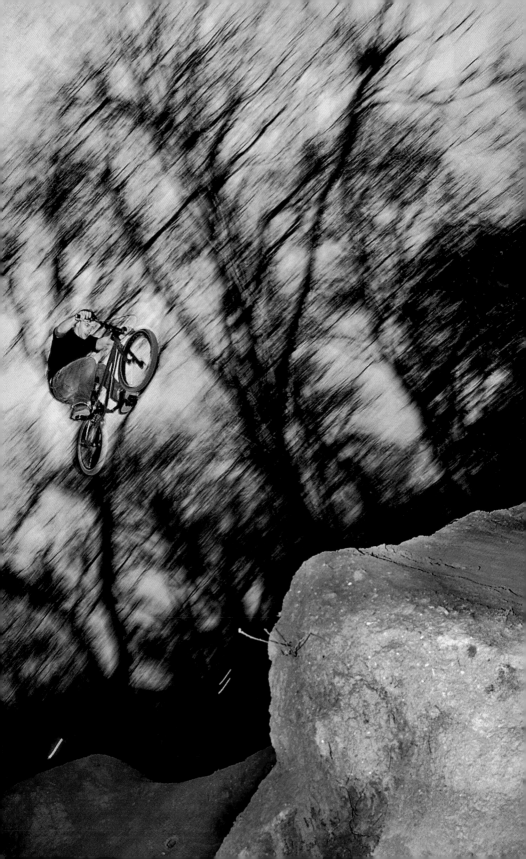

How to Use the Gray Card and Color Checker

Have you ever wondered how some photographers are able to consistently produce photos with such accurate color and exposure? It's often because they use gray cards and color checkers. Knowing how to use these tools helps you take some of the guesswork out of capturing photos with great color and correct exposures every time.

The Gray Card

Because the color of light changes depending on the light source, what you might decide is neutral in your photograph, isn't neutral at all. This is where a gray card comes in very handy. A gray card is designed to reflect the color spectrum neutrally in all sorts of lighting conditions, providing a standard from which to measure for later color corrections or to set a custom white balance.

By taking a test shot that includes the gray card, you guarantee that you have a neutral item to adjust colors against later if you need to. Make sure that the card is placed in the same light that the subject is for the first photo, and then remove the gray card and continue shooting.

 When taking a photo of a gray card, de-focus your lens a little; this ensures that you capture a more even color.

Because many software programs enable you to address color correction issues by choosing something that should be white or neutral in an image, having the gray card in the first of a series of photos allows you to select the gray card as the neutral point. Your software resets red, green and blue to be the same value, creating a neutral midtone. Depending on the capabilities of your software, you might be able to save the adjustment you've made and apply it to all other photos shot in the same series.

If you'd prefer to make adjustments on the spot, for example, and if the lighting conditions will remain mostly consistent while you shoot a large number of images, it is advisable to use the gray card to set a custom white balance in your camera. You can do this by taking a photo of the gray card, filling as much of the frame as possible. Then, use that photo to set the custom white balance.

The Color Checker

A color checker contains 24 swatches that represent colors found in everyday scenes, including skin tones, sky, foliage, etc. It also contains red, green, blue, cyan, magenta, and yellow, which are used in all printing devices. Finally, and perhaps most importantly, it has six shades of gray.

Using a color checker is a very similar process to using a gray card. You place it in the scene so that it is illuminated in the same way as the subject. Photograph the scene once with the reference in place, then remove it and shoot away. You should create a reference photo each time you shoot in a new lighting environment.

Later on in software, open the image containing the color checker. Measure the values of the gray, black, and white swatches. The red, green, and blue values in the gray swatch should each measure around 128, in the black swatch around 50, and in the white swatch around 245. If your camera's white balance was set correctly for the scene, your measurements should fall into the range (and deviate by no more than 7 either way) and you can rest easy knowing your colors are true.

If your readings are more than 7 points out of range either way, use software to correct it. But now we also have black and white reference points to help. Use the levels adjustment tool to bring the known values back to where they should be measuring (gray around 128, black around 50 and white around 245).

If your camera offers any kind of custom styles, you can also use the color checker to set or adjust any of the custom styles by taking a sample photo and evaluating it using the on-screen histogram, preferably the RGB histogram if your camera offers one. You can then choose that custom style for your shoot, perhaps even adjusting that custom style to better match your expectations for color.

Glossary

Active D-Lighting A camera setting that preserves highlight and shadow details in a high-contrast scene with a wide dynamic range.

AE (autoexposure) A general-purpose shooting mode where the camera selects the aperture and/or shutter speed according to the camera's built-in light meter. See also *Shutter Priority* and *Aperture Priority*.

AF-assist illuminator An LED that emits light in low-light or low-contrast situations. The AF-assist illuminator provides enough light for the camera's AF to work in low light.

ambient lighting Lighting that naturally exists in a scene.

angle of view The area of a scene that a lens can capture, which is determined by the focal length of the lens. Lenses with a shorter focal length have a wider angle of view than lenses with a longer focal length. The angle of view of a specific focal length will change depending on the image format, DX or FX. See also *DX* and *FX*.

aperture The physical opening of the lens similar to the iris of any eye. The designation for each step in the aperture is called the *f-stop*. The smaller the f-stop (or f/number), the larger the actual opening of the aperture, and the higher-numbered f-stops designate smaller apertures, letting in less light. The f/number is the ratio of the focal length to the aperture diameter.

Aperture Priority A camera setting where you choose the aperture and the camera automatically adjusts the shutter speed according to the camera's metered readings. Aperture Priority is often used by a photographer to control depth of field.

aspect ratio The proportions of an image as printed, displayed on a monitor, or captured by a digital camera.

autofocus The capability of a camera to determine the proper focus of the subject automatically.

backlighting A lighting effect produced when the main light source is located behind the subject. Backlighting can be used to create a silhouette effect or to illuminate translucent objects. See also *frontlighting* and *sidelighting*.

barrel distortion An aberration in a lens in which the lines at the edges and sides of the image are bowed outward. This distortion is usually found in shorter focal-length (wide-angle) lenses.

bounce flash Pointing the flash head in an upward position or toward a wall so that it bounces off another surface before reaching the subject. This softens the light illuminated on the subject. Bouncing the light often eliminates shadows and provides a smoother light for portraits.

bracketing A photographic technique in which you vary the exposure of your subject over three or more frames. By doing this, you ensure a proper exposure in difficult lighting situations where your camera's meter can be fooled.

broad lighting When your main light is illuminating the side of the subject that's facing toward you.

camera shake The movement of the camera, usually at slower shutter speeds, which produces a blurred image.

catchlight Highlights that appear in the subject's eyes.

Center-weighted meter A light-measuring device that emphasizes the area in the middle of the frame when you're calculating the correct exposure for an image.

colored gel filters Colored translucent filters that are placed over a flash head or light to change the color of the light emitted on the subject. Colored gels can be used to create a colored hue of an image. Gels are often used to change the color of a background or to match the flash output with the ambient lighting by placing the gel over the flash head.

Continuous Autofocus (AF-C) A camera setting that allows the camera to continually focus on a moving subject.

contrast The range between the lightest and darkest tones in an image. In a high-contrast image, the shades fall at the extremes of the range between white and black. In a low-contrast image, the tones are closer together.

dedicated flash An electronic flash unit, such as the Nikon SB-900, SB-800, SB-600, or SB-400, designed to work with the autoexposure features of a specific camera.

default settings The factory settings of the camera or Speedlight.

depth of field (DOF) The portion of a scene from foreground to background that appears sharp in the image.

diffuse lighting A soft, low-contrast lighting.

digital SLR (dSLR) A single-lens reflex camera with interchangeable lenses and a digital image sensor.

DX Nikon's designation for digital single-lens reflex cameras (dSLRs) that use a 23.6 × 15.8mm APS-C–sized sensor.

equivalent focal length A DX-format digital camera's apparent focal length, which is translated into the corresponding values for 35mm film or the FX format.

exposure The amount of light allowed to reach the film or sensor, which is determined by the intensity of the light, the amount admitted by the aperture of the lens, and the length of time determined by the shutter speed.

exposure compensation A technique for adjusting the exposure indicated by a photographic exposure meter, in consideration of factors that may cause the indicated exposure to result in a less-than-optimal image.

exposure mode Camera settings that determine how the exposure settings are chosen. In Aperture Priority mode, the shutter speed is automatically set according to the chosen aperture (f-stop) setting. In Shutter Priority mode, the aperture is automatically set according to the chosen shutter speed. In Manual mode, both aperture and shutter speeds are set by the photographer, bypassing the camera's metered reading. In Programmed Auto mode, the camera selects the aperture and shutter speed. Some cameras also offer Scene modes, which are automatic modes that adjust the settings to predetermined parameters, such as a wide aperture for the Portrait mode and a high shutter speed for the Sports mode.

fill flash A lighting technique where the Speedlight provides enough light to illuminate the subject to eliminate shadows. Using a flash for outdoor portraits often brightens the subject in conditions where the camera meters light from a broader scene.

fill lighting The lighting used to illuminate shadows. Reflectors or additional incandescent lighting or electronic flash can be used to brighten shadows. One common technique outdoors is to use the camera's flash as a fill.

flash An external light source that produces an almost instant flash of light to illuminate a scene. Also known as *electronic flash*.

Flash Exposure Compensation (FEC) Adjusting the flash output. If images are too dark (underexposed), you can use FEC to increase the flash output. If images are too bright (overexposed), you can use FEC to reduce the flash output.

flash modes Modes that enable you to control the output of the flash by using different parameters. Some of these modes include Red-Eye Reduction and Slow Sync.

flash output level The output level of the flash as determined by one of the Flash modes used.

Front-curtain sync Front-curtain sync causes the flash to fire at the beginning of this period when the shutter is completely open in the instant that the first curtain of the focal plane shutter finishes its movement across the film or sensor plane. This is the default setting. See also *Rear-curtain sync*.

frontlighting The illumination coming from the direction of the camera. See also *backlighting* and *sidelighting*.

f-stop See *aperture*.

full-frame sensor A digital camera's imaging sensor that's the same size as a frame of 35mm film (36mm × 24mm).

FX Nikon's designation for dSLRs that use a sensor that's equal in size to a frame of 35mm film.

histogram A graphic representation of the range of tones in an image.

hot shoe The slot located on the top of the camera where the flash connects. The hot shoe is considered hot because it has electronic contacts that allow communication between the flash and the camera.

ISO sensitivity The ISO (International Organization for Standardization) setting on the camera indicates the light sensitivity. Film cameras need to be set to the film ISO speed being used (such as ISO 100, 200, or 400 film), whereas a digital camera's ISO setting can be set to any available setting. In digital cameras, lower ISO settings provide better quality images with less image noise; however, a lower ISO setting requires more exposure.

Kelvin A unit of measurement of color temperature based on a theoretical black body that glows a specific color when heated to a certain temperature. The sun is approximately 5500K.

LCD (liquid crystal display) This is where the settings are displayed on the back of the Speedlight.

lag time The length of time between when the Shutter Release button is pressed and the shutter is actually released. The monitor pre-flash can cause shutter lag, which may make it unsuitable for shooting some action scenes.

leading line An element in a composition that leads a viewer's eye toward the subject.

lighting ratio The proportion between the amount of light falling on the subject from the main light and the secondary light. An example would be a 2:1 ratio in which one light is twice as bright as the other.

macro flash. A flash specifically made for close-up and macro photography.

manual exposure Bypassing the camera's internal light meter settings in favor of setting the shutter and aperture manually. Manual exposure is beneficial in difficult lighting situations where the camera's meter doesn't provide correct results. When you switch to manual settings, you may need to review a series of photos on the camera's LCD to determine the correct exposure.

Matrix metering The Matrix meter (Nikon exclusive) reads the brightness and contrast throughout the entire frame and matches those readings against a database of images (over 30,000 in most Nikon cameras) to determine the best metering pattern to be used to calculate the exposure.

metering Measuring the amount of light by using the a light meter.

noise Pixels with randomly distributed color values in a digital image. Noise in digital photographs tends to be more pronounced with low-light conditions and long exposures, particularly when you set your camera to a higher ISO setting.

noise reduction (NR) A technology used to decrease the amount of random information in a digital picture, usually caused by long exposures and high ISO settings.

pincushion distortion An aberration in a lens in which the lines at the edges and sides of the image are bowed inward. This distortion is usually found in longer focal-length (telephoto) lenses.

Programmed Auto (P) An exposure mode in which the camera determines both the shutter speed and the aperture.

Rear-curtain sync Rear-curtain sync causes the flash to fire at the end of the exposure an instant before the second, or rear, curtain of the focal plane shutter begins to move. With slow shutter speeds, this feature can create a blur effect from the ambient light, showing as patterns that follow a moving subject, with the subject shown sharply frozen at the end of the blur trail. This setting is usually used in conjunction with longer shutter speeds. See also *Front-curtain sync*.

red-eye An effect from flash photography that appears to make a person's eyes glow red or an animal's yellow or green. It's caused by light bouncing from the retina of the eye and is most noticeable in dimly lit situations (when the irises are wide open) as well as when the electronic flash is close to the lens and, therefore, prone to reflect the light directly back.

Red-Eye Reduction A Flash mode controlled by a camera setting that's used to prevent the subject's eyes from appearing red in color. The Speedlight fires multiple flashes just before the shutter is opened, with the intention of causing the subject's iris to contract, therefore reflecting less light from the retina to the camera.

self-timer A mechanism that delays the opening of the shutter for several seconds after the Shutter Release button has been pressed.

short lighting When your main light is illuminating the side of the subject that's facing away from you.

shutter A mechanism that allows light to pass to the sensor for a specified amount of time.

Shutter Priority In this camera mode, you set the desired shutter speed and the camera automatically sets the aperture for you. It's best used when you're shooting action shots to freeze the subject's motion by using fast shutter speeds.

Shutter Release button When this button is pressed, the camera takes a picture.

shutter speed The length of time the shutter is open to allow light to fall onto the imaging sensor. The shutter speed is measured in seconds or, more commonly, fractions of seconds.

sidelighting Lighting that comes directly from the left or the right of the subject. See also *frontlighting* and *backlighting*.

Single Autofocus (AF-S) A focus setting that locks the focus on the subject when the Shutter Release button is half-pressed. This allows you to focus on the subject and then recompose the image while retaining focus settings as long as the Shutter Release button is half-pressed.

Slow Sync A Flash mode that allows the camera's shutter to stay open for a longer time to allow the ambient light to be recorded. The background receives more exposure, which gives the image a more natural appearance.

Speedlight A Nikon-specific term for its dedicated flash units.

Spot meter A metering system in which the exposure is based on a small area of the image; usually, the spot is linked to the AF point.

TTL (through-the-lens) A metering system where the light is measured directly though the lens.

tungsten light The light from a standard incandescent light bulb.

Vibration Reduction (VR) A function of the camera in which the lens elements are shifted to reduce the effects of camera shake.

white balance A setting used to compensate for the differences in color temperature common in different light sources. For example, a typical tungsten light bulb is very yellow-orange, so the camera adds blue to the image to ensure that the light looks like standard white light.

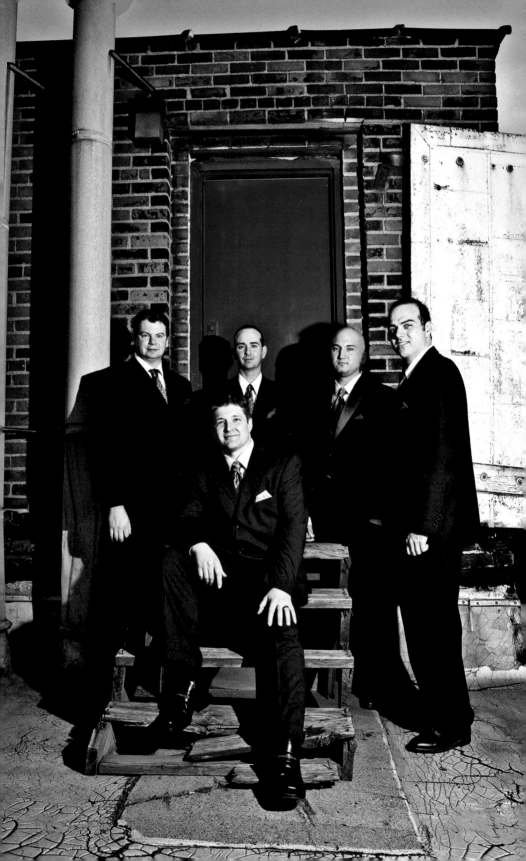

Index

SYMBOLS AND NUMERICS

+/- (plus/minus) buttons (SB-600), 19–20
1:1 lighting ratio, 75, 165
2:1 lighting ratio, 76
3D Multi Sensor metering system, 49
4:1 lighting ratio, 76
5-in-1 reflector discs, 140
10 degree angle of light, 75
45 degree angle of light, 75
60 degree angle of light, 75
90 degree angle of light, 75
180 degree angle of light, 75

A

AA. *See* Auto Aperture flash setting
accent light, 74
accessories
 add-on, 41–44
 included with SB-400, 38
 included with SB-600, 41
 included with SB-800, 40–41
 included with SB-900, 38–39
 included with SU-800, 38
 for studio strobes versus Speedlights, 114
action and sports photography
 AWL for, 116
 examples, 157, 158
 fill flash for, 156
 setup, 156–157
 tips and tricks, 158–159
Active D-Lighting, 209
Advanced Wireless Lighting (AWL). *See also* flash
 groups
 adjusting output on the fly, 126–127
 bounce flash with, 105
 cameras and Speedlights supporting, 10

 communication channel for, 118
 described, 10, 115
 fill light for, 116, 118
 flash modes for, 118, 120–123
 flash setup for, 116–118
 how it works, 117
 key light for, 116, 118
 Master or Commander flash setup, 117–118,
 119–120
 number of lights needed for, 116
 remote flash setup, 123–124
 remote groups for, 118, 124–125
 uses for, 116
AE (autoexposure), 209
AF-Assist Illuminator
 Custom Function options (SB-600), 70
 Custom Function options (SB-800), 68
 Custom Function options (SB-900), 59–60
 defined, 209
 described, 11
 in Red-Eye Reduction mode, 93
 SB-600, 17
 SB-800, 22
 SB-900, 29
AF-C (Continuous Autofocus), 210
AF-S (Single Autofocus), 214
air-cushioned light stands, 131
alkaline-manganese batteries, 46
amber filter, white balance setting for, 147
ambient lighting
 defined, 209
 recorded with slow shutter speeds, 92
angle of incidence for bounce flash, 105
angle of light, 75, 76
angle of view (field of view), 12, 209
Ansel Adams Gallery Workshops, 204

aperture
 for bounce flash, 105
 defined, 209
 in equations for good exposure, 82, 88, 100–
 101, 105, 109
 for macro photography, 162
 wide, advantages of, 87
Aperture Priority mode
 defined, 209
 Slow Sync applied with Rear-curtain sync in, 94
architecture photography, AWL for, 116
arms in portraits, 193, 194, 200
AS-19 Speedlight stand
 SB-600 accessory, 41
 SB-800 accessory, 40
AS-21 Speedlight stand (for SB-900), 38
aspect ratio, 209
attaching
 colored gel filters, 145–146
 Speedlights, 2–3
Auto Aperture (AA) flash setting
 for AWL, 121
 FEC applicable with, 97
 SB-800, 51, 66
 SB-900, 50, 56
 SB-900 function buttons in, 33
Auto Aperture with preflash setting (SB-900),
 50, 56
Auto FP High Speed Sync, 10, 91, 188
Auto mode, SU-4 mode as remote in, 55
autoexposure (AE), 209
autofocus, 210
Automatic Balanced Fill Flash. *See* i-TTL BL flash
 mode
Automatic white balance setting, 11, 98
AWL. *See* Advanced Wireless Lighting

B

backdrops. *See also* background
 canvas, 144
 muslin, 143–144
 seamless paper, 142–143
 stands for, 144
 uses for, 140
 vinyl, 143
background. *See also* backdrops
 for portrait photography, 200
 special effect filters for changing, 148–149
 for still-life and product photography, 181
 underexposed for portrait photography,
 174–175
 underexposed for wedding and engagement
 photography, 188
background light, 75

background stands, 144
backlighting, 75, 210
bags for equipment, 152–153
barrel distortion, 210
batteries
 carrying an extra set, 46, 190
 nonrechargeable, 46
 polarity reversal of, 47
 rechargeable, 46, 47
battery compartment lid
 SB-400, 14
 SB-600, 16
 SB-800, 22
 SB-900, 29
black body radiator, 97
blooming with electronic shutters, 90
blue filter, white balance setting for, 147
blur with slower shutter speeds and Front-curtain
 sync, 92
BMX. *See* action and sports photography
bounce cards
 for catchlights, 111–112
 homemade, 112
 SB-800, 22, 112
 SB-900, 28, 112
 using outside, 112
bounce diffusers, 110
bounce flash
 AWL with, 105
 defined, 3, 104, 210
 diffusion domes with, 109
 for food photography, 184
 illustrated, 106
 off ceiling, 104, 105
 off wall, 104
 overview, 104–105
 pitfalls to avoid, 105
 for portrait photography, 171
 reflectors for, 140
 for wedding and engagement photography,
 186, 190
bracketing, 210
brackets, 131
broad lighting, 77, 210
Brooks Institute Weekend Workshops, 204
built-in flash
 cameras not supporting AWL with, 11
 Commander mode setup, 120
 for fill light with AWL, 118
 groups controlled by, 118
 as Master or Commander, 119
 RPT with, 100, 104
Bulb setting for RPT mode, 103
butterfly portrait lighting pattern, 75

C

camera shake, 210
canceling the flash (SB-800), 68–69
canvas backdrops, 144
catchlights
 bounce cards for, 111–112
 defined, 210
 fill flash for, 196
ceiling, bounce flash off, 104, 105, 186
Center-weighted Illumination pattern (SB-900), 57
Center-weighted meter, 210
channel for AWL, 118
close-ups. See macro accessories; macro
 photography
CLS. See Creative Lighting System
color checker, using, 208
color correction
 color checker for, 208
 filters for, 144–145, 147–148
 gray card for, 207–208
color filter sets. See colored gel filters
color temperature. See also white balance (WB)
 color-correction filters for, 147–148
 defined, 97
 information communicated to camera, 11
 Kelvin scale for, 97–98
 for mixed lighting, 98–99
 white balance settings for, 98
colorcast. See color temperature; white balance
colored gel filters
 attaching, 145–146
 cameras detecting, 146
 changing background color using, 148–149
 changing subject color using, 150–151
 color correcting, 144–145, 147–148
 defined, 210
 settings (SB-600 and SB-800), 147
 settings (SB-900), 146–147
 SJ-1 filter set (for SB-600 and SB-800), 99, 145
 SJ-2 filter set (for SB-R200), 99, 145
 SJ-3 filter set (for SB-900), 99, 145
 SJ-800 filter set (for SB-800), 40–41
 SJ-900 filter set (for SB-900), 38–39
 special effect, 144–145, 148–152
 for special effects photography, 181
 SZ-2 color filter holder (SB-900 accessory), 39
colored surfaces, bounce flash off, 105
combination buttons
 SB-600, 20
 SB-800, 26
Commander unit. See also Master flash mode;
 SU-800 wireless Speedlight Commander
 for action and sports photography, 156
 AWL setup, 116, 117–118, 119–120

built-in flash for, 120
how AWL works with, 117
for macro photography, 166
SB-800 easiest to set up for, 117
for still-life and product photography, 182
communication channel for AWL, 118
concert photography
 examples, 160, 161
 flash not often used for, 159–160
 setup, 160
 tips and tricks, 161–162
Continuous Autofocus (AF-C), 210
contrast
 defined, 210
 high, hard lighting for, 80
control buttons
 locking (SB-600), 20
 locking (SB-800), 26
 SB-600, 19–20
 SB-800, 25–26
 SB-900, 30, 32–34
control panel
 SB-600, 19
 SB-800, 25
 SB-900, 45
COOLPIX P5000, P5100, and P6000 cameras, 12
Creative Lighting System (CLS)
 camera caveats, 36–37
 camera compatibility list, 11–12
 camera compatibility (table), 34–36
 communication channels, 118
 components of, 9
 main features and functions, 9–10
 as modular system, 9
Custom Functions Menu (SB-600)
 accessing, 20, 69
 AF-Assist options, 70
 LCD illuminator option, 72
 Power zoom options, 71
 Remote ready light options, 70
 Sound monitor options, 69–70
 Standby options, 71
 Wireless remote flash mode options, 69
 Zoom position setting for wide-flash panel
 option, 71
Custom Functions Menu (SB-800)
 accessing and using, 64
 AF-Assist options, 68
 Distance unit options, 67
 Flash Cancel option, 68–69
 ISO options, 64
 LCD panel contrast options, 68
 LCD panel illuminator options, 68
 Non-TTL Auto flash options, 65–66
 Power zoom options, 67

Custom Functions Menu (SB-800) *(continued)*
Sound monitor options, 65
Standby options, 66
Wireless Flash mode options, 64–65
Zoom position setting for wide-flash panel
option, 67
Custom Functions Menu (SB-900)
accessing and using, 56
AF-Assist options, 59–60
Distance unit options, 62
Firmware option, 63–64
Flash output level of test firing in iTTL option,
58
FX/DX options, 58–59
Illumination pattern options, 57–58
ISO options, 60
LCD panel contrast options, 62
LCD panel illuminator options, 61
Master RPT flash option, 57
My Menu settings, 63
Non-TTL Auto flash options, 56
Power zoom options, 59
Remote ready light options, 61
Reset option, 64
Sound monitor options, 62
Standby options, 60
SU-4 option, 57
Test firing button options, 58
Thermal cut-out options, 61–62
usefulness of, 55
Zoom position setting for wide-flash panel
option, 62–63
Custom Settings Menu (CSM). *See* Custom
Functions Menu (SB-600)
custom styles, color checker for adjusting, 208

D

D1/D1X/D1H/D100 cameras, 49
D2H/D2Hs cameras, 36, 37
D2X/D2Xs cameras, 36, 37
D3/D3X cameras
CLS compatibility, 36, 37
filter detection with, 146
D40/D40X cameras
Auto FP High Speed Sync not supported by, 91
for AWL, 34
AWL not supported with built-in flash, 11, 119
CLS compatibility, 34
FV Lock not available with, 11
hybrid shutter with, 89
D50 cameras
Auto FP High Speed Sync not supported by, 91
AWL not supported with built-in flash, 11, 119
AWL with, 34
CLS compatibility, 34

FV Lock not available with, 11
hybrid shutter with, 89
D60 cameras
Auto FP High Speed Sync not supported by, 91
AWL not supported with built-in flash, 11, 119
AWL with, 34
CLS compatibility, 34
FV Lock not available with, 11
D70/D70s cameras
Auto FP High Speed Sync not supported by, 91
channel for Commander use, 118
CLS compatibility, 35, 36–37
groups controlled by built-in flash, 118
hybrid shutter with, 89
as Master for AWL, 119
D80 cameras
CLS compatibility, 35, 37
groups controlled by built-in flash, 118
D90 cameras
CLS compatibility, 35, 37
filter detection with, 146
groups controlled by built-in flash, 118
RPT with built-in flash, 100, 104
D200 cameras
CLS compatibility, 35, 37
groups controlled by built-in flash, 118
D300 cameras
CLS compatibility, 35, 37
groups controlled by built-in flash, 118
RPT with built-in flash, 100, 104
D700 cameras
CLS compatibility, 35, 37
filter detection with, 146
groups controlled by built-in flash, 118
RPT with built-in flash, 100, 104
D3000 cameras
Auto FP High Speed Sync not supported by, 91
AWL not supported with built-in flash, 119
D5000 cameras
Auto FP High Speed Sync not supported by, 91
AWL not supported with built-in flash, 11, 119
AWL with, 34
CLS compatibility, 34
FV Lock not available with, 11
dedicated flash, 210
default settings
defined, 210
resetting SB-600 to, 20
resetting SB-800 to, 26
resetting SB-900 to, 64
depth of field (DOF), 162, 211
diffused lighting. *See also* light modifiers
defined, 81, 211
illustrated, 81
for still-life and product photography, 182

Index

uses for, 81
 for wedding and engagement photography, 186
diffusion domes
 bounce flash with, 109
 Gary Fong Lightsphere II, 111, 186
 for pet portraits, 6
 Sto-Fen Omni-Bounce, 110, 186
 SW-10H (SB-800 accessory), 41, 110
 SW-13H (SB-900 accessory), 39, 59, 67, 110
 using, 7
 for wedding and engagement photography, 186
diffusion panels, 138–139
Digital Photo Pro site, 205
Digital Photographer site, 204
digital SLR (dSLR) cameras. *See also specific cameras*
 Auto FP High Speed Sync support by, 91
 backward compatibility with older cameras, 49
 CLS-compatible models, 11–12
 defined, 211
 DX versus FX format sensors, 12–13
distance
 in equations for good exposure, 82, 88, 100–101, 105, 109
 for flash with action and sports photography, 156
 importance for exposure, 87
 inverse square law for, 87–88
 SB-600 Guide Numbers (table), 86
 SB-800 Guide Numbers (table), 85
 SB-900 Guide Numbers, DX format (table), 83
 SB-900 Guide Numbers, FX format (table), 84
Distance (GN) Priority mode. *See* Guide Number (GN) Distance Priority mode
distance unit options
 SB-800, 67
 SB-900, 62
DOF (depth of field), 162, 211
dragging the shutter
 ambient light recorded with, 92
 blur with Front-curtain sync, 92
 ghosting with, 92
 Slow Sync for, 93–94
dSLR cameras. *See* digital SLR cameras
DTTL flash metering system, 49
DX format sensors
 defined, 211
 FX/DX options (SB-900), 58–59
 overview, 12–13

E

electronic/mechanical or hybrid shutters, 89–90
engagement photography. *See* wedding and engagement photography

equations for good exposure
 for bounce flash, 105
 overview, 82, 88
 for RPT mode, 100–101
equipment for portable studio
 backdrops, 140, 142–144
 brackets, 131
 diffusion panels, 138–139
 filters, 144–152
 light stands, 130–131
 multiclamps, 131–132
 reflectors, 139–140, 141
 softboxes, 135–137
 studio strobes versus Speedlights, 113
 transporting, 152–153
 umbrellas, 133–135
equivalent focal length, 211
Even Illumination pattern (SB-900), 58, 188
exposure. *See also* aperture; distance; Guide Number (GN)
 for action and sports photography, 156
 defined, 211
 GN/D=A equation for, 82, 88, 100–101, 105, 109
 inconsistency with electronic shutters, 90
 for night photography, 167
 SB-600 Guide Numbers (table), 86
 SB-800 Guide Numbers (table), 85
 SB-900 Guide Numbers, DX format (table), 83
 SB-900 Guide Numbers, FX format (table), 84
exposure compensation, 211
exposure mode, 211
external AF-assist contacts
 SB-600, 17
 SB-800, 23
external power source terminal
 SB-800, 23
 SB-900, 29
eyes, in portraits
 catchlights, 111–112, 196, 210
 importance of, 194
 looking directly toward lens, 194, 198–199
 looking slightly down, 195
 looking up and left, 196
 looking up and right, 197

F

F80/F90/F90x/F100 cameras, 49
FEC. *See* Flash Exposure Compensation
Field Guide Companion site, 203
field of view (angle of view), 12, 209
fill card, 182
fill flash
 for action and sports photography, 156
 for catchlights, 196

fill flash (continued)
 defined, 107, 211
 illustrated, 5, 107–108
 i-TTL BL flash mode for, 49, 108
 manual, 109
 for still-life and product photography, 182, 183
 uses for, 4, 107–108
fill light
 for AWL, 116, 118
 defined, 74, 211
 SB-800 or SB-900 for, 117–118
 for still-life and product photography, 182
filter detector (SB-900), 28
filters. See colored gel filters
firmware (SB-900)
 displaying current version, 63
 updating, 63–64
fisheye lens, 157
5-in-1 reflector discs, 140
flash, defined, 212
flash button
 SB-600, 19
 SB-800, 25
Flash Cancel option (SB-800), 68–69
Flash Color Information Communication, 11
flash duration
 importance for special effects photography,
 178–179
 for manual output settings (table), 178
Flash Exposure Compensation (FEC)
 for action and sports photography, 157
 applicable flash modes for, 97
 applying directly via the Speedlight, 97
 applying via the camera, 96
 defined, 212
 overview, 95–97
 uses for, 95–96
 for wedding and engagement photography, 190
flash groups
 for action and sports photography, 156
 adjusting output on the fly, 126–127
 assigning flash modes to, 118, 121–123
 camera and Speedlight capabilities for
 controlling, 118
 controlling three groups, 124–125
 for macro photography, 163–165
 for night photography, 169
 remote group setup for AWL, 118, 124–125
 SB-600 setup, 125
 SB-800 setup, 125
 SB-900 setup, 125
 for still-life and product photography, 182–183
 for wedding and engagement photography, 188

flash head lock release button
 SB-600, 15
 SB-800, 22
 SB-900, 28
flash head rotating angle scale
 SB-600, 18
 SB-800, 23
 SB-900, 30
flash head tilting angle scale
 SB-600, 17
 SB-800, 23
 SB-900, 30
flash meter, GN determination using, 87
flash modes
 assigning to groups (SB-800), 122
 assigning to groups (SB-900), 121–122
 assigning to groups (SU-800), 122–123
 for AWL, 118, 120–123
 defined, 212
 flash sync modes versus, 47
 Guide Number (GN) Distance Priority, 52–53
 i-TTL/i-TTL BL, 10, 33, 48–50
 Manual, 53, 57
 Non-TTL Auto (SB-800), 51
 Non-TTL Auto (SB-900), 50–51, 56
 Repeating (RPT), 33, 54, 57, 100–104
 SU-4, 54–55, 57
flash output level
 adjusting for remote groups, 126–127
 defined, 212
 determining for RPT mode, 100–101
 flash duration with manual settings (table), 178
 Manual mode settings, 58
 maximum flashes with, 100, 101, 102
 SB-600 Guide Numbers (table), 86
 SB-800 Guide Numbers (table), 85
 SB-900 Guide Numbers, DX format (table), 83
 SB-900 Guide Numbers, FX format (table), 84
 for still-life and product photography, 186
 for test firing (SB-900), 58
flash sync modes
 Auto FP High Speed Sync, 10, 91
 described, 88–89
 flash modes versus, 47
 Front-curtain sync, 91–92, 212
 Rear-curtain sync, 92, 94–95, 214
 Red-Eye Reduction, 93, 214
 Slow Sync, 93–94, 215
 sync speed with, 89–90
Flash test fire button setting (SB-900), 58
Flash Value Lock (FV Lock), 11
flash-mount softboxes, 135–136
FL-G1/FL-G2 filters, 146, 147
Flickr site, 205

Fluorescent filters, 146, 147
f/number. *See* aperture
focal length effect on angle of view, 12
focal plane shutters, 89
food photography, 183–185. *See also* still-life and
 product photography
45 degree angle of light, 75
4:1 lighting ratio, 76
free-sliding light stands, 131
frequency for RPT mode
 defined, 100
 maximum flashes with, 101, 102
 setting, 101
Front-curtain sync
 blur with slower shutter speeds, 92
 as default sync mode, 91
 defined, 91, 212
 illustrated, 92
 Rear-curtain sync versus, 92
frontlighting, 212
f-stop. *See* aperture
full-frame sensor, 212
function buttons (SB-900), 33–34
FV Lock (Flash Value Lock), 11
FX format sensors, 12, 212
FX/DX options (SB-900), 58–59

G

Gary Fong Lightsphere II, 111, 186
gating for higher shutter speeds, 89–90
gels. *See* colored gel filters
ghosting, 92, 93
GN. *See* Guide Number
GN/D=A equation
 for bounce flash, 105
 for fill flash, 109
 overview, 82, 88
 for RPT mode, 100–101
gray card, using, 207–208
Great American Photography Workshops, 204
groups. *See* flash groups
Guide Number (GN)
 adjusting for ISO setting, 86–87
 defined, 81
 determining using flash meter, 87
 in equations for good exposure, 82, 88,
 100–101, 105, 109
 for RPT mode, 101
 SB-600 Guide Numbers (table), 86
 SB-800 Guide Numbers (table), 85
 SB-900 Guide Numbers, DX format (table), 83
 SB-900 Guide Numbers, FX format (table), 84
Guide Number (GN) Distance Priority mode
 exposure modes preferred for, 52
 FEC not applicable with, 97

for non-CPU lens with camera not supporting
 data from, 52, 53
 overview, 52
 SB-800 settings for, 53
 SB-900 function buttons in, 33
 SB-900 settings for, 52
gun case for equipment, 152–153

H

hair in portraits, 193, 197, 198
hair light, 75
hands in portraits, 193, 194, 200
hard lighting, 80
head and neck position for portraits
 hair as complimentary to, 198
 looking directly toward lens, 194, 198–199
 looking slightly down, 195
 looking up and left, 196
 looking up and right, 197
 reducing amount of neck showing, 199
 reducing double chins, 199
 tilting the head, 194, 198, 200
high key lighting, 79
histogram, defined, 212
hot shoe, 212. *See also* mounting foot
hotspots, 136
hybrid shutters, 89–90

I

Illumination pattern settings (SB-900)
 Center-weighted, 57
 Even, 58, 188
 Standard, 57
image quality problems with electronic shutters, 90
Internet resources. *See* Web sites
inverse square law, 87–88
ISO sensitivity
 Custom Function options (SB-800), 64
 Custom Function options (SB-900), 60
 defined, 212
 Guide Number adjustment for, 86–87
 night photography setting, 170
 SB-600 Guide Numbers at ISO 100 (table), 86
 SB-800 Guide Numbers at ISO 100 (table), 85
 SB-900 Guide Numbers at ISO 100, DX format
 (table), 83
 SB-900 Guide Numbers at ISO 100, FX format
 (table), 84
i-TTL BL flash mode
 as Automatic Balanced Fill Flash, 49, 108
 exposure modes required for, 50
 FEC applicable with, 97
 mixed lighting with, 99
 overview, 4, 10, 48–49
 for portrait photography, 173

i-TTL flash mode *(continued)*
 SB-900 function buttons in, 33
 for action and sports photography, 156–157
 for AWL, 121
 backward compatibility with older cameras, 49
 for bounce flash, 105
 FEC applicable with, 97
 for macro photography, 163
 overview, 4, 10, 48
 SB-400 (i-TTL only), 50
 SB-900 function buttons in, 33
 studio strobes lacking capability, 113
 wide aperture with, 87

K

Kelvin temperature scale
 defined, 97, 212
 "warm" and "cool" colors on, 98
key light
 for AWL, 116, 118
 broad lighting using, 77
 defined, 74
 reflectors with, 139
 short lighting using, 78
 sun as, 172, 174

L

lag time, 213
LCD (liquid crystal display), 213
LCD panel
 contrast options (SB-800), 68
 contrast options (SB-900), 62
 for fill flash preview, 109
 illuminator options (SB-600), 72
 illuminator options (SB-800), 68
 illuminator options (SB-900), 61
 SB-600, 18
 SB-800, 23
 SB-900, 30
leading line, 213
Lee Filters, 148
light modifiers
 bounce cards, 22, 28, 111–112
 bounce diffusers, 110
 brackets or multiclamps for, 131
 diffusion domes, 39, 41, 59, 67, 109–111
 diffusion panels, 138–139
 light stands for, 130
 reflectors, 139–140, 141
 softboxes, 135–137
 umbrellas, 133–135
light sensor for automatic non-TTL flash
 (SB-900), 29

light sensor for TTL wireless flash
 SB-600, 17
 SB-800, 22
 SB-900, 29
light stands
 for portable studio, 130–131
 Speedlight accessories, 38, 40, 41
lighting patterns
 angle of light determining, 75, 76
 backlighting, 75
 butterfly portrait, 75
 loop or Paramount, 75
 Rembrandt, 75
 split, 75
lighting ratio
 1:1 ratio, 75, 165
 2:1 ratio, 76
 4:1 ratio, 76
 defined, 213
 for macro photography, 163, 165
Lightsphere II by Gary Fong, 111, 186
limbs in portraits, 193, 200
liquid crystal display (LCD), 213
lithium batteries, 46
loop lighting pattern, 75
low key lighting, 79
LumiQuest bounce diffusers, 110
LumiQuest Softbox III, 136

M

macro accessories
 R1/R1C1 kits, 42–43
 SB-R200 Speedlight, 43
 SG-31R, 44
macro flash, 213
macro photography
 examples, 164, 165, 166
 lighting ratios for, 163, 165
 magnification of lenses, 162
 R1/R1C1 kits for, 42–43, 163, 165, 166
 ring flash setup, 163
 setup, 163–165
 SY-1 adapter for, 163, 165
 technical challenges of, 162–163
 tips and tricks, 165–166
magazines online, 204–205
mAh (milliampere hours) ratings for NiMH
 batteries, 47
main light. *See* key light
manual exposure, defined, 213
Manual mode
 for AWL, 121
 bounce flash with, 105
 Custom Function option (SB-900), 57
 FEC not applicable with, 97

fill flash in, 109
flash duration with (table), 178
flash output settings in, 53
SB-900 function buttons in, 33
using SU-4 mode as a remote, 55
wide aperture with, 87
Master flash mode. See also Commander unit
AWL setup, 116, 117–118, 119–120
Custom Function option (SB-900), 57
Custom Function options (SB-800), 65
RPT mode with, 100
SB-800 setup, 119–120
SB-900 function buttons in, 34
SB-900 setup, 119
Matrix metering
defined, 213
i-TTL BL flash mode with, 4
mechanical shutters, 89
Mentor Series Worldwide Photo Treks, 204
metering, defined, 213
milliampere hours (mAh) ratings for NiMH
batteries, 47
mixed lighting, 98–99, 148
mode button
SB-600, 20
SB-800, 26
SB-900, 32
modeling flash illuminator button (SB-800), 23
modeling light, studio strobes versus Speedlights
for, 114
Modeling test fire button setting (SB-900), 58
monolights
described, 112
Speedlights versus, 113–114
mounting foot
SB-400, 14
SB-600, 17
SB-800, 23
SB-900, 29
mounting foot locking lever
SB-400, 15
SB-600, 19
SB-800, 24
SB-900, 30
Multi-Area AF-Assist Illuminator, 11. See also
AF-Assist Illuminator
multiclamps, 131–132
multi-selector button (SB-800), 25
muslin backdrops, 143–144
My Menu settings (SB-900), 63

N

N80/N90/N90s cameras, 49
neck, in portraits, 199

night photography
examples, 168, 169, 170
setup, 167
technical challenges of, 167
tips and tricks, 167–170
Nikon Creative Lighting System. See Creative
Lighting System (CLS)
Nikon Web site, 203
Nikonians.org site, 203
NiMH (nickel-metal hydride) batteries, 47
90 degree angle of light, 75
noise, defined, 213
noise reduction (NR), 213
non-CPU lenses
GN Distance Priority mode with, 52, 53
power zoom with (SB-800), 67
nonrechargeable batteries, 46
Non-TTL Auto flash setting
for AWL, 121
FEC applicable with, 97
SB-800, 51, 66
SB-900, 51, 56
Non-TTL Auto with preflash setting (SB-900),
51, 56

O

OK button (SB-900), 32
1:1 lighting ratio, 75, 165
180 degree angle of light, 75
online resources. See Web sites
on/off switch
location of, 3
SB-400, 14
SB-600, 19
SB-800, 25
on-off/Wireless mode setting switch (SB-900), 32
Outdoor Photographer site, 205

P

P (Programmed Auto) mode
defined, 213
Slow Sync applied with Rear-curtain sync in, 94
pack and head studio strobes
described, 112
Speedlights versus, 113–114
paper backdrops, seamless, 142–143
Paramount lighting pattern, 75
PC sync terminal
SB-800, 23
SB-900, 30
pet portraits
examples, 6, 176, 177
overview, 175–176
tips for, 177

Photo District News site, 205
Photo Quest Adventures, 204
Photoflex LiteDisc Holder, 140
Photoflex LiteDome xs Accessory Hardware/
 Adjustable Shoe Mount, 131
Photoflex Shoe Mount Multiclamp, 131, 132
photography magazines online, 204–205
Photo.net site, 203
pincushion distortion, 213
plus/minus (+/-) buttons (SB-600), 19–20
Pocket Bouncer by LumiQuest, 110
polarity reversal of NiMH batteries, 47
Popular Photography & Imaging site, 205
portable studio setup
 backdrops, 140, 142–144
 brackets, 131
 diffusion panels, 138–139
 filters, 144–152
 light stands, 130–131
 minimum requirements, 130
 multiclamps, 131–132
 reflectors, 139–140, 141
 softboxes, 135–137
 Speedlight advantages for, 129
 studio strobes versus Speedlights, 113
 transporting your studio, 152–153
 umbrellas, 133–135
portrait photography. See also posing
 considerations
 AWL for, 116
 catchlights, 111–112, 196, 210
 challenges of, 170–171
 evoking a mood or ambience, 171
 examples, 172, 173, 174, 176, 177
 filling the frame, 200
 indoor, 171–172
 lighting patterns for, 75
 outdoor, 172–175
 pet portraits, 175–177
 portrait, defined, 170
 underexposed background for, 174–175
posing considerations. See also portrait
 photography
 background, 200
 catchlights, 196
 cautions for, 200
 checking everything in the frame, 193
 examples, 192, 193, 195–199, 201
 eyes, 194–197
 general tips, 200
 getting started, 191–194
 hair, 193, 197, 198
 hands and arms, 193, 194, 200
 head and neck position, 194–199, 200

limbs, 193, 200
 studying poses from photographers and
 artists, 191–192
power requirements
 carrying an extra set of batteries, 46, 190
 nonrechargeable batteries, 46
 rechargeable batteries, 46, 47
 of studio strobes versus Speedlights, 113
power zoom options
 SB-600, 71
 SB-800, 67
 SB-900, 59
product photography. See still-life and product
 photography
Programmed Auto (P) mode
 defined, 213
 Slow Sync applied with Rear-curtain sync in, 94

Q
Quick Recycling Battery Pack (SB-800), 46
Quick Tour
 getting started, 2–3
 Speedlight advantages, 1
 taking your first photos, 4–7

R
R1/R1C1 close-up and macro kits
 overview, 42–43
 using, 163, 165, 166
ready light. See also wireless remote ready light
 SB-400, 14–15
 SB-600, 19
 SB-800, 24
 SB-900, 30
Rear-curtain sync
 for concert photography, 161
 defined, 94, 214
 Front-curtain sync versus, 92
 illustrated, 95
 overview, 94–95
 Slow Sync activated automatically in some
 modes, 94
rechargeable batteries, 46, 47
recycle time of studio strobes versus Speedlights,
 113
red filter, white balance setting for, 147
red-eye, defined, 214
Red-Eye Reduction, 93, 214
reflectors, 140–141, 184
Rembrandt lighting pattern, 75
remote flash. See wireless remote mode
remote ready light. See wireless remote ready light
Repeating (RPT) flash mode
 for AWL, 121
 with built-in flash, 100, 104

Custom Function option (SB-800), 65
Custom Function option (SB-900), 57
FEC not applicable with, 97
frequency, defined, 100
illustrated, 101
maximum flashes, 100, 101, 102
overview, 54
SB-900 function buttons in, 33
setting flash output level, 100–101
setting frequency of flashes, 101
setting number of flashes, 101
setting on SB-800, 103
setting on SB-900, 103
shutter speed for, 101, 103
Speedlights offering, 100
times, defined, 100
resetting to defaults
 SB-600, 20
 SB-800, 26
 SB-900, 64
resolution problems with electronic shutters, 90
rim light, 75
ring flash, Speedlight setup for, 163
Roscoe filters, 148

S

sample packs for special effect filters, 148
Santa Fe Photographic Workshops, 204
SB-400 Speedlight. *See also specific features*
 battery chamber lid, 14
 bounce flash off wall with, 104
 diffusion dome for, 110
 features, 14–15
 front view, 14
 mounting foot, 14
 mounting foot locking lever, 15
 on/off switch, 14
 ready light, 14–15
 soft case included with, 38
 tilting flash head, 14
SB-600 Speedlight. *See also specific features and buttons*
 accessories included with, 41
 AF-Assist Illuminator, 17
 AF-Assist options, 70
 back view, 18
 backward compatibility with older cameras, 49
 battery compartment lid, 16
 combination buttons, 20
 control buttons, 19–20
 control panel, 19
 custom settings, 69–72
 Custom Settings Menu access, 20, 69
 diffusion dome for, 110
 displaying underexposure value, 20

external AF-assist contacts, 17
features, 15–19
filter attachment, 145
filter settings, 147
flash button, 19
flash duration (table), 178
flash head lock release button, 15
flash head rotating angle scale, 18
flash head tilting angle scale, 17
flash modes, 47–50, 53–54
front view, 16
FX format sensors covered by, 11
Guide Numbers (table), 86
i-TTL/i-TTL BL flash modes, 47–50
LCD illuminator option, 72
LCD panel, 18
light sensor for TTL wireless flash, 17
locking control buttons, 20
Manual flash mode, 53
mode button, 20
mounting foot, 17
mounting foot locking lever, 19
Multi-Area AF-Assist Illuminator with, 11
Non-TTL Auto flash modes not supported by, 50
on/off button, 19
plus/minus (+/-) buttons, 19–20
power zoom options, 71
ready light, 19
remote group setup for AWL, 125
remote ready light options, 70
repeating flashes with SB-900 or SB-800 as Master, 100
resetting to defaults, 20
RPT (Repeating) flash mode, 54
SJ-1 Color Filter Set for, 99, 145
sound monitor options, 69–70
Standby mode options, 71
wide-flash adapter, 15, 17
wireless remote flash mode options, 69
wireless remote mode setup, 124
wireless remote ready light, 17
zoom button, 19
zoom position setting for wide-flash panel, 71
zooming/tilting flash head, 15
SB-800 Speedlight. *See also specific features and buttons*
 accessories included with, 40–41
 adjusting output of remote groups, 127
 AF-Assist Illuminator, 22
 AF-Assist options, 68
 assigning flash modes to groups, 122
 AWL with, 10
 back view, 24
 backward compatibility with older cameras, 49

SB-800 Speedlight *(continued)*
 battery compartment lid, 22
 bounce card, 22, 112
 combination buttons, 26
 control buttons, 25–26
 control panel, 25
 custom functions, 64–69
 Custom Functions Menu access, 64
 displaying underexposure warning value, 26
 distance unit options, 67
 external AF-assist contacts, 23
 external power source terminal, 23
 features, 21–24
 filter attachment, 145
 filter settings, 147
 flash button, 25
 Flash Cancel option, 68–69
 flash duration (table), 178
 flash head lock release button, 22
 flash head rotating angle scale, 23
 flash head tilting angle scale, 23
 flash modes, 47–55
 front view, 21
 FX format sensors covered by, 11
 groups controlled by, 118
 Guide Number (GN) Distance Priority mode,
 52, 53
 Guide Numbers (table), 85
 ISO options, 64
 i-TTL/i-TTL BL flash modes, 47–50
 LCD panel, 23
 LCD panel contrast options, 68
 LCD panel illuminator options, 68
 light sensor for TTL wireless flash, 22
 locking control buttons, 26
 Manual flash mode, 53
 Master flash mode setup, 119–120
 mode button, 26
 modeling flash illuminator button, 23
 mounting foot, 23
 mounting foot locking lever, 24
 Multi-Area AF-Assist Illuminator with, 11
 multi-selector button, 25
 Non-TTL Auto flash modes, 51, 65–66
 on/off button, 25
 PC sync terminal, 23
 power zoom options, 67
 Quick Recycling Battery Pack, 46
 ready light, 24
 remote group setup for AWL, 125
 resetting to defaults, 26
 RPT (Repeating) flash mode, 54, 100–103
 SJ-1 Color Filter Set for, 99, 145
 sound monitor options, 65
 Standby mode options, 66

SU-4 flash mode, 54–55
SW-10H diffusion dome, 41, 110
TTL multiple flash terminal, 23
wide-flash adapter, 22
Wireless Flash mode options, 64–65
wireless remote mode setup, 123–124
zoom position setting for wide-flash panel, 67
zooming/tilting flash head, 22
SB-900 Speedlight. *See also specific features and*
 buttons
 accessories included with, 38–39
 adjusting output of remote groups, 126
 AF-Assist Illuminator, 29
 AF-Assist options, 59–60
 assigning flash modes to groups, 121–122
 AWL with, 10
 back view, 31
 backward compatibility with older cameras, 49
 battery compartment lid, 29
 bounce card, 28, 112
 Commander setup easy with, 117
 control buttons, 30, 32–34
 control panel, 45
 custom functions, 55–64
 Custom Functions Menu access, 56
 distance unit options, 62
 external power source terminal, 29
 features, 27–30
 filter attachment, 146
 filter detector, 28
 filter settings, 146–147
 firmware for, 63–64
 flash duration (table), 178
 flash head lock release button, 28
 flash head rotating angle scale, 30
 flash head tilting angle scale, 30
 flash modes, 47–55, 56–57
 front view, 27
 function buttons, 33–34
 FX/DX options, 58–59
 groups controlled by, 118
 Guide Number (GN) Distance Priority mode, 52
 Guide Numbers, DX format (table), 83
 Guide Numbers, FX format (table), 84
 Illumination pattern options, 57–58
 ISO options, 60
 i-TTL/i-TTL BL flash modes, 47–50
 LCD panel, 30
 LCD panel contrast options, 62
 LCD panel illuminator options, 61
 light sensor for automatic non-TTL flash, 29
 light sensor for TTL wireless flash, 29
 locking settings, 34
 Manual flash mode, 53, 57
 Master flash mode setup, 119

mode button, 32
mounting foot, 29
mounting foot locking lever, 30
Multi-Area AF-Assist Illuminator with, 11
My Menu settings, 63
Non-TTL Auto flash modes, 50–51, 56
on-off/Wireless mode setting switch, 32
OK button, 32
PC sync terminal, 30
power zoom options, 59
ready light, 30
remote group setup for AWL, 125
resetting to defaults, 64
RPT (Repeating) flash mode, 54, 57, 100–103
selector dial, 32
sensor size recognized by, 11
SJ-3 Color Filter Set for, 99, 145
sound monitor options, 62
Standby mode options, 60
SU-4 flash mode, 54–55, 57
SW-13H diffusion dome, 39, 59, 67, 110
Test firing options, 58
thermal cut-out feature, 61–62
wide-flash adapter, 28
wireless remote mode setup, 123
wireless remote ready light, 29
wireless remote ready light options, 61
zoom button, 33
zoom position setting for wide-flash panel, 62–63
zooming/tilting flash head, 28
SB-R200 Speedlight
 attaching filters, 146
 for macro photography, 163, 165
 R1/R1C1 close-up and macro kits with, 43, 163, 165, 166
 SJ-2 Color Filter Set for, 99, 145
seamless paper backdrops, 142–143
selector dial (SB-900), 32
self-timer, 214
sensors, DX versus FX format, 12–13
SG-31R, 44
short lighting, 78, 214
shutter, defined, 214
Shutter Priority, 214
Shutter Release button, 214
shutter speed. See also dragging the shutter; flash sync modes
 Auto FP High Speed Sync, 10, 91
 defined, 214
 electronic shutter problems, 90
 flash duration with (table), 178
 gating for higher speeds, 89–90
 limited by sync speed, 89
 for RPT mode, 101, 103

shutter types
 electronic shutter problems, 90
 electronic/mechanical or hybrid, 89
 focal plane, 89
 gating for higher speeds, 89–90
 mechanical, 89
Shutterbug site, 205
sidelighting, 75, 214
Single Autofocus (AF-S), 214
60 degree angle of light, 75
SJ-1 Color Filter Set, 99, 145
SJ-2 Color Filter Set, 99, 145
SJ-3 Color Filter Set, 99, 145, 146
SJ-800 color filter set, 40–41
SJ-900 color filter set, 38–39
skateboarding. See action and sports photography
slave flash. See wireless remote mode
sleep options. See Standby mode options
slow shutter speeds. See dragging the shutter
Slow Sync
 for action and sports photography, 158–159
 activated automatically with Rear-curtain sync in some modes, 94
 for concert photography, 160–161
 defined, 93, 215
 ghosting with, 93
 illustrated, 94
 for night photography, 167
 overview, 93–94
 Red-Eye Reduction with, 93
 for wedding and engagement photography, 188–190
soft case
 SB-400 accessory, 38
 SB-600 accessory (SS-600), 41
 SB-800 accessory (SS-800), 40
 SB-900 accessory (SS-900), 38
 SU-800 accessory, 38
softboxes
 brackets or multiclamps for, 131
 described, 135
 flash-mount, 135–136
 hotspots avoided with, 136
 light stands for, 130
 size considerations, 137
 speedrings for, 137
 stand-mounted, 136–137
 umbrellas versus, 133, 136
sound monitor options
 SB-600, 70
 SB-800, 65
 SB-900, 62
special effect filters. See also colored gel filters
 changing background color using, 148–149
 changing subject color using, 150–151

special effect filters *(continued)*
 described, 144–145
 sample packs for, 148
special effects photography
 examples, 179, 180
 flash duration for, 178–179
 setup, 179
 tips and tricks, 180–181
Speedlight stands
 AS-19 (SB-600 accessory), 41
 AS-19 (SB-800 accessory), 40
 AS-21 (SB-900 accessory), 38
Speedlights. *See also specific Speedlights*
 attaching, 2–3
 camera caveats, 36–37
 camera compatibility (table), 34–36
 defined, 215
 main features and functions, 9–10
 SB-400 overview, 14–15
 SB-600 overview, 15–20
 SB-800 overview, 21–27
 SB-900 overview, 27–34
 studio strobes versus, 112–114
speedrings, 137
split lighting pattern, 75
sports photography. *See* action and sports
 photography
Spot meter
 for action and sports photography, 156
 defined, 215
Standard Illumination pattern (SB-900), 57
Standby mode options
 SB-600, 71
 SB-800, 66
 SB-900, 60
stand-mounted softboxes, 136–137
stands
 for portable studio, 130–131
 Speedlight accessories, 38, 40, 41
still-life and product photography
 AWL for, 116
 examples, 183, 184, 185
 food photography, 183–185
 overview, 181–182
 setup, 182–183
 tips and tricks, 183–186
Sto-Fen Omni-Bounce diffusion domes, 110, 186
studio setup. *See* portable studio setup
studio strobes
 Speedlights versus, 113–114
 types of, 112
SU-4 flash mode
 Custom Function option (SB-800), 65
 Custom Function option (SB-900), 57
 flash modes usable with, 54–55

overview, 54
using as a master, 54–55
using as a remote, 55
SU-800 wireless Speedlight Commander
 adjusting output of remote groups, 127
 assigning flash modes to groups, 122–123
 AWL with, 10
 for food photography, 184
 groups controlled by, 118
 Multi-Area AF-Assist Illuminator with, 11
 overview, 41–42
 soft case included with, 38
 for still-life and product photography, 182
Summit Series of Photography Workshops, 204
SW-10H diffusion dome
 SB-800 accessory, 41
 zoom head position with, 110
SW-13H diffusion dome
 power zoom disabled with, 59, 67
 SB-900 accessory, 39
 zoom head position with, 110
SY-1 adapter for macro photography, 163, 165
sync speed. *See also* flash sync modes
 Auto FP High Speed Sync, 10, 91
 defined, 89
 electronic shutter problems, 90
 gating for higher speeds, 89–90
 for most recent Nikon cameras, 89
 shutter speed limited by, 89
SZ-2 color filter holder (SB-900 accessory), 39

T

tactical rifle bag for equipment, 152–153
10 degree angle of light, 75
Test firing (SB-900), 58
thermal cut-out feature (SB-900), 61–62
Thomas, J. Dennis, blog site of, 203
3D Multi Sensor metering system, 49
tilting flash head
 bounce flash using, 3, 104
 SB-400, 14
 SB-600, 15
 SB-800, 22
 SB-900, 28
tilting the head for portraits, 194, 198, 200
times for RPT mode
 defined, 100
 maximum flashes, 100, 101, 102
 setting, 101
TN-A1 filter, white balance setting for, 146, 147
TN-A2 filter, white balance setting for, 146
transporting your portable studio, 152–153
tripod for night photography, 169
TTL (through-the-lens), 4, 48, 215

TTL metering system. *See also* i-TTL BL flash
 mode; i-TTL flash mode
 described, 4, 49
 ease of using, 6–7
 with Speedlights versus studio strobes, 113
TTL multiple flash terminal (SB-800), 23
tungsten light, 215
2:1 lighting ratio, 76

U

ultrawide lens, cautions for using, 157
umbrellas
 brackets or multiclamps for, 131
 choosing, 135
 convertible, 133
 illustrated, 134
 light stands for, 130
 shoot-through, 133
 size considerations, 133, 135
 softboxes versus, 133, 136
 standard, 133
underexposure warning value, displaying
 SB-600, 20
 SB-800, 26

V

Vibration Reduction (VR), 215
vinyl backdrops, 143

W

wall, bounce flash off, 104
Web sites
 informational, 203
 online magazines and other, 204–205
 for workshops, 204
wedding and engagement photography
 challenges of, 186
 diffused lighting for, 186
 examples, 187, 189, 190
 setup, 187–188
 tips and tricks, 188–190
 underexposed background for, 188
white balance (WB). *See also* color temperature
 Automatic setting for, 11, 98
 camera setting for, 97
 defined, 97, 215
 gray card for setting, 207–208
 importance of, 98
 settings for colored gel filters, 146–147

wide-flash adapter
 power zoom disabled with, 59, 71
 SB-600, 15, 17
 SB-800, 22
 SB-900, 28
 zoom position setting (SB-600), 71
 zoom position setting (SB-800), 67
 zoom position setting (SB-900), 62–63
wireless remote mode
 Custom Function options (SB-600), 69
 Custom Function options (SB-800), 64–65
 SB-600 setup, 124
 SB-800 setup, 123–124
 SB-900 function buttons in, 34
 SB-900 setup, 123
 using SU-4 mode with, 55
wireless remote ready light
 Custom Function options (SB-600), 70
 Custom Function options (SB-900), 61
 SB-600, 17
 SB-900, 29
workshops, 204

Y

yellow filter, white balance setting for, 147

Z

zoom button
 power zoom options (SB-600), 71
 power zoom options (SB-800), 67
 power zoom options (SB-900), 59
 SB-600, 19
 SB-900, 33
zoom head position
 SB-600 Guide Numbers (table), 86
 SB-800 Guide Numbers (table), 85
 SB-900 Guide Numbers, DX format (table), 83
 SB-900 Guide Numbers, FX format (table), 84
 setting for wide-flash panel (SB-600), 71
 setting for wide-flash panel (SB-800), 67
 setting for wide-flash panel (SB-900), 62–63
 with SW-10H diffusion dome, 110
 with SW-13H diffusion dome, 110
zooming flash head
 benefits of, 6–7
 SB-600, 15
 SB-800, 22
 SB-900, 28